EXPRESSIONS OF A NEW SPIRIT

EXPRESSION

PUBLICATION MADE POSSIBLE BY UNITED TECHNOLOGIES CORPORATION

OF A NEW SPIRIT

Elizabeth V. Warren, Curator
Stacy C. Hollander, Assistant Curator

MUSEUM OF AMERICAN FOLK ART, NEW YORK

ISBN 0–912161–01–9 (hardcover)
ISBN 0–912161–02–7 (paperback edition)

Library of Congress Catalog Card Number 89–50388

Designed by Derek Birdsall RDI
Produced by Omnific Studios
Typeset in Monophoto Modern No. 7 and Clarendon 12
Printed and bound in Great Britain by Penshurst Press
Limited on Parilux Matt white paper

Cover
Girl in Red Dress with Cat and Dog (Detail)
Ammi Phillips (1788–1865)
Vicinity of Amenia, New York; 1834–1836
Oil on canvas; 30 × 25in.
Promised anonymous gift. P2.1984.1
See catalogue #**1**

Expressions of a New Spirit: Highlights from the Permanent Collection of the Museum of American Folk Art is a celebration—a celebration of wonderful art and of the Museum of American Folk Art's new home at Manhattan's Lincoln Center.

This show is also a sequel of sorts, a finale to the *Expressions of a New Spirit* exhibition, which toured the United States, Europe, and Canada from 1983 to 1987, through the sponsorship of United Technologies.

We are proud to underwrite this show and to join millions of admirers of American folk art in wishing the museum great success in its new quarters.

Robert F. Daniell
Chairman and Chief Executive Officer
United Technologies Corporation

ACKNOWLEDGEMENTS

Seldom does a museum have the opportunity to mount a special exhibition from its permanent collection for presentation throughout Europe, followed by a national American tour and then a tour of Canada. This is exactly what the Museum of American Folk Art has been able to achieve with the assistance of United Technologies Corporation of Hartford, Connecticut.

In April, 1982, Mabel H. Brandon, then president of Rogers & Cowan, Inc., introduced the Museum to Gordon Bowman of United Technologies. We discussed the possibility of corporate sponsorship for a European tour of the Museum's collection, to be accompanied by a major publication. The book, *American Folk Art: Expressions of a New Spirit*, was produced with funds from United Technologies, and designed by the remarkable Derek Birdsall of London.

The oversized, full-color effort was published in both hard cover and paperback editions in English, French, and German. This record of the Museum's growing collection was a wonderful way for our institution to offer its collection to the public, since the development plans for a new Museum of American Folk Art on Manhattan's fifty-third street were stalled because of tenant conflicts in the buildings scheduled for demolition.

The exhibition opened April 27, 1983, at the Pavillon des Arts in Paris. From there it moved to the Munchner Stadtmuseum in Munich for the summer of 1983, then to the Altonaer Museum in Hamburg for a fall presentation; and finally to the Barbican Art Gallery in London for a winter showing.

Because the exhibition was such a success, new plans were developed for a national tour of the United States. Between July, 1984, and July, 1986, *American Folk Art: Expressions of a New Spirit* was seen at the Minneapolis Institute of Arts in Minneapolis, Minnesota; the John Deere Company, Moline, Illinois; the Portland Art Museum, Portland, Oregon; the Phoenix Art Museum, Arizona; the Colorado Springs Fine Art Center, Colorado Springs, Colorado; the Seattle Art Museum, Seattle, Washington; the Columbus Museum of Art, Columbus, Ohio; and the Fort Wayne Museum of Art, Fort Wayne, Indiana.

As the exhibition toured the works of art were very carefully monitored by the Museum's professional staff. During the course of the tour a number of works were removed to be "rested" and others were substituted.

Just prior to the opening of the exhibit in Fort Wayne, Indiana, United Technologies Corporation proposed that four additional venues in Canada be considered. Beginning December 9, 1986, the Canadian tour included four locations: the Koffler Gallery, Willowdale, Ontario; the Art Gallery of

Nova Scotia, Halifax, Nova Scotia; the Nickle Arts Museum, Calgary, Alberta; and the Musée de la Civilisation, Quebec.

We have always known that this permanent collection exhibition would be the show that would inaugurate our new exhibition space in the Eva and Morris Feld Gallery at Two Lincoln Square, immediately across the street from Lincoln Center in New York City. Now titled *Expressions of a New Spirit: Highlights from the Permanent Collection of the Museum of American Folk Art*, the exhibition has been refocused by Elizabeth Warren, Museum curator, and augmented by major works of art recently acquired for the Museum's permanent collection.

This new book was also made possible by United Technologies Corporation. It documents many of the remarkable holdings in the permanent collection of the Museum of American Folk Art. I am especially grateful to Robert F. Daniell, Chief Executive Officer/Chairman of United Technologies; Carol Palm, Manager, Cultural Programs, United Technologies Corporation; and Gordon Bowman, arts consultant to United Technologies.

In the years to come, many of the works of art included in this book will be on frequent display at the new Eva and Morris Feld Gallery. We celebrate this new exhibition space with the presentation of the inaugural exhibition and the book/catalogue written by Elizabeth Warren and designed and produced by Derek Birdsall.

Dr. Robert Bishop
Director, Museum of American Folk Art
January, 1989

In many ways, this catalogue serves as an updated version of the 1983 publication, *American Folk Art: Expressions of a New Spirit*. While building on the collection presented in that book and the traveling exhibition it catalogued, this publication includes both new information and new accessions to the Museum of American Folk Art's permanent collection. United Technologies Corporation provided financial support for both the previous book and the worldwide tour of the exhibition. Once again we are grateful to United Technologies for funding this catalogue and the accompanying presentation, which will be the initial exhibition at the Museum of American Folk Art/Eva and Morris Feld Gallery at Lincoln Square.

Many of the people thanked in the past have once again contributed their time and effort to helping in the production of this book. At United Technologies, Gordon Bowman and Carol Palm have been continually supportive of the Museum's efforts. Derek Birdsall has once again brought his professional expertise to the design and production of the catalogue. And without the generous support of the many people who have contributed both objects and funds for purchase, the Museum would not have a collection of such high quality to present. We are grateful to both the donors mentioned in the captions accompanying the illustrations and to those who prefer to give anonymously.

A number of photographers, including Wit McKay, Schecter Lee, Carleton Palmer, and Helga Studios, contributed the images seen here. We are especially grateful to John Parnell who provided new photography of the catalogue numbers 10, 20, 30, 34, 36, 44, 49, 51, 53, 54, 55, 57, 60, 61, 65, 67, 74, 88, 89, 91, 100, 101, 122. We also especially appreciate the help of Ann-Marie Reilly, Registrar, and Dawn Geigerich, Assistant Registrar at the Museum of American Folk Art, who measured, moved, and cared for the works of art, and prepared them for photography.

For their valuable editorial assistance, we would like to thank Robert Bishop, Director of the Museum of American Folk Art; Gerard C. Wertkin, Assistant Director of the Museum; and friends and colleagues Sharon Eisenstat and Irwin Warren. We are also grateful to the scholars who so generously provided us with the fruits of their research, especially Joyce Hill, Mary Black, Betty Ring, Davida Deutsch, Lee Kogan, Michael Hall, Richard Miller, and Jeff Waingrow. And special thanks to Edith Wise, Eugene Sheehy, and June Griffiths in the Museum of American Folk Art Library who were always available for last-minute research assignments.

Elizabeth V. Warren
Curator, Museum of American Folk Art
January, 1989

FOREWORD

American folk art is enjoying a popularity today that is unequaled in the history of the field. Exhibitions of quilts, weathervanes, decoys, paintings, and other forms have traveled extensively not only in America, but throughout Europe and Japan. And, as interest in the wide variety of objects included under the umbrella term "folk art" grows, so does the debate about what exactly folk art is, what is the proper way to study, collect, and exhibit it, and even what is the correct term to use when referring to these objects.

Such controversy, however, attests to the importance of folk art in today's world. Disagreement spurs discussion and research, and opens minds to new points of view and different approaches to a young and still evolving field. A brief historical look at appreciation for American folk art provides perspective and some understanding of how interest in the subject developed.[1]

Some of the first folk art collectors were early twentieth-century artists, a number of whom spent their summers in an artists' colony in Ogunquit, Maine. Robert Laurent, Yasuo Kuniyoshi, Bernard Karfiol, Niles Spencer, Marsden Hartley, and William Zorach were among the artists who summered in fishing shacks that were furnished by Hamilton Easter Field with decoys, weathervanes, and "early American" paintings. Some members of the Ogunquit Colony began collecting folk art for themselves and also influenced other New York artists such as Charles Sheeler and Elie Nadelman. Nadelman, in fact, became so involved with folk art that he and his wife amassed two collections of "art for people" and in 1924 opened a museum on the grounds of their estate in Riverdale for the purpose of displaying their objects to the public.

These artists clearly saw a relationship between the abstract qualities of folk sculpture and painting and their own art. In their attempts to break away from the traditions of late-nineteenth-century academic art, they drew inspiration and, perhaps, validation for what they were trying to accomplish, from eighteenth- and nineteenth-century folk art.

The first recorded exhibition of American folk art was presented in 1924 at the Whitney Studio Club in New York City. Then under the direction of Juliana Force, one of the early serious collectors of folk art, the Whitney Studio Club was the precursor of the Whitney Museum of American Art. H. E. Schnackenberg, a painter who served as curator of the exhibition, borrowed many of the pieces in the show from contemporary artists.

As interest in the field began to grow, and dealers began exhibiting and advertising the work, articles appeared advising collectors how to view and

1. For the history of collecting folk art in the early years of the twentieth century, see Beatrix T. Rumford, "Uncommon Art of the Common People: A Review of Trends in the Collecting and Exhibiting of American Folk Art," in Ian M. G. Quimby and Scott T. Swank, *Perspectives on American Folk Art*, (New York, 1980) pp.13–53.

understand folk art. In 1927, Homer Eaton Keyes, editor of *The Magazine Antiques*, explained to his readers that they could not look at folk paintings in the same way as academic paintings:

> *On first examination, their inadequacies of drawing will be the only element that is apparent to the average person. If, however, the fact is borne in mind that, in many of these pictures, the various elements of the design are to be viewed only as decorative symbols, and not as naturalistic renderings of particular objects, appreciation will shortly begin to develop.*[2]

Keyes also issued a warning about folk paintings that remains valid today. He wrote that even though many "crude" pictures contained features valued by us, the appearance of "crudity" does not necessarily mean that the paintings should be viewed with favor.[3] He was arguing for aesthetic criteria to be applied in evaluating a work of folk art, as they are in other areas of art.

The first museum in the United States to mount a major exhibition of American folk art was The Newark Museum in New Jersey. In 1930 Holger Cahill, who had been introduced to folk art by Robert Laurent, assembled eighty-three paintings divided into three categories according to the subject: portraits, landscapes and other scenes, and decorative pictures. *American Primitives: An Exhibit of the Paintings of Nineteenth-Century Folk Artists* focused primarily on the aesthetic qualities of folk painting and proved so popular that some of the pictures were selected for travel to the Memorial Art Gallery in Rochester, the Renaissance Society of Chicago, and the Toledo Museum of Art.

In 1931 Cahill was commissioned to present a second folk art show in Newark, *American Folk Sculpture: The Work of Eighteenth- and Nineteenth-Century Craftsmen*. Among the nearly two-hundred examples of wood carving, metalwork, pottery and plaster ornaments selected for the exhibition were a number from the private collection of Abby Aldrich Rockefeller, whose interest in American folk art grew out of her appreciation of contemporary art, and whose extensive collection was to form the basis of the Abby Aldrich Rockefeller Folk Art Center at Colonial Williamsburg.

Mrs. Rockefeller's collection, much of it assembled by the New York dealer Edith Gregor Halpert, was also used for the first exhibition to display both painting and three-dimensional art, *American Folk Art, the Art of the Common Man*. With Holger Cahill again serving as curator,

2. Homer Eaton Keyes, "Some American Primitives," *The Magazine Antiques* 12, no. 2 (August 1927) p.122.

3. Keyes, p.122.

the presentation opened at the Museum of Modern Art in New York City in 1932, then traveled to six other American cities in 1933 and 1934. In his introduction to the catalogue, Cahill included a definition of folk art that served more than one generation of collectors, curators, and scholars. He wrote that American folk art is

... the unconventional side of the American tradition in the fine arts, ... It is a varied art, influenced from diverse sources, often frankly derivative, often fresh and original, and at its best an honest and straightforward expression of the spirit of a people. This work gives a living quality to the story of American beginnings in the arts, and is a chapter ... in the social history of this country.[4]

In this essay Cahill defended his use of the term "folk art," saying that it "is the most nearly exact term so far used to describe the material," and stressed the concept that folk art grew out of a craft tradition "plus the personal quality of the rare craftsman who is an artist." He also put into the vocabulary of those who followed him the phrase "expression of the common people."[5]

Also in 1932, Allen Eaton published *Immigrant Gifts to American Life*, a book that included descriptions of a number of folk art exhibitions that had been held across the country between 1919 and 1932. Eaton, a sociologist with a background in art appreciation, advocated viewing folk art as a social as well as an aesthetic document, and championed the contributions made by immigrants to America's cultural life. Eaton's idea of folk art, however, was more inclusive than that of Cahill's, and purely utilitarian and undecorated objects were presented alongside paintings and sculpture. Eaton's view of the field, including "many things which people do day by day, as well as they know how,"[6] comes closer to the understanding of folk art that is held by folklorists today than the definitions expressed by Cahill and his fellow collectors and curators.

In the 1930s and 1940s, many of the great collections of folk art were assembled by people who were originally buying art work suitable as decoration for their old houses or to complement their Early American furniture. Living with the art, however, inspired such early collectors and scholars as Nina Fletcher Little and Jean Lipman to research the artists and to contemplate the meaning of folk art. Mrs. Little examined the relationship of fine art to folk art in her introduction to the publication of the Abby Aldrich Rockefeller Folk Art Collection in 1957:

4. Holger Cahill, *American Folk Art: The Art of the Common Man in America 1750–1900*, (New York, 1932) p.3.

5. Cahill, p.6.

6. Quoted in John Michael Vlach, "Myths in American Folk Art History," in *Maine Antique Digest* (November, 1986) p.10–B.

Two kinds of art have flourished side by side in nearly all nations. Very often their courses have run independently of each other. One we call fine art. Created by the great masters largely for the rich and ruling classes and the church, fine art served the Doges of Venice and the Kings of France. In America it served the gentry of the South and the merchant princes of New England. It was sponsored by the great families of great states.

The other category includes American folk art. This is the art of the people — often anonymous or forgotten men and women. In the first group we see the glory and majesty of the ages. In the second we discover the character and interests of a people and the forces that molded their lives.

American folk art is not an unskilled imitation of fine art. This must be stressed for in it lies the personal flavor of folk art. It lives in its own world and is responsive to its own surroundings. It was produced by amateurs who worked for their own gratification and the applause of their families and neighbors, and by artisans and craftsmen of varying degrees of skill and artistic sensitivity who worked for pay.[7]

Mrs. Lipman has been just as adamant in her defense of the quality of the best folk art, and her belief that it should be considered as part of the mainstream of American art. In the preface to the catalogue for the 1974 exhibition, *The Flowering of American Folk Art (1776–1876)*, she wrote:

… In my two books on American folk painting, I expressed the opinion, "radical though this may seem" that a number of gifted folk artists arrived at a power and originality and beauty that were not surpassed by the greatest of the academic painters. I have never changed my mind and am convinced that the entire field of activity of the folk artists was absolutely not, as has often been said, a charming postscript. I believe it was a central contribution to the mainstream of American culture in the formative years of our democracy.[8]

In recent years, the emphasis placed on aesthetics by the early collectors and curators — and continued in art museums and other institutions with an art-historical orientation — has come under attack by those who support the folklorists' point of view that "folk material culture" must be, first of all, produced by anthropologically definable folk cultures and, secondly, to be called "folk art," must be defined as art by the folk group itself. Furthermore, folk material culture should be viewed in the context of the culture that produced (and/or continues to produce) it, and such "elitist" terms as "painting," "sculpture," and "decorative arts" should not be used to describe it.

7. Nina Fletcher Little, *The Abby Aldrich Rockefeller Folk Art Collection*, (Williamsburg, Va., 1957) p.xiii.

8. Jean Lipman, "Preface," *The Flowering of American Folk Art*, (New York, 1974) p.7.

Following such a strict definition, most of what has traditionally been called "folk art," and most of what is seen in this catalogue and accompanying exhibition (except, perhaps, for the Pennsylvania German *fraktur* and the Navajo blanket) could not be referred to as American folk art.

The battle, it appears, is over the right to use the words "American folk art" and it is a battle that is important in today's world at least in part because of the economic benefits to be reaped from the association with the term. As folk art grows more popular, not only are government grants available for its study and exhibition, but publishers of books and corporate sponsors of catalogues and exhibitions also want their names associated with such a crowd-pleasing subject. Two camps have laid claim to the words and each asserts sole right to its use.

An interesting compromise has been offered by David Park Curry in his essay, "Rose-Colored Glasses: Looking for 'Good Design' in American Folk Art." In this introduction to an exhibition of folk sculpture and textiles from the collection of the Shelburne Museum in Vermont, Curry writes:

> *I doubt that the term "American folk art" will go away; it is as entrenched as it is vague. To differentiate it from art made by identifiable folk groups, the term should be used in quotation marks. My understanding of "American folk art" is that it means the body of popular painting, sculpture, and decorative art collected in the early twentieth century, surrounded by a valence of attitudes toward both modernism and "the common man" that governed the collectors. Today one would no more mistake a piece of "American folk art" for an object created by an anthropologically defined "folk" than one would take Whistler's* Peacock Room *for a chamber imported from Japan.*[9]

While it is unlikely that simply putting quotation marks around the words "American folk art" will stop the battles in print and at academic conferences, perhaps it will make it evident that such discussion about the terms used to describe what is studied is less important than the study of the objects and the artists and cultures that produced them.

Curry's definition, however, fails to include the large body of work produced by folk artists in the years since the early twentieth century. These contemporary self-taught artists are not considered by either the traditionalist collectors and curators, who assert that folk art cannot be produced in today's "high-tech" world, or folklorists, who state that their work does not grow out of a folk culture.[10]

Controversy about modern folk art has raged since Sidney Janis published *They Taught Themselves: American Primitive Painters of the*

9. David Park Curry, "Rose-Colored Glasses: Looking for 'Good Design' in American Folk Art," in *An American Sampler: Folk Art from the Shelburne Museum*. (Washington, D.C., 1987) p.31.

10. For a discussion of the controversy surrounding contemporary folk art, see Didi Barrett, *Muffled Voices: Folk Artists in Contemporary America* (New York, 1986) pp.4–11.

Twentieth Century in 1942. Conservative collectors felt that many of the artists described painted only for monetary advancement and that their works were not valid folk art. These critics chose to forget that the portraits they so avidly collected were nearly always created for a fee and that the eighteenth- and nineteenth-century itinerant folk portraitist was a professional who earned his living from his art.

Critics of modern folk art have also argued that television and other mass media combine to inform the contemporary artists to such a degree that it is impossible for them to be uninfluenced by academic principles of art. This selective memory ignores the role that prints and the paintings of academic artists played in the artwork of earlier folk artists. Ammi Phillips, for example, painted many women with paisley shawls in clear imitation of the work of the academic painter Ezra Ames.

The contemporary self-taught artists share a kinship with their forebears even in their sources of inspiration. Religion, patriotism, everyday events, popular culture — all play a role in the folk art of the past as well as the present.

In part, it is the difficulty of judging contemporary art that is behind the controversy between the traditional folk art collector and the advocates of twentieth-century folk art. With historical perspective, it is easier to look at eighteenth- and nineteenth-century objects and develop a consensus about which pieces are of significance. Without hindsight, it it difficult to judge what will endure. Yet more and more collectors, scholars, and the institutions they represent are willing to take the initiative and pursue the study of contemporary folk art.

In this area, too, there is a war over words. Besides "folk," "primitive," "self-taught," and "non-academic," all used for historic material as well, in the contemporary field the terms "outsider" and "isolate" have also evolved to describe the artists and their work. In this arena, as in the battle for the term "folk art," it is hoped that study will concentrate on the objects and their creators rather than the words used to refer to them.

Discussion and disagreement in the study of American folk art goes beyond terms, however, and beyond the question of whether or not to include contemporary works. Every form of art traditionally considered as folk art, from portrait painting to cigar-store Indians to quilts, has come under scrutiny about whether or not it is *really* folk art.[11] The cigar-store figures, carousel animals, and factory-made weathervanes and decoys were all created using "assembly-line" production methods, so they cannot be viewed as the work of a single artist. Quilts, too, were often quilted at a

11. The most recent discussion of painting in this context can be found in John Michael Vlach, *Plain Painters: Making Sense of American Folk Art* (Washington, D.C.,1988).

quilting bee where many hands would be involved in sewing the bedcovers. Perhaps "popular art" would be a better term for some of these objects, yet that phrase tends to ignore the amount of handcraftsmanship that went into the making of the items. And even if more than one artisan contributed to the final product, does that make the object less worthy of study or appreciation? The disagreement comes down to terms and a definition of the scope of folk art. Probably more people would agree that the art is worthy of attention than about what it should be called.

The Museum of American Folk Art, founded in 1961, takes an open-minded approach to all these issues. Through an extensive schedule of exhibitions, publications, and educational programs, it is the Museum's purpose to be a forum in which the many controversies that are a part of the field can be raised and the many points of view disseminated. From its beginnings, the Museum has sought to examine the different areas of interest. Exhibitions of traditional eighteenth- and nineteenth-century objects, for example, have been presented at the same time as shows that focus on contemporary folk art, and many exhibitions have included works of art from the eighteenth through the twentieth centuries. Specific artists such as Ammi Phillips, Erastus Salisbury Field, and Howard Finster, have been investigated, as have such diverse and specific subjects as weathervanes, decoys, and Amish quilts.

As research in the field continues, the designations "Artist Unknown" and "Region Unknown" have begun to be replaced by specific names and places. A glance through one of the early catalogues from the Newark Museum or Museum of Modern Art exhibitions mentioned above will show how far the research has come, for many of the unidentified artists now have complete biographies. This catalogue of works in the permanent collection of the Museum of American Folk Art has also been updated from a previous volume published six years ago. A grant from the National Endowment for the Arts provided funds for much of the research, and students in the Museum's two educational arms — a master's and Ph.D. program presented in conjunction with New York University and The Folk Art Institute, a certificate-granting program accredited by the National Association of Schools of Art and Design — have also contributed to the research into the specific objects and the different forms of folk art in general. And as more is known about the artists and the environments in which they worked, more of the objects, some previously appreciated for their aesthetic qualities alone, can be placed in a specific context and

appreciated for what they tell us about the society that created them.

The Museum's magazine, *The Clarion*, also serves as a forum for the discussion of issues in the field, and as a means to disseminate new research and information. The only publication in the United States that deals solely with folk art, *The Clarion* welcomes contributions from scholars across the country concerning all the various forms of folk expression.

Access to Art®, a new program at the Museum of American Folk Art, has been created to make folk art available to everyone. Tactile exhibitions with large print and braille labels and audio guides introduce the blind and visually impaired museum visitor to the different forms of folk art. Exhibition furniture has been designed so that all objects are easily seen from a wheelchair, and aisles are wide enough so that two wheelchairs can pass at the same time. Access to Art® also publishes braille and large print guides to the exhibitions and books, such as the *Museum Directory for Blind and Visually Impaired People*, that make information about the arts available to all. Educational programming ranges from seminars on quilting for the visually impaired to videotapes for museum personnel on how to make their museums more accessible.

As we move into the last decade of the twentieth century, a definition of folk art and an exact understanding of what the parameters of the field are remain elusive and subject to much debate. That the artists were *mostly* self-taught; that *many* of them came from a crafts tradition; that *most* of it is handmade; that *some* of it is utilitarian; that *some* aesthetic criteria, admittedly subjective, should be applied as it is in all forms of art — perhaps these few generalities can still be used as a starting point. The field has come a long way from the days when the artists and the times in which they lived were seen as "simple" and a romantic, nostalgic attitude pervaded the writing. But, there is still a long way to go if we are to understand who the folk artist was and is, and why and how he or she creates. If nothing else, the controversy is evidence of a healthy prospect for folk art enthusiasm and scholarship in the future.

PAINTING AND DECORATED FURNITURE

Portraiture, decorative architectural painting, religious scenes and depictions of saints, illuminated certificates and manuscripts, and painted and decorated furniture — the forms of painting most commonly considered in the folk art tradition today — can all be traced to Old World predecessors and sources of inspiration. Many of the artists, especially in the first years of settlement, had been at least introduced to the principles or "schools" of art that flourished in Europe during and following the Renaissance. While perhaps not "folk artists" as the term is used today, their work influenced the American artists who followed them and adapted their styles as best they could. It is to these European immigrants that we look to understand the roots of folk painting in America.

In the settlements of the East Coast, portraiture was the most important form of painting during the Colonial period. As many of the artists were English emigrants, their styles of painting reflect the traditions in vogue in England at the time of their emigration. One style, first seen in America in the late seventeenth century, was Elizabethan in feeling with mannerist overtones. Rather than a true portrait, the painting was idealized, and was usually not representative of the personality of the sitter. Artists generally focused upon that which they considered most important in a portrait: the material wealth of the subjects as exemplified by their clothing and accessories. The backgrounds were simplified and stylized and the painting had a linear, two-dimensional feeling.

A second style of portraiture was introduced in the beginning of the eighteenth century by new waves of immigrant English painters. These artists were influenced by the High Renaissance concepts of painting that had been brought to England by Italian and Dutch artists traveling and fulfilling commissions there in the late seventeenth and early eighteenth centuries. Artists working in this mode attempted to accurately recreate realistic spatial relationships within their compositions and so the works have a more three-dimensional quality. In these paintings, more attention is paid to trying to depict a realistic likeness of the sitter and to capturing something of the subject's personality. Frequently, however, the artists relied on English mezzotint engravings for their background settings, poses, and accessories. Most popular were the engravings made from the portraits painted by Peter Lely and Sir Godfrey Kneller, court painter from the reign of Charles II to that of George I, who was painting to please the English nobility and persons of fashion. In eighteenth-century America, the artists were pleasing a nobility of another kind: those who had become wealthy in trade and commerce or were the political or social

leaders of their colony and had commissioned portraits as symbols of their status in the community. Paintings of this type are most often seen portraying the well-to-do Dutch of the Hudson River Valley in New York as well as the Colonial aristocracy in Virginia, Boston, and New York City.

In the eighteenth and nineteenth centuries, many originally self-taught folk painters developed a competence that earned them national and international reputations. Benjamin West, John Singleton Copley, and John Trumbull were among the artists who began their careers without fully-developed skills and whose techniques developed from personal experimentation. In time, formal training in varying degrees changed their styles to the point that the majority of their paintings cannot be considered folk art. However, thousands of folk painters lacked the luxury of training afforded men like West and Copley, and, because of economic, cultural, and social considerations they failed to attain the impressive stature of these masters. Though much of their work lacks technical competence, it does demonstrate a power of observation, a sense of design, and a wide range of imaginative vision. It was also widely accepted and valued by the country folk who commissioned it.

By the late eighteenth century, portraits were desired by and available to a much greater audience than in the Colonial period. The middle class that emerged after the Revolution had both the means to hire an artist and the need to show that they were worthy of having their likenesses taken and therefore worthy of being remembered by future generations. In the late eighteenth and first half of the nineteenth centuries, there were countless artists who earned their living by satisfying that need.

Many of these portraitists emerged from the craft tradition, and began and often supplemented their portrait careers by doing sign, carriage, house, decorative and general "fancy" painting. These were primarily self-taught artists who found their own solutions to the problems of anatomy, composition, and color. Others had rudimentary training in the studios of more established painters, some of whom had had little formal instruction themselves. No doubt these artists crossed each other's paths enough to be influenced by both earlier and contemporary painters.

While some painters lived in cities that were large and wealthy enough to support their careers, or combined portrait painting with different forms of work, others had a more itinerant lifestyle, traveling from town to town in search of commissions. Many relied on friends and relatives or on the good word of previous clients to recommend them to new areas that might prove fruitful. Usually, an artist arriving in town would place an advertisement

in the local paper advising the populace of his or her availabilty to undertake portrait commissions. Frequently, entire members of a family would be painted by an artist during his stay and then he would move on to another town where he would paint a different branch of the family.

Because folk artists often painted portraits that are very similar (Ammi Phillips, for example, painted a number of children in poses and costumes almost identical to the "Girl in Red Dress with Cat and Dog") it was once believed that itinerant artists would spend the winters painting "stock" portraits of headless bodies. They would then, it was said, travel from town to town during the summer months, offering patrons their choice of body to which a head would be added. Research into the careers of these artists has proved that this was not how they worked.

What folk portraitists such as Phillips did do was to keep in mind a file of themes and motifs upon which they could call as needed. After all, the more portraits they completed the more they could earn, so it was incumbent upon them to finish paintings as quickly as possible. These stock methods of solving problems such as costumes, backgrounds, poses, and anatomy were used frequently as timesaving devices. This was also a reasonably sure way of pleasing clients, who could be shown recently completed commissions and be assured of what they would be getting. Because most folk paintings are unsigned, such stylistic devices provide clues for folk art historians in attributing the works to specific artists.

Folk painters, however, sometimes evolved in their style of painting or were capable of painting in more than one style. Phillips, for example, who painted in the border areas of Connecticut, Massachusetts, and New York, has been shown to have painted in three completely different styles during his long career. William Matthew Prior, who painted with a number of relatives, including Sturtevant J. Hamblin and George Hartwell, in his well-known "Painting Garret" in Boston, adapted his technique to the potential sitter's financial means: a flat likeness "without shade" could be had for about one dollar. For more affluent subjects, he would provide a realistic portrait at a price as high as twenty-five dollars. Prior also practiced the art of reverse painting on glass (specializing in portraying the founding fathers), and late in his career turned to painting landscapes of famous American sites including "Mount Vernon and the Tomb of Washington."

By 1840, the portrait artists were beginning to lose the battle for commissions to takers of daguerreotypes, introduced to America from France in 1839 by the painter Samuel F. B. Morse, better known today

as the inventor of the telegraph. Daguerreotypes were cheaper and faster to produce than painted portraits, and their images were more realistic. Many artists found they simply could not compete, and had to find other means of employment, including learning the new technology themselves and taking to the road as itinerant photographers. Others stayed in business for a while by offering what the photographs could not — color, large size, and the ability to include family members who were not present, including those who were deceased. And many artists found a way to combine painting and photography in their portraits, either by painting over photographs or copying photographic images onto a large canvas. In general, however, both the quality and artistic merit of folk portraits painted after mid-century declined and the artists were forced to find new avenues for artistic expression as well as for making a living.

In contrast to nineteenth-century examples, twentieth-century folk portraiture is marked by idiosyncratic styles that owe little to the accurate depictions of the camera. Portraits are rarely undertaken as commissions; nor are they necessarily meant to please their subjects. Instead, they tend to be the work of artists who have chosen portraiture as a medium for self-expression. Rarely are the artists professional in the sense of the eighteenth- and nineteenth-century painters who relied on portrait commissions to make their living.

In the eighteenth and nineteenth centuries, many of the same artists who earned a living painting portraits were also called upon to do decorative painting in houses. These generally took the form of overmantels and fireboards, as well as painted doors and walls. Usually the paintings were landscapes that represented either a local scene or the actual house in which the painting was done. Sometimes, the view was of Mount Vernon or a classical ruin, places the artist had never personally seen. Prints served as the primary design source for the self-taught "landskip" painter. Many books were also available for the artist trying to teach himself the principles of drawing. Among the earliest available in America was *The Graphice, or The Most Ancient and Excellent Art of Limning*, written by Henry Peachem and published in London in 1612. *The Artist's Assistant in Drawing, Perspective, Etching, Engraving, Mezzotinto Scraping, Painting on Glass, in Crayons, in Water Colours, and on Silks and Satins, the Art of Japanning, etc.*, originally produced by Carrington Bowles, an English publisher and print seller, about 1750, also provided a visual encyclopedia for the beginning artist who lacked access to formal training.

Land– and seascapes that were not architectural decoration became

more popular in the nineteenth century when prosperous home—and ship owners would commission artists to paint their houses or ships, much as they would hire a portrait painter to paint their likenesses. Businessmen, too, might hire an artist to record the workplace for posterity. Landscapes with a patriotic sentiment, often taken from widely distributed prints, were especially popular in the nineteenth century, as witnessed by the many scenes depicting George Washington, his home, and his tomb.

In the twentieth century, many folk artists have chosen not to paint their immediate environment, but to look backwards in "memory" pictures. Often, the memories they recall in their paintings are sweeter than their lives actually were—they prefer to paint life as they wish it had been rather than as it was. Just as earlier artists were inspired by prints, these artists sometimes draw their subject matter from magazines, calendars, greeting cards, and other contemporary sources.

Religion has always been a major inspiration for the folk artist. From the first outpost settlements of the Spanish adventurers, established in the second half of the sixteenth century, came a rich outpouring of artistic efforts designed to serve and propagate the Catholic Church. Three-dimensional sculptural pieces and wooden panels and animal hides decorated with painted representations of holy figures were used both in the home and in the church. These were initially created by the Franciscans, who taught the native Indian converts to execute religious works depicting Christ and the most important patron saints. Portraiture and landscapes were rarely attempted in the Spanish colonies in what is now the southwestern United States.

In the Hudson Valley, Dutch settlers between New York City in the south and Albany in the north produced a body of religious art of great significance as well. Dutch immigrants and their descendants adorned their walls with paintings based on illustrations in Bibles brought from The Netherlands. Many of these pictures have been shown to have been executed by the same artists who were also painting portraits of the local population.

Closely related to religious painting is the *fraktur* tradition of the Pennsylvania Germans. *Fraktur*, a term that is broadly defined as illuminated manuscripts, is an art form that can be traced back to medieval Europe. *Fraktur-schriften*, "fraktur writing," was one of the arts the German-speaking immigrants brought with them from the Old World. Almost every eighteenth-century group of German-speaking Protestants migrating to America included a minister or schoolmaster who was skilled

in *fraktur* writing. To add to their incomes, these men and their successors prepared the certificates of birth, baptism, marriage, and death that had been required by law in Europe and continued to be made by tradition-loving Germans in their new home.

Birth and baptismal certificates (*taufscheine*) are the most common, but not the only form of *fraktur*. *Vorschrift*, a penmanship example (usually including a Biblical passage or a hymn, together with sample alphabets) prepared by a schoolmaster for his pupils to copy, is the next most numerous type. Other kinds of *fraktur* are "rewards of merit," drawn by teachers for diligent students, bookplates and illustrations for hymnals, house blessings, and other presentation pieces.

Schools in Pennsylvania continued to teach *fraktur* writing until the mid-nineteenth century. Eventually, the establishment of the English school system and the wide availability of inexpensive, mass-produced certificates designed to be colored and filled in at home, led to the disappearance of this art form.

Religion continues to be a powerful source of inspiration for folk artists in the twentieth century. Some artists are essentially preachers who use their paintings as a means of spreading the Gospel. Others have been deeply influenced by their religious heritage, and turn to the Bible and other holy texts, as well as the folklore and traditions associated with their religion, for the subject matter that they paint.

At the end of the eighteenth century and the beginning of the nineteenth, Americans of some financial means showed their pride in their success by sending their daughters to academies or finishing schools where the polite arts of needlework, music, dancing, writing, and watercolor painting—all intended to prepare young ladies for marriage—were major parts of the curriculum. At the same time, the Romantic movement, imported from England and France, was reaching American shores and meeting with great popularity. Accordingly, girls in school were encouraged to engage in sentimentality and the paintings they produced reflected the influence of Romanticism. Idealized pictures, moody moonlit landscapes, and romantic story paintings were painted at these schools in great numbers. Delicate watercolors showing landscapes filled with castles and ruins, mourning pictures, and both grisaille and brightly colored theorems were all part of this manifestation. There was also an interest in Biblical subjects and scenes taken from Classical mythology that resulted in pictures produced in both watercolor and needlework, most adapted from prints imported from Europe.

Painting continues to be a major form of self-expression for self-taught artists in the twentieth century. For some, the motivation and inspiration to paint are similar to those of the past: religion, patriotism, a desire to record everyday life as it is happening. The best of the art continues to be strong in the areas of design, imagination, and color, and the artists continue to find their own inventive solutions to the problems of perspective, scale, and anatomy. Just as the folk painting of the past reflected the concerns, interests, and aesthetics of previous centuries, so a great deal of the painting of today deals with such contemporary themes as nuclear war, sexuality, and psychological issues in ways that are closely related to modern art styles. And immigrants and descendants of immigrants are still utilizing transplanted exotic designs and motifs to infuse America's artistic heritage with a unique blend of the old and the new.

No discussion of folk painting in America would be complete without an acknowledgement of the contributions made by the furniture decorator, who had the ability to transform an ordinary piece of furniture into a work of art. Folk furniture inevitably reflected European tastes of earlier periods. A furniture style would first emerge at an English or Continental court and almost immediately be adapted by those associated with the ruling classes. It would then filter down to the lesser nobles and ultimately to the lower classes. Immigrants then brought these styles with them to the New World. The designs first enjoyed popularity in Colonial cities where they were incorporated into the patterns of the leading cabinetmakers. Finally, the basic styles were adopted by rural craftsmen, who also adapted the designs to the needs of their clientele and the materials they had available.

Nearly all country or folk furniture was painted, either to hide the fact that it was made from inexpensive types of wood, such as pine, or to disguise the fact that a number of different woods were used in the construction. Frequently, furniture decorators would paint *faux* finishes on a piece in imitation of the more expensive varieties of wood, often creating a beautiful grain on lumber that had an unremarkable one to begin with. Furniture could also be painted using sponges, putty, leaves, combs, and a variety of other imaginative materials.

Finally, the same motifs (geometric devices, plant forms, hearts, animals, etc.) that are found on *fraktur*, tombstones, and samplers, as well as on other forms of painting, are also found on decorated furniture. This is especially true for furniture made in the communities with strong ethnic ties to Old World communities and traditions or those with religious affiliations.

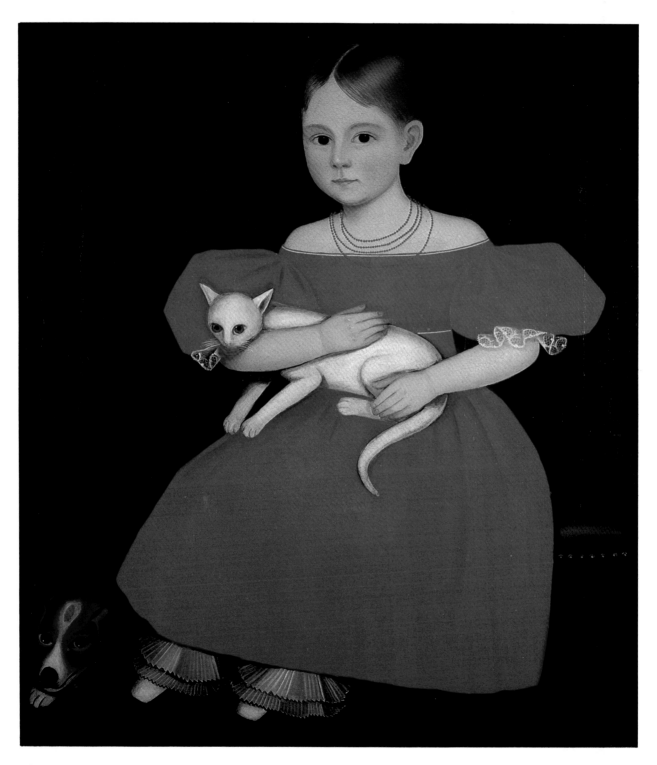

24

1

Girl in Red Dress with Cat and Dog
Ammi Phillips (1788–1865)
Vicinity of Amenia, New York;
 1834–1836
Oil on canvas; 30 × 25 in.
Promised anonymous gift. P2.1984.1

Phillips was an extremely prolific
artist who is known for more than five
hundred portraits painted in the
border areas of Connecticut,
Massachusetts, and New York.
Over time, he painted in three distinct
styles and his paintings were once
believed to be the work of three
different artists. The Kent Period is the
name ascribed to Phillips' work dating
from 1829 to 1838. These portraits
show that Phillips used formula
methods and stock poses and gestures
as shortcuts—at least two other nearly
identical portraits of little girls dressed
in red are known—although the results
were often dramatic and beautiful.

2

Unidentified Child
Prior-Hamblin School
Boston, Massachusetts or Portland,
 Maine; 1835–1845
Oil on canvas; $26\frac{3}{4} \times 21\frac{3}{4}$ in.
Promised gift of Robert Bishop.
 P78.101.1

Five artists have been currently
identified as working in the style of
William Matthew Prior and his
brother-in-law, Sturtevant J. Hamblin.
Besides Prior and Hamblin, they
are George Hartwell, William W.
Kennedy, and E. W. Blake. Ongoing
research indicates that this portrait
may be by George Hartwell, also a
relative of Prior's. Symbolic elements
in the painting—the cut tree, the
departing ship—suggest that this is
a post-mortem portrait.

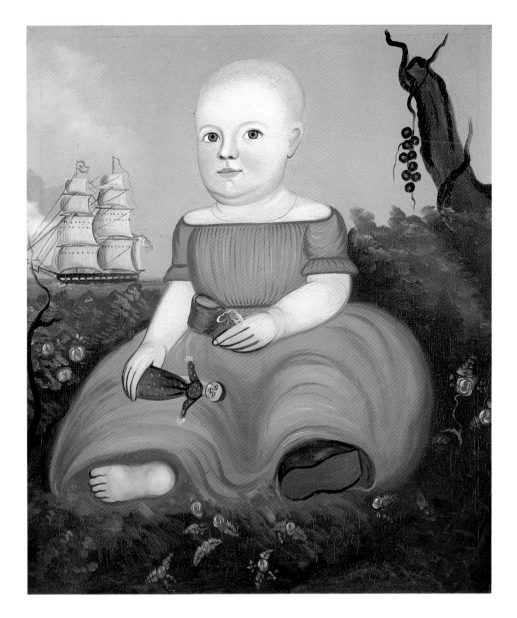

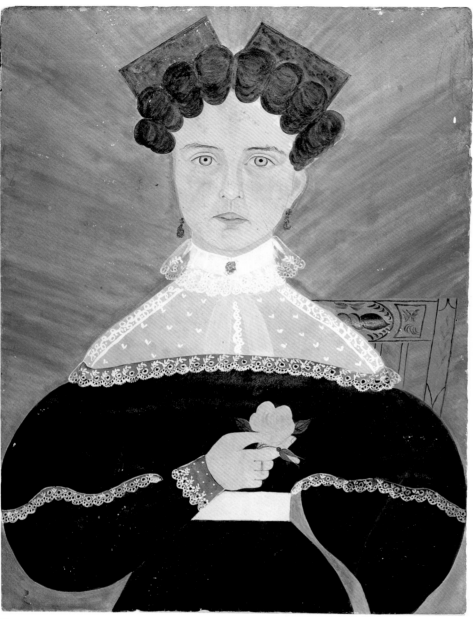

Ruth Whittier Shute and her husband, Dr. Samuel Addison Shute, painted separately, but their best works are the watercolors that they collaborated on, Ruth doing the "drawing," and her husband, the "painting," according to the inscriptions on some of their works. This painting bears all the hallmarks characteristic of their years of collaboration: strong diagonal wash in the background, use of gilt as well as watercolor, small hands, ribbonlike negative space between arms and body, heavy pencil shading and drawing on face. The subject, Mrs. Zophar Willard S. Brooks, was married to a chair decorator and maker and this painting was executed while she was working at the Phoenix Mill in Peterboro, New Hampshire.

4
Portrait of a Woman in a Mulberry Dress (Probably Mrs. Smith)
Isaac Sheffield (1807–1845)
Probably New London, Connecticut; 1835–1840
Oil on canvas; $33\frac{1}{8} \times 27$in.
Gift of Ann R. Coste. 1970.1.1

Sheffield is first documented as a painter in the New York City directory of 1828 in which he is listed as a "miniature painter." By 1830 he was listed in the Brooklyn directory as a "portrait and miniature painter." His father's death in 1830 brought him back to New London, Connecticut, where he consistently painted prominent sea captains and their relatives. This portrait probably represents the wife of one of the five sea captains named Smith in New London at the time. It is possibly a wedding portrait.

3
Portrait of Eliza Gordon Brooks (Mrs. Zophar Willard Brooks)
Ruth Whittier Shute (1803–1882) and Dr. Samuel Addison Shute (1803–1836)
Peterboro, New Hampshire; c.1833
Watercolor and gold metallic paint on paper; sight: $24\frac{5}{8} \times 19$in.
Museum of American Folk Art purchase. 1981.12.24

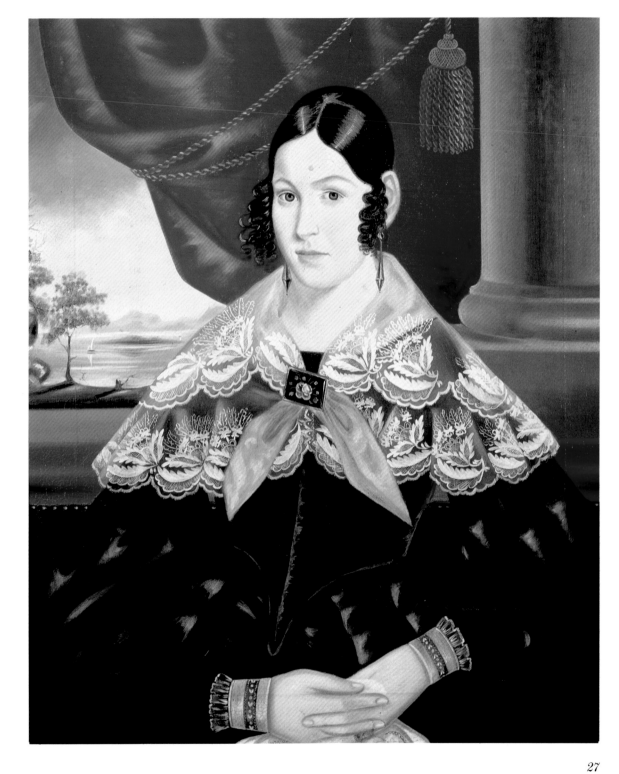

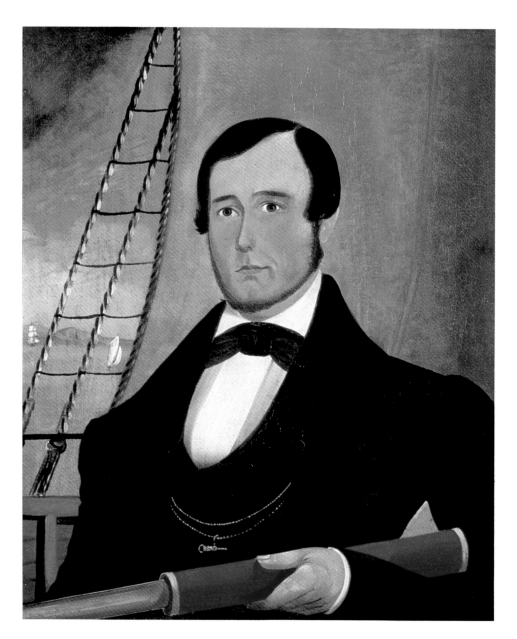

5
Unidentified Sea Captain
Prior-Hamblin School
Boston, Massachusetts or Portland,
 Maine; 1835–1845
Oil on canvas; $27\frac{1}{8} \times 22\frac{1}{4}$ in.
Promised gift of Robert Bishop.
 P78.101.2

The members of the "Prior-Hamblin
School" painted in such similar styles
that it is often difficult to tell their
works apart. This painting exhibits
traits that have been identified with
the works of both Sturtevant J.
Hamblin and George Hartwell. The
inclusion of accessories and
background settings associated with
the sitter's profession, in this case, the
telescope, ship's rigging, and sailing
ships, is common in folk portraiture.

6
Portrait of a Miller
Erastus Salisbury Field (1805–1900)
South Egremont, Massachusetts;
 c.1836
Oil on canvas; $30\frac{1}{2} \times 25\frac{1}{4}$ in.
Gift of Cyril I. Nelson in honor of
 Howard and Jean Lipman. 1981.13.1

Erastus Salisbury Field, who briefly
studied with Samuel F. B. Morse in
1824, was itinerant for much of his
career, traveling throughout the New
England countryside. Many of his
clients were relatives or were referred
to him by members of his large family.
In 1841, Field returned to New York,
possibly to learn daguerreotypy.
Eventually, Field could no longer make
a living as an artist but still spent his
old age painting Biblical, mythological,
and historical paintings at his familial
home, Plumtrees, Massachusetts.

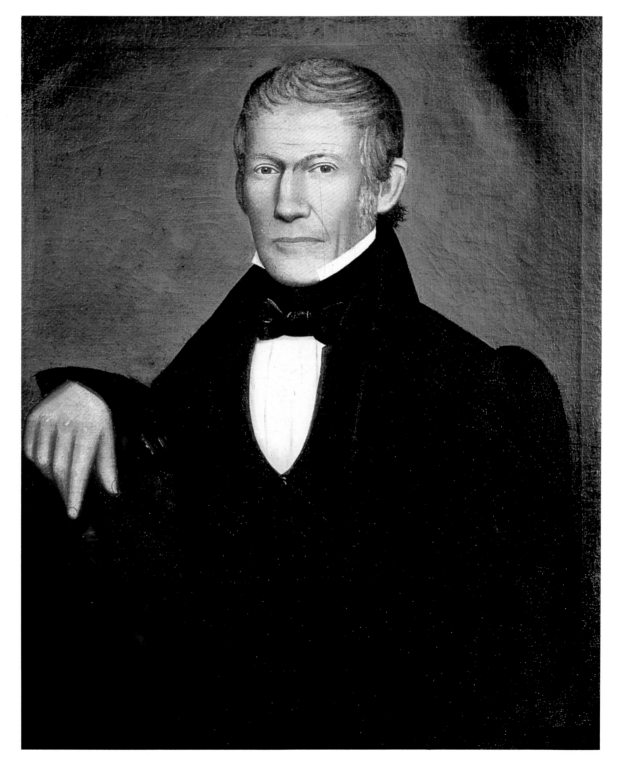

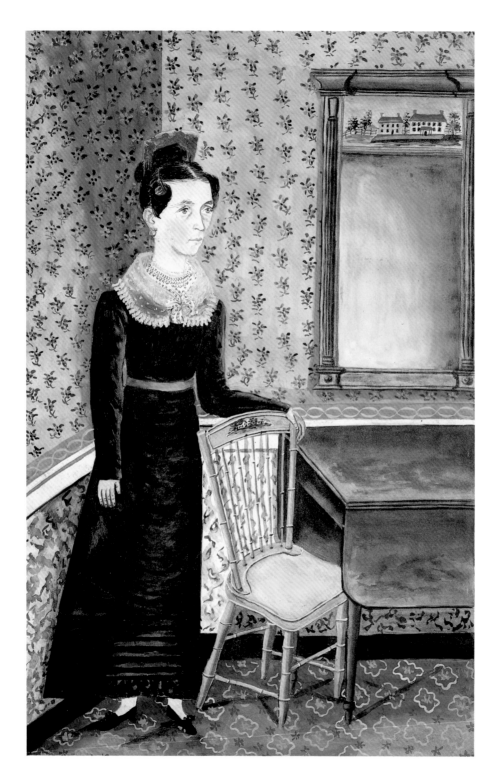

7,8
Portraits of Maria Rex and
 Peter Zimmerman
Jacob Maentel (1763–1863)
Schaefferstown, Pennsylvania; c.1828
Watercolor on paper; $17 \times 10\frac{1}{2}$ in. each
Promised anonymous gift

Jacob Maentel was born in Kassel, Germany, and died almost a full hundred years later in New Harmony, Indiana. During his long life he worked as a physician, secretary, farmer, and served as a soldier under Napoleon and in the War of 1812. He is remembered today, however, for the more than two hundred watercolor portraits he painted of friends and neighbors in Pennsylvania and Indiana. By 1828 Maentel had switched from the profile portraits he typically painted and began to paint frontal figures such as these portraits of the Zimmermans. Maria Rex was a descendant of Alexander Schaeffer, the founder of Schaefferstown. Peter Zimmerman was from Jackson Township (Myerstown), Pennsylvania. Both were born in 1802 and their first child was baptised in 1827 in Schaefferstown.

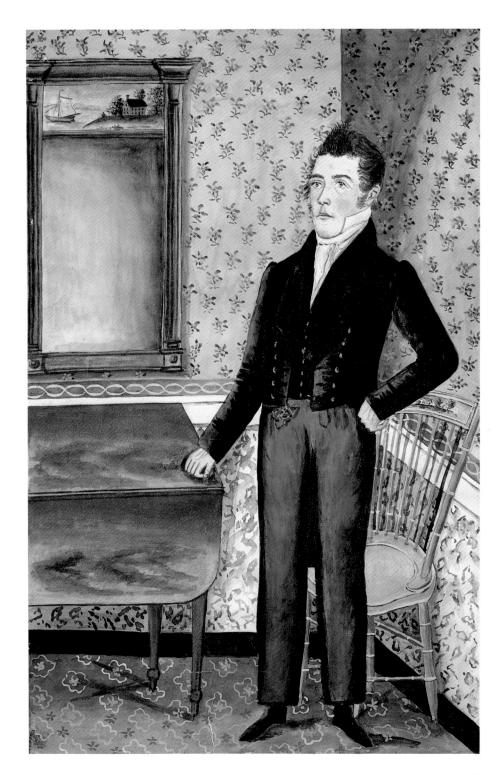

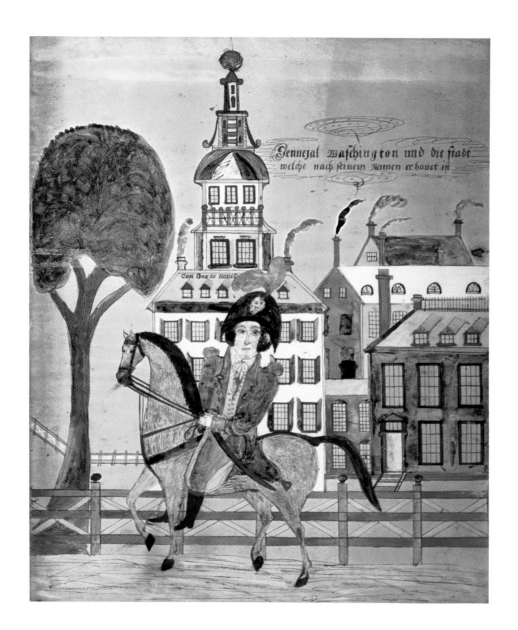

9

General Washington
Artist unknown
Southeastern Pennsylvania; c.1810
Gouache, watercolor and ink on paper;
 9¾ × 8in.
Promised anonymous gift

This watercolor portrait of George
Washington is similar in style to the
watercolor *frakturs* of the Pennsylvania
Germans. The inscription at the top is
translated as *"General Washington and
the city built in his name."* The artist has
added excitement to the painting by
using gold sparkles for Washington's
epaulets, buttons, and the buckle on
his hat.

10

**Geburts and Taufschein
 (Birth and Baptismal Certificate)
 of Martin Andres**
John Spangenberg, "The Easton Bible
 Artist" (before 1755–1814)
New Jersey or Pennsylvania;
 dated 1788
Watercolor and ink on paper;
 15½ × 13in.
Promised anonymous gift

John Spangenberg was a schoolmaster
in Easton, Pennsylvania, both before
and after his service in the Continental
Army. He supplemented his teaching
salary by executing writings both
decorative and mundane. Spangenberg
is known for the lively borders on his
frakturs that depict engaging figures of
musicians and partying ladies and
gentlemen. The *frakturs* that he
painted for the children of Bernard and
Mary Andres of Greenwich Township,
Sussex County, New Jersey, are
unusual because they are written in
English.

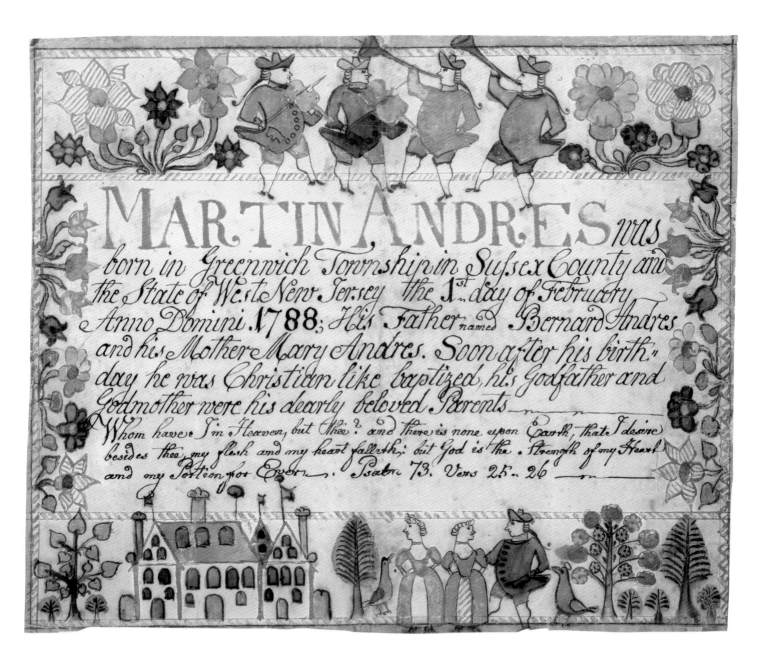

MARTIN ANDRES was
born in Greenwich Township in Sussex County and the State of West New Jersey the 1st day of February Anno Domini 1788; His Father named Bernard Andres and his Mother Mary Andres. Soon after his birth day he was Christian like baptized, his Godfather and Godmother were his dearly beloved Parents

Whom have I in Heaven, but thee? and there is none upon Earth, that I desire besides thee, my flesh and my heart falleth; but God is the Strength of my Heart and my Portion for Ever. Psalm 73. Vers 25. 26

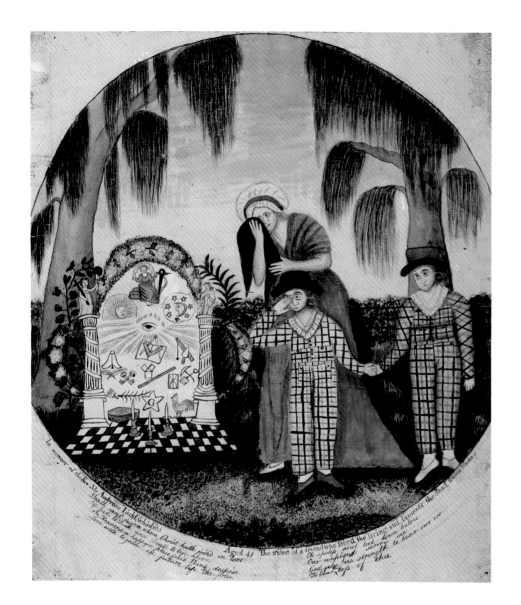

In memory of the Rev. Mr Ambrose Todd who died
Aged 41 The tribut of a friend who loved the living and laments the dead *Eunice Pinney*

11
Masonic Memorial Picture for Reverend Ambrose Todd
Eunice Pinney (1770–1849)
Windsor or Simsbury, Connecticut;
 1809
Watercolor on laid paper, pen and ink
 inscription; sight: $14 \times 11\frac{7}{8}$in.
Museum of American Folk Art purchase.
 1981.12.7

Reverend Ambrose Todd (1764–1809),
rector of the Episcopal Church in
Simsbury, Connecticut, married
Eunice Griswold to Butler Pinney in
1797. His Masonic affiliations (he was
inducted in April, 1798) are clearly
shown by the many symbols painted
on the gravestone. Eunice Pinney was
a well-born and well-educated woman
who turned to painting as a hobby in
the early years of the nineteenth
century.

12
Mourning Picture for Mrs. Ebenezer Collins
Probably Lovice Collins
South Hadley, Massachusetts; 1807
Watercolor, silk thread, metallic
 chenille thread on silk, pencil on
 paper label; 17in. diameter
Eva and Morris Feld Folk Art
 Acquisition Fund. 1981.12.8

All of Azubah and Ebenezer Collins'
seven children are depicted in this
memorial picture that was most likely
painted and stitched by their daughter,
Lovice, at Abby Wright's school in
South Hadley, Massachusetts. This
mourning picture has all the elements
typical of the art form: the urn set
upon a tomb, weeping willows,
evergreens, a village in the distance,
and weeping relatives. Each object in
the picture has a symbolic value:
weeping willows symbolized mourning;
evergreens meant resurrection; and the
town stood for a temporary
environment on earth.

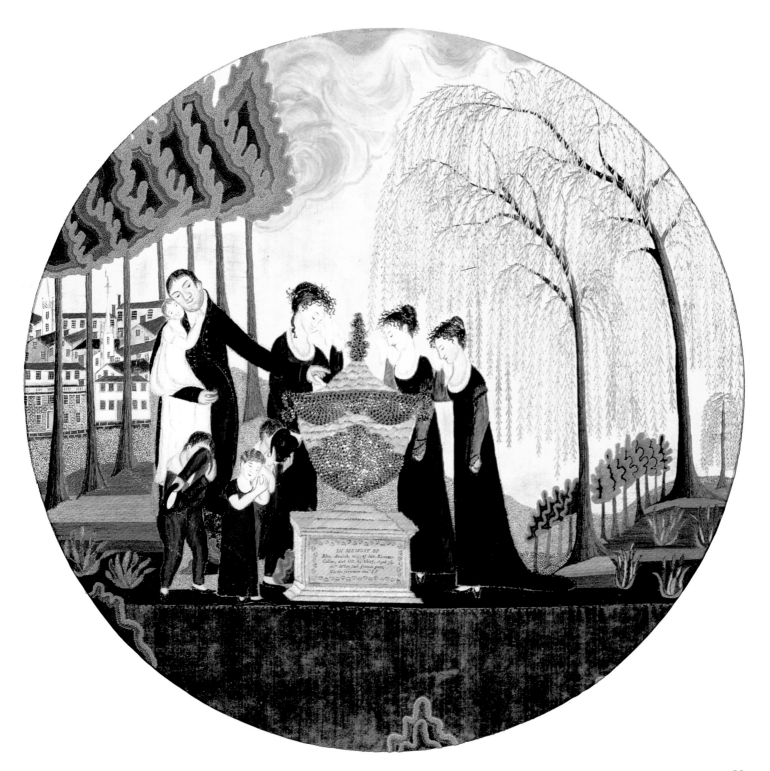

13
Mourning Locket: Woman and Ship

Attributed to Samuel Folwell
 (1764–1813)
Philadelphia, Pennsylvania;
 1791–1813
Watercolor on ivory, gold bezel, human
 hair; sight, oval: $2\frac{1}{8} \times 1\frac{3}{4}$in.
Museum of American Folk Art purchase.
 1981.12.27

Samuel Folwell's wife ran a school in
Philadelphia for which he painted
backgrounds, faces, and embroidery
designs for the young ladies'
needlework. In 1793 Folwell advertised
that he had opened an art school in
Philadelphia where "All kinds of Pencil
work will be taught, as also Painting
upon Sattin, Ivory, Paper … ." The
obverse of this locket shows the
allegorical figure of Hope with an
anchor, gesturing toward a departing
ship. The reverse contains a plait of
brown hair and a depiction of a small
child with a lamb.

14
Mourning Locket: Woman and Urn

Attributed to Samuel Folwell
 (1764–1813)
Philadelphia, Pennsylvania;
 1791–1813
Watercolor on ivory, gold bezel, human
 hair; frame, oval: $2\frac{1}{2} \times 1\frac{3}{4}$in.
Museum of American Folk Art purchase.
 1981.12.28

Attribution of a group of miniature
memorials (including 1981.12.27) to
the Philadelphia artist Samuel Folwell
is strengthened by the information on
this piece. The tombstone on this
locket is inscribed "*In Memory of
Andrew Kennedy.*" In 1789, Folwell
joined the Philadelphia militia as an
ensign in Captain Andrew Kennedy's
Eighth Company, first battalion of
Philadelphia. The reverse has a plait
of brown hair and is inscribed with the
initials "*MR.*"

15
Miniature: Child on Cushion

Artist unknown
New England; 1830–1840
Oil on ivory, hair; sight, oval: $2\frac{3}{4} \times 2\frac{1}{8}$in.
*Gift of Howard and Jean Lipman in
 memory of Joyce Hill. 1989.2.1*

This portrait of a young child was
probably painted posthumously. As
was the fashion, the reverse contains
plaited hair which would have
belonged to the deceased.

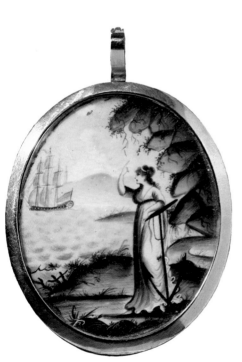

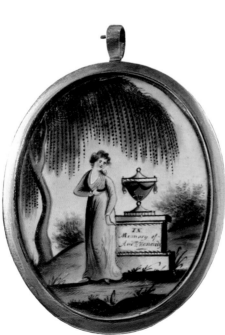

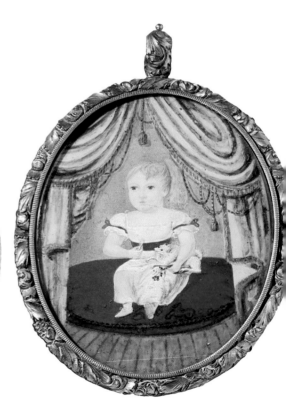

16
Miniature Pin: Soldiers
Artist unknown
American; 1830–1840
Watercolor on ivory; $1\frac{1}{4} \times 1$ in.
Joseph Martinson Memorial Fund,
Frances and Paul Martinson.
1981.12.29

The inscription on the back of this pin
reads: "*I. W. Seely to Job Taber.*"

17
Silver Watch Chain with Mourning
Picture
Artist unknown
European or American; 1825–1840
Watercolor on horn, silver;
sight: $1 \times 1\frac{1}{4}$ in.
Museum of American Folk Art purchase.
1981.12.32

The opposite side of this miniature
portrait of a cow has a more usual
mourning scene: two hearts on a
pedestal base beneath a weeping willow
tree.

18
Miniature Friendship Pin
(Clasped Hands)
Artist unknown
American; c.1830
Watercolor on ivory; $\frac{7}{8} \times 1\frac{1}{8}$ in.
Joseph Martinson Memorial Fund,
Frances and Paul Martinson.
1981.12.31

This pin is inscribed: "*Friendship the*
Fountain of Love." Similar pins with
the same composition and the same
inscription are known.

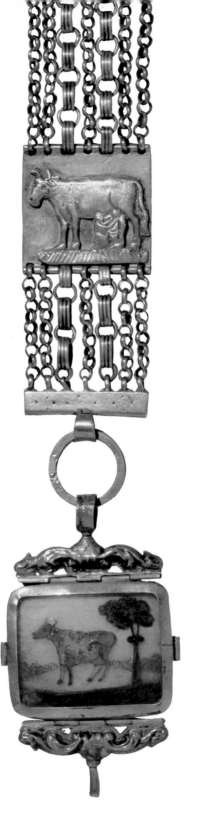

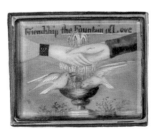

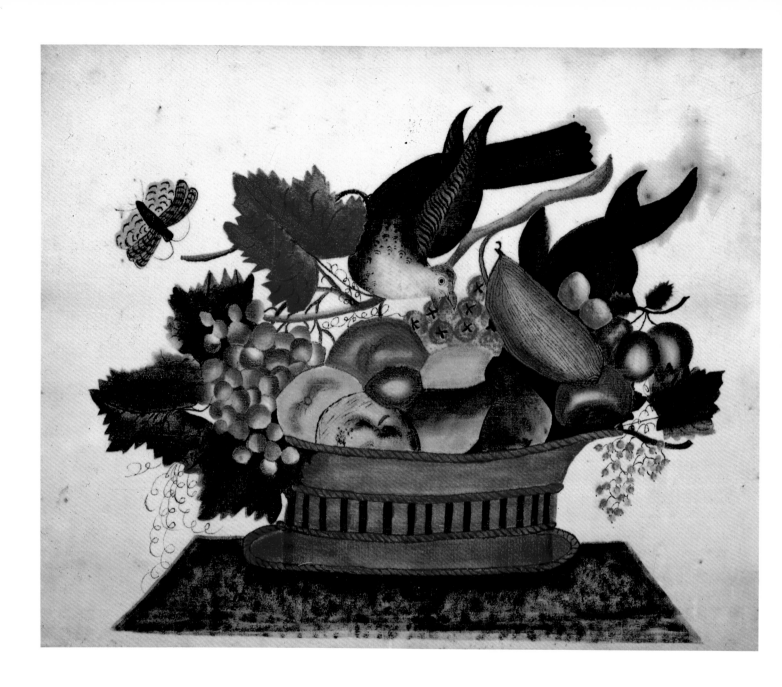

19
Theorem Painting: Fruit, Bird and Butterfly

Artist unknown
Possibly New England; 1825–1840
Watercolor on velvet;
 sight: $15\frac{3}{8} \times 18\frac{3}{4}$in.
Gift of Mrs. William P. Schweitzer.
 1984.13.1

Creating still-life compositions of
abundant displays of fruit and flowers
was a popular pastime for young
women in the early nineteenth century.
Executed in pastels on paper or
watercolor on paper or velvet, these
still life paintings were created with
the aid of stencils or "theorems." The
stencils were cut from heavy paper
which had been shellacked and oiled
to create a stiff, strong surface. Some
of these pieces were sketched free hand
as well.

20
Grisaille Theorem

Artist unknown
New England; 1830–1840
Grey wash and pencil on paper;
 sight: $14\frac{1}{2} \times 10\frac{1}{2}$in.
Gift of Cyril Irwin Nelson in memory of
 his grandparents, Guerdon Stearns and
 Elinor Irwin Holden, and in honor of
 his parents, Cyril Arthur and Elise
 Macy Nelson. 1983.29.2

Grisaille painting was introduced into
America by seventeenth-century
Dutch settlers in the Hudson Valley
who used the technique in still-life
painting on furniture. Theorem
painting came into vogue early in
the nineteenth century, peaked in
the 1820s and 1830s, and waned
toward mid-century. Grisaille theorems
are infrequently found as they were
more difficult to execute than those in
color.

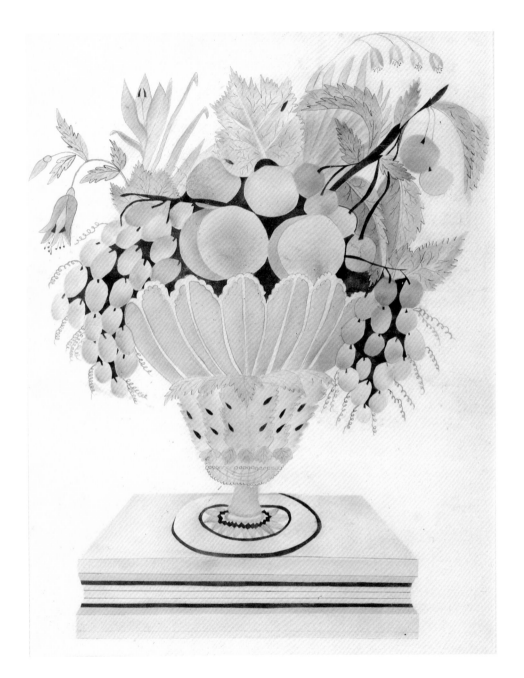

21

Tinsel Picture: Birds, Flowers and Child
Artist unknown
Pennsylvania; 1850–1880
Ink and reverse glass painting, tinsel,
 and framed hand-colored
 photograph; $12 \times 14\frac{1}{8}$ in.
Gift of Mr. and Mrs. Day Krolik, Jr.
 1979.3.1

Tinsel pictures were primarily created
in the Northeast in the second half of
the nineteenth century. The reverse
painting on glass is backed with
crinkled foil which provides a
shimmery effect through the
translucent paint. Here, the tinsel
painting provides a frame for a
nineteenth-century hand-colored
photograph.

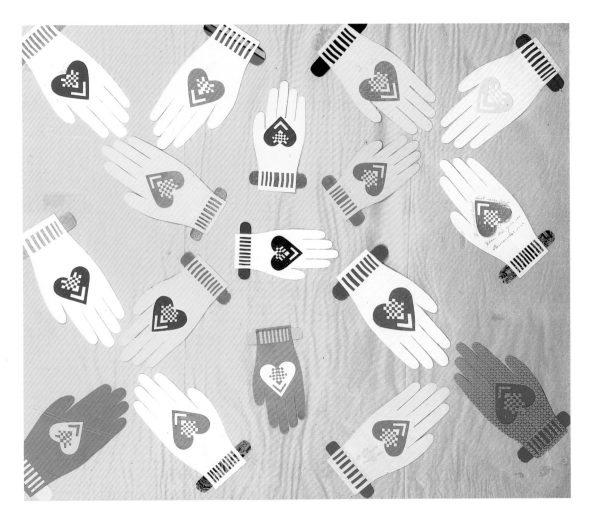

22

Heart and Hand Valentine
Artist unknown
Possibly Connecticut; 1840–1860
Cut paper, varnish, ink; 14 × 12 in.
Museum of American Folk Art purchase.
1981.12.15

Although New Year's is the oldest
"Day" celebrated, Valentine's Day
was the first on which greetings were
exchanged. The heart and hand motif
might have evolved from the earlier
custom of giving gloves to a sweetheart
for Valentine's Day to be worn on
Easter Sunday. This theme was
adapted in the late-eighteenth century
in the form of cut-paper hands with
separate hearts intertwined with
woven paper strips. By the middle of
the nineteenth century, publications
such as *Godey's Lady's Book* and
Harper's Weekly were suggesting verses
and cut-paper projects for both men
and women.

The inscription on this valentine reads:

> *Hand and heart shall never part*
> *When this you see*
> *Remember me*

23
Paper Dolls: Soldiers and Horses
Artist unknown
Boston, Massachusetts; 1840–1850
Watercolor, pen and ink on cut paper
 and card;
Soldiers: 4 × 2 in.
Horses: 4 × 4¼ in.
Gift of Pat and Dick Locke. 1981.8.1–11

These paper toys were cut with fine
scissors or possibly a sharp blade.
They were originally fitted with paper
folds that made them stand.

43

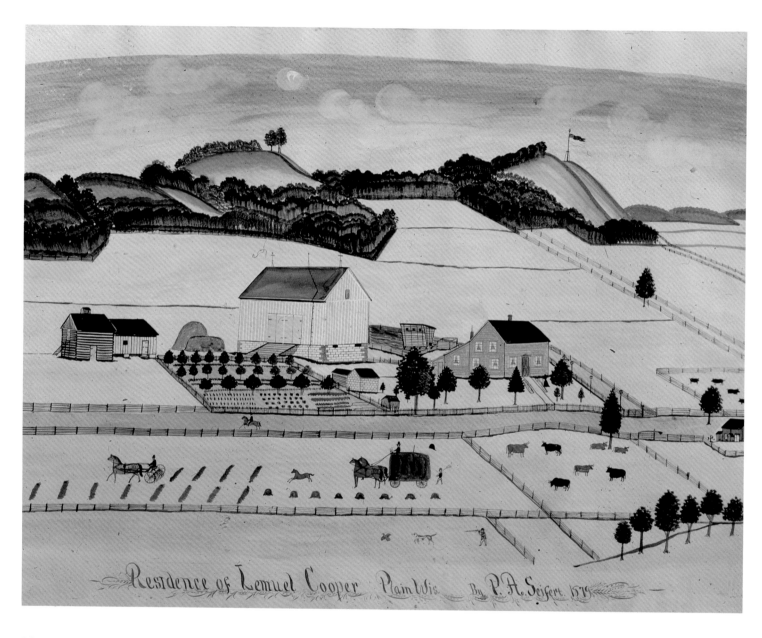

Residence of Lemuel Cooper Plain Wis. By P. A. Seifert 1879

24
The Residence of Lemuel Cooper
Paul A. Seifert (1840–1921)
Plain, Wisconsin; 1879
Watercolor, oil and tempera on paper;
 $21\frac{7}{8} \times 28$ in.
Museum of American Folk Art purchase.
 1981.12.26

Paul Seifert was a German immigrant who arrived in Wisconsin on a lumber raft in 1867. He first earned his living by selling the flowers, fruits, and vegetables he grew on his farm, and later in life, as a taxidermist. His greatest enjoyment, however, was painting precise views of Wisconsin farms. These were executed on colored papers which affected the dominant tones of the paintings and were often further enlivened by the addition of metallic paints.

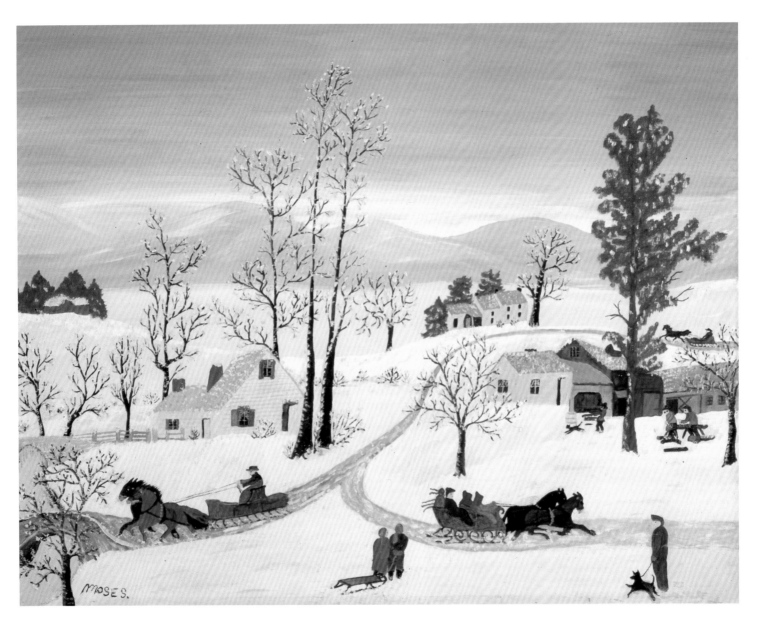

25
Dividing of the Ways
Anna Mary Robertson Moses
 (Grandma Moses) (1860–1961)
Hoosick Falls, New York; 1947
Oil and tempera on masonite;
 16 × 20 in.
Copyright © 1987, Grandma Moses
 Properties Co., New York

*Gift of Galerie St. Etienne, New York, in
 memory of Otto Kallir. 1983.10.1*
Grandma Moses is unquestionably the
most well known of the twentieth-
century folk painters. Her scenes of
rural life in upstate New York have
been classified as both memory
paintings and landscapes. Moses did

not begin to paint in earnest until she
was in her seventies and had the time
to spare from her farm duties. Much of
her work was inspired by popular
prints, such as those by Currier & Ives,
as well as greeting cards and calendars.

26
Oswego Starch Factory
Artist unknown; signed AJH/77
Oswego, New York; possibly 1877
Watercolor, pen and ink on wove
 paper; $36\frac{1}{8} \times 53\frac{1}{4}$ in.
Museum of American Folk Art purchase.
 1981.12.16

Many lithographs exist of the Oswego
factory and it is not clear whether this
watercolor was hand drawn and
painted after one of the lithographic
pieces or if it was a prototype for a
lithograph. The printed views were
used mainly as advertisements and the
Kingsford family, owners of the
factory, had at least three hanging in
their offices.

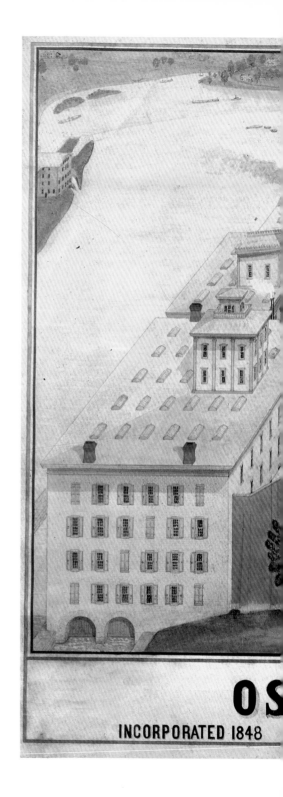

OS

INCORPORATED 1848

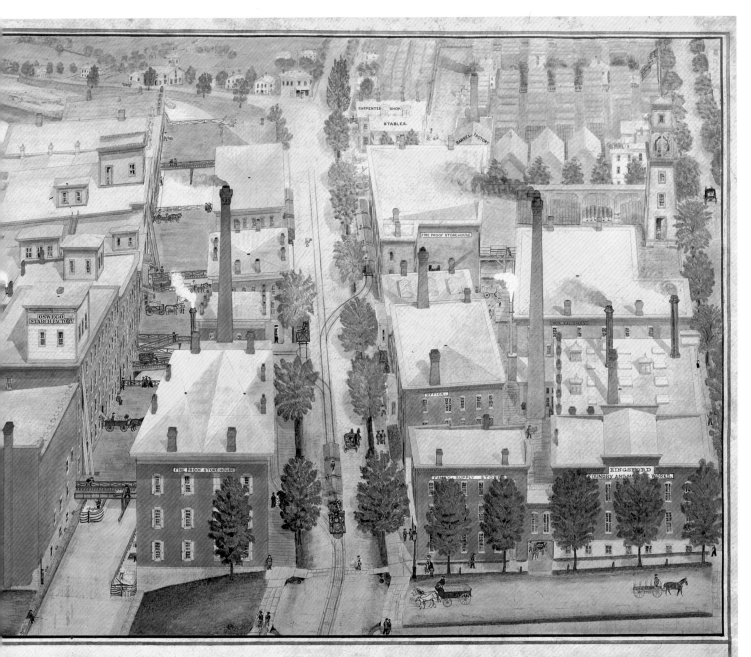

EGO STARCH FACTORY.

OSWEGO N.Y. T. KINGSFORD & SON Manufacturers.

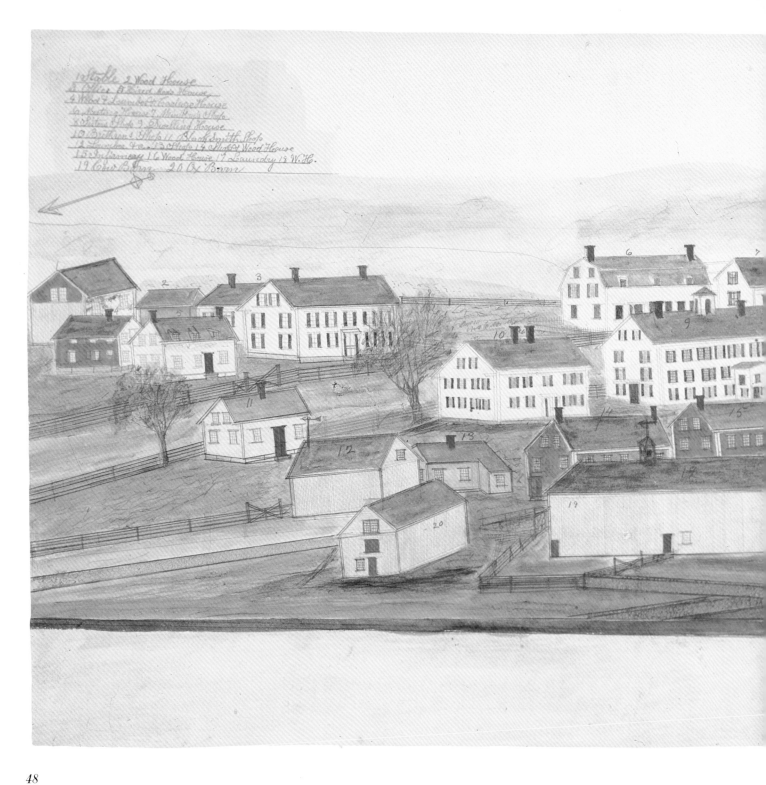

1 Stable 2 Wood House
3 Office 4 Hired Men's House
4 Wood & Lumber & Cooperage House
5 Meeting House 7 Ministry's Shop
8 Sisters Shop 9 Dwelling House
10 Brethren's Shop 11 Black Smith Shop
12 Laundry &c. 13 Shop 14 Shed & Wood House
15 Infirmary 16 Wood House 17 Laundry 18 W.H.
19 Cow Barn 20 Ox Barn

27
View of the Church Family,
 Alfred, Maine
Attributed to Joshua Bussell
 (1816–1900)
Alfred, Maine; c.1880
Pencil and watercolor on paper;
 $17\frac{3}{4} \times 28$ in.
Promised anonymous gift

Shaker village views functioned as
maps that documented a community.
They first appeared at the beginning of
the nineteenth century. In the 1840s,
Shaker map makers became more
ambitious and sought to embellish
their village views with elements
drawn from the American landscape
tradition. They also began to be
influenced by print sources.
Among these artists, Joshua Bussell
was particularly known for his
embellishments of what was originally
a utilitarian art form. A revival of
interest in the views occurred in the
last quarter of the nineteenth century,
particularly in Alfred, Maine,
a community that was undergoing
much physical change at the time.

Key to View of the Church Family,
Alfred Maine

1 *Stable*
2 *Wood House*
3 *Office*
4 *Wood & Lumber & Car[r]iage House*
5 *Hired Men's House*
6 *Meeting House*
7 *Ministry's Shop*
8 *Sisters Shop*
9 *Dwelling House*
10 *Brethrens Shop*
11 *Black Smith Shop*
12 *Lumber &c.*
13 *Shop*
14 *Shop & Wood House*
15 *Infirmery*
16 *Wood House*
17 *Laundry*
18 *W.H. [Wood House?]*
19 *Cow Barn*
20 *Ox Barn*

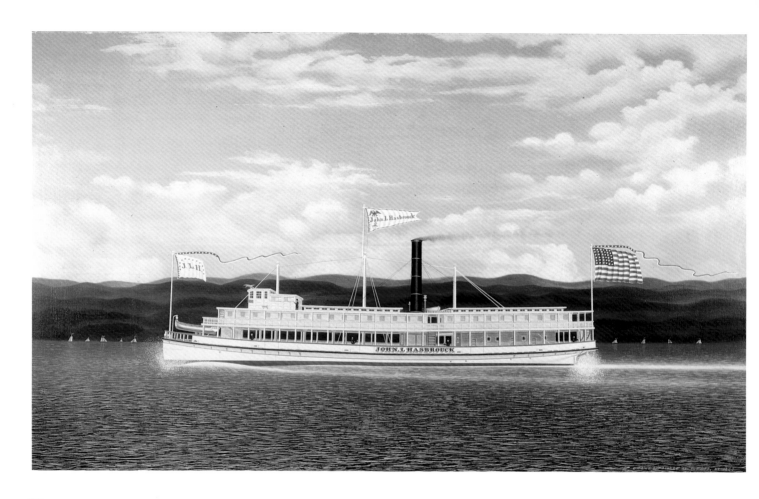

28

The John L. Hasbrouck
James Bard (1815–1897)
New York, New York; 1865
Oil on canvas; 30¼ × 50 in.
Gift of Mr. G. L. (Jack) Reeves, Jr.
1984.18.1

For twenty years, James Bard and his twin brother, John, specialized in portraits of the steamships that traveled up the Hudson from their home port of New York City. After John's death in 1856, James continued painting steamboats in the same characteristic manner. Ships painted by the Bards are almost always shown from the port side and the details of construction are almost always exact as the painters worked from plans. The steamship *John L. Hasbrouck* was built in 1864 and was used between Stuyvesant and New York City and later as the Poughkeepsie night boat.

29
Harbor Scene on Cape Cod
Artist unknown
Massachusetts; 1890–1900
Oil on canvas; 23 × 31¾in.
Promised gift of Robert Bishop.
 P78.101.5

Land- and seascapes such as this
did not become popular in America
until the middle of the nineteenth
century, when they were inspired by
publications in magazines and other
periodicals and published prints.

30
Whosoever Reports a Thing
Harry Lieberman (1876–1983)
Great Neck, New York; c. 1976
Acrylic on canvas; 24 × 30 in.
Gift of a Friend of the Museum.
1988.15.1

Harry Lieberman was born Naftulo
Hertzke Liebhaber in Gnieveshev,
Poland, in 1876. His family belonged
to the Hasidic sect founded in the
eighteenth century by Rabbi Israel
Baal-Shem. Lieberman began
rabbinical studies with his uncle, the
village rabbi, but was never ordained.
In 1906, he emigrated to America
where he operated a successful candy
business on New York's lower east side.
He began painting at age eighty when
he attended an art class given at a
Golden Age Club on Long Island.
Lieberman's many paintings illustrate
tales from Jewish folklore, religion, and
literature, and often raise moral and
ethical questions. To be sure that
people understood the meaning of his
paintings he wrote each story out in
Yiddish on the back of the canvas.
"Whosoever Reports a Thing"
recounts the story of Queen Esther.
In Lieberman's words: "If you tell a
thing that helps another person, you
bring honor to yourself. I use the
story of Purim to show this."

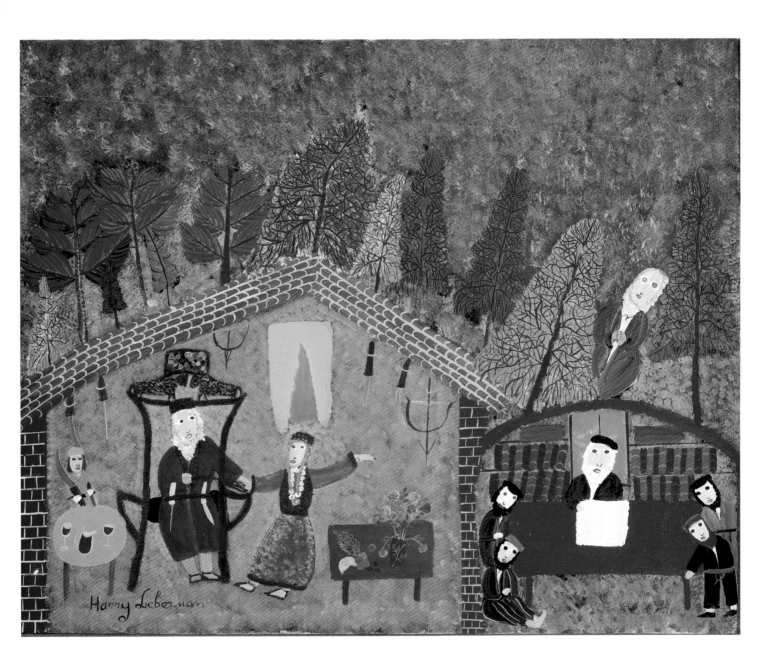

31
The Messiah's Crown
Franklin Wilder (c.1878–1955)
Leominster, Massachusetts; 1918–1925
Ink, pencil, and watercolor on wove
 paper, sight: $15\frac{1}{2} \times 16\frac{3}{4}$in.
Gift of Mr. and Mrs. Philip M. Issacson.
 1979.28.1

The Ku Klux Klan was originally
founded about 1865 by Confederate
Army veterans in Pulaski, Tennessee.
It was formally disbanded in 1869.
The twentieth-century revival was
founded in 1915 by William J.
Simmons with all the racist intent that
we associate with the organization
today. The height of KKK activity in
the Leominster-Fitchburg area of
Massachusetts occurred between 1925
and 1935. Franklin Wilder's strong
expressions of distaste for both secret
"pledged" societies and the KKK
refers to the unfortunate alliance on
the part of segments of the
freemansonry membership with the
KKK and its sentiments. Wilder is
listed in the Leominster directories
starting in 1900 as a mechanic, a clerk,
and an employee of the Whitney Reed
Chair Co. Beginning in 1910, Wilder
listed himself in the Leominster
directory as "painter."

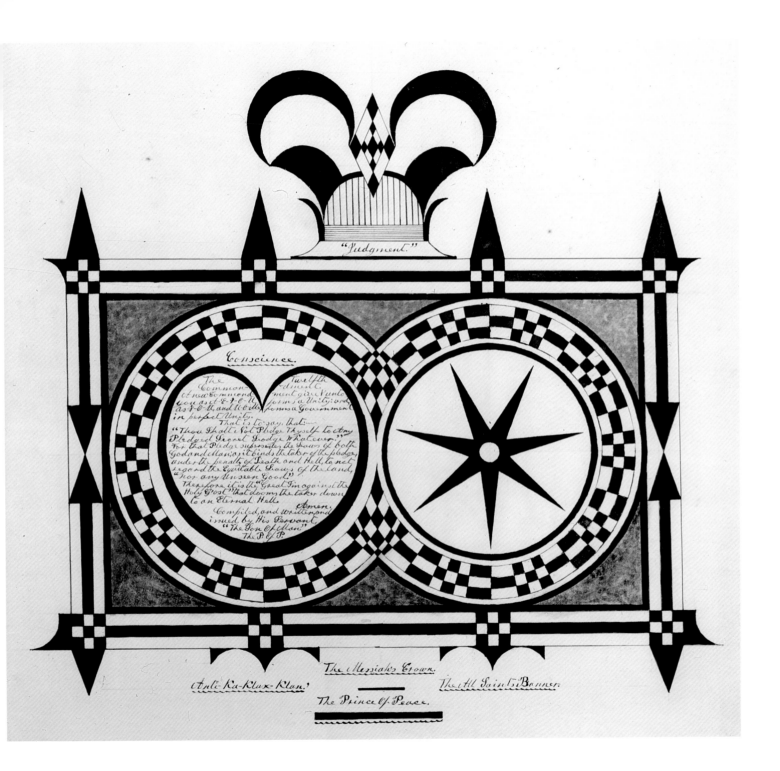

"Judgment."

Conscience.

The Command-
ment new Command-
ment give unto
you as I.O.U. forms a Unity: and
as I Orth, and I Orth, forms a Government.
in perfect Unity.
That is to say, that:—
"Thou Shalt Not Pledge Thyself to Any
Pledged Secret Lodge Whatever."
For that Pledge supersedes the Laws of both
God and Man; as it binds the taker of the pledge,
under the penalty of Death and Hell, to not
regard the Equitable Laws of the land,
"nor any Unseen Good."
Therefore it is the "Great Im ogainst the
Holy Ghost" that dooms the taker down
to an Eternal Hell. Amen.
Compiled, and written and
issued by His Pervant,
"The Son Of Man."
The P. Of P.

Anti-Ka-Klux-Klan. The Messiah's Crown. The All Saints Banner.

The Prince Of Peace.

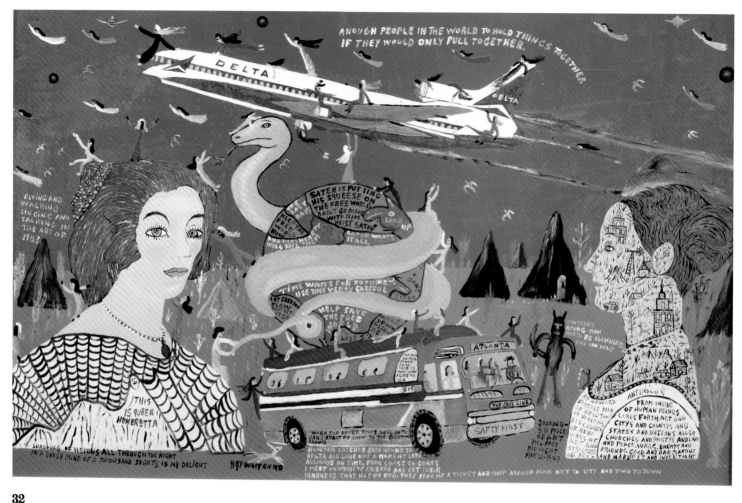

32
Delta Painting
Reverend Howard Finster (b. 1916)
Summerville, Georgia; 1983
Enamel on wood panel, frame molding;
$25\frac{5}{8} \times 45\frac{1}{8}$ in.
Gift of Elizabeth Ross Johnson.
1985.35.33

The very prolific Howard Finster
was a minister for approximately
forty years until poor health forced
him to channel his energies into
creating religious art. In 1976, in
response to a vision that told him to
"Make Sacred Art," he began to paint.
Finster is one of the most versatile of all
contemporary folk artists. He is the
architect and builder of the "Paradise
Garden" environment in Georgia
as well as a painter, sculptor, singer,
poet, and performance artist. In his
paintings, Finster often warns against
the destruction of the earth and sees
himself as mankind's "Last Red Light."

33
Portrait of Frank Peters

Joseph P. Aulisio (1910–1974)
Stroudsburg, Pennsylvania;
 1965
Oil on masonite; 28 × 20 in.
Gift of Arnold B. Fuchs.
 1978.8.1

Joseph Aulisio owned a dry
cleaning store in Old Forge,
Pennsylvania, where Frank
Peters was employed as
a tailor. Aulisio began to paint
at age fifty and produced
approximately thirty oil
paintings of people and
the Pennsylvania landscape.
This contemporary painting
exhibits many of the
characteristics that are
associated with traditional
folk portraiture: frontality of
the figure with the figure filling
most of the canvas, accessories
to indicate the profession of
the sitter, and a plain
background.

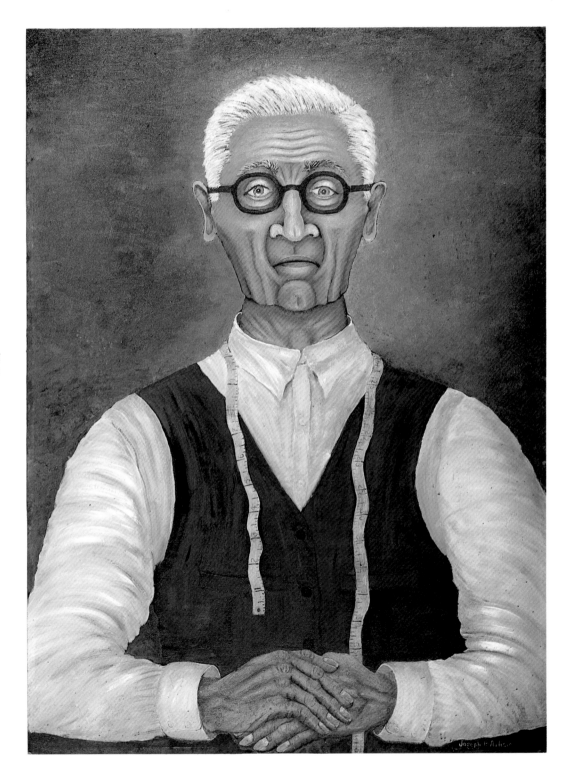

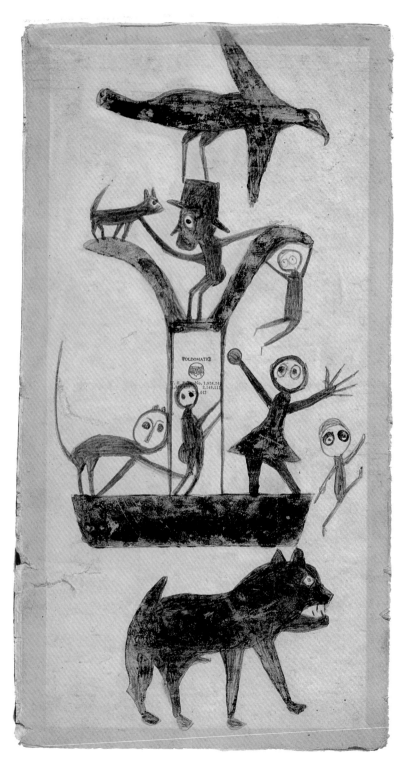

34
Figure and Construction with
Blue Border

Bill Traylor (1854–1947)
Montgomery, Alabama; 1941–1942
Poster paint on cardboard box top;
 $15\frac{1}{2} \times 8$ in.
Promised gift of Charles and Eugenia
 Shannon. P2.1988.1

The artist was born a slave on the
Traylor plantation between Selma and
Montgomery in 1854. He continued
to live there until the 1930s, when he
moved to Montgomery. He slept in
the back room of a funeral parlor and
spent his days on the sidewalk by a
fruit stand where he began to draw.
This drawing is one of about twenty-
five similar works by Bill Traylor that
were done late in the three-year period
of his artistic productivity when he
was at the height of his skills. In these,
the most complex of his compositions,
he departs from his commonly used
single element subjects.

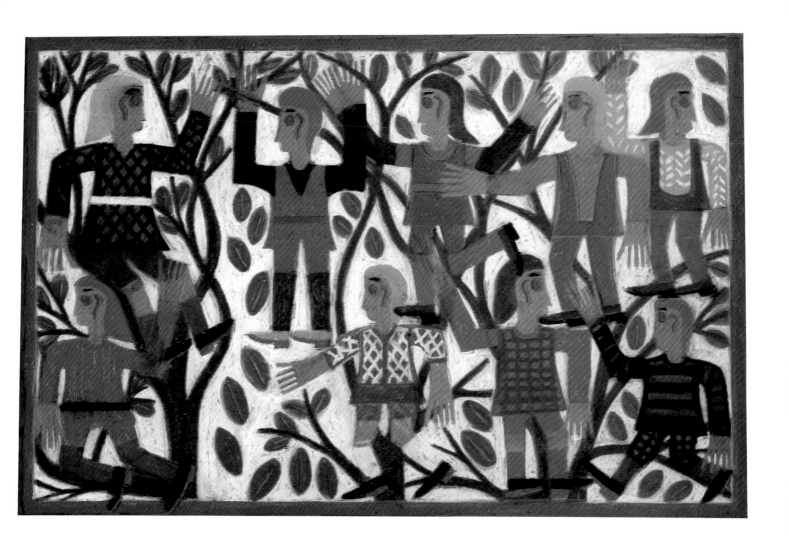

35
Nine Figures Climbing Trees
Eddie Arning (b.1898)
Austin, Texas; January 16–22, 1972
Oil pastel and pencil on wove paper;
$21\frac{1}{2} \times 31\frac{1}{2}$ in.
Gift of Mr. and Mrs. Alexander Sackton.
1985.1.10

Eddie Arning was born in a German farming community outside of Kenney, Texas. He began experiencing symptoms of schizophrenia in his mid-twenties and in 1928 was committed to Austin State Hospital where he remained for more than thirty years. Arning began to draw in 1964, just prior to his transfer to a nursing home

and he continued to draw until his release from the home in 1973. Many of his works are based on printed sources, such as magazine and newspaper pictures. "Nine Figures Climbing Trees" was inspired by a colored drawing that appeared in *Good Housekeeping* magazine in 1971.

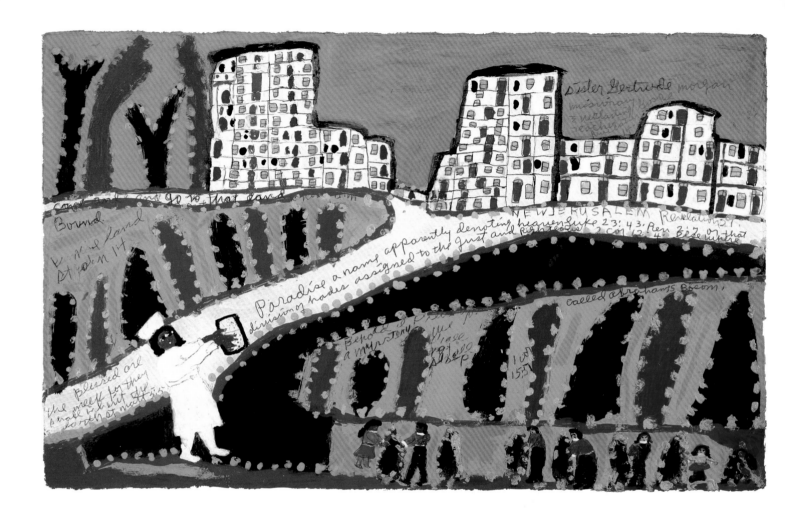

36
New Jerusalem
Sister Gertrude Morgan (1900–1980)
New Orleans, Louisiana; c.1970
Acrylic and tempera on cardboard;
 sight: 12 × 19in.
Gift of Sanford and Patricia Smith.
 1986.21.1

This painting is typical of the work of
Sister Gertrude Morgan who is known
for her religious expression. She spent
most of her life preaching the Gospel
on street corners and, starting
about 1956, through her painting.
She frequently included herself,
dressed in white, in her pictures and
"New Jerusalem," the subject
of this painting, was a common
theme.

37
Neil House with Chimney
William Hawkins (b.1895)
Columbus, Ohio; 1986
Enamel and composition material on
 masonite; 72 × 48in.
Gift of Warner Communications Inc.
 1988.19.1

William Hawkins was born in Madison
County, Kentucky, in 1895, a fact that
is recorded on all of his paintings. He
came north, looking for work, in 1916
and settled in Columbus, Ohio, where
he drove a truck for a construction
company. Hawkins was fascinated by
the development of the city and the
new architecture and when, decades
later, he began to paint, he drew upon
the city's buildings for inspiration. In
recent years, his subject matter has
expanded and he now also paints
animals, genre scenes, and landscapes,
many of which have been adapted
from the post cards, magazine pictures,
and advertisements that decorate the
walls of his home.

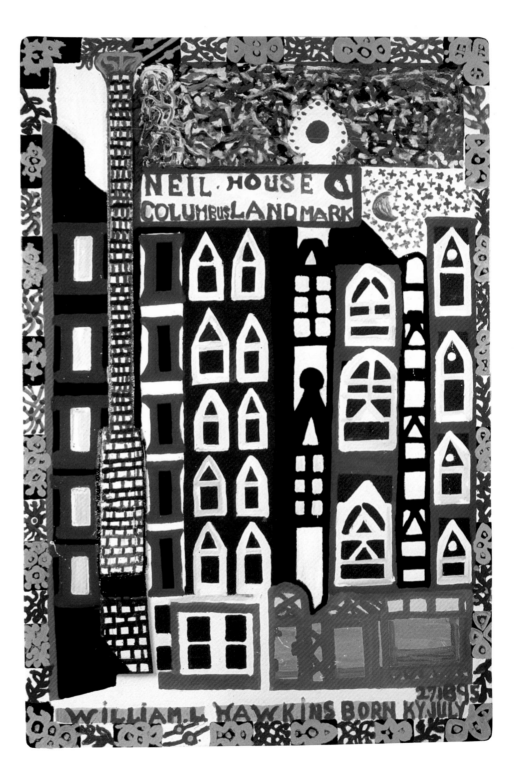

38
Sample Box Containing Ten Panels
Moses Eaton (1753–1833)
Dublin, New Hampshire; 1800–1830
Painted and decorated pine, brass;
 box: $8\frac{3}{4} \times 15\frac{1}{16} \times 2\frac{5}{8}$in.
 panels: $6\frac{7}{8} \times 14 \times \frac{1}{8}$in.
Anonymous gift and gift of the Richard
 Coyle Lilly Foundation. 1980.28.1 a-k

Moses Eaton, an itinerant artist until
he married and turned to farming,
is best known for the stencils that he
painted in homes throughout New
England. His talents also included
grain painting, which was used to
embellish doors, chairs, chests, or other
wooden objects fashioned from less
desirable wood. Eaton's sample box,
containing examples of ten different
types of graining, was found on his
farmstead in New Hampshire.

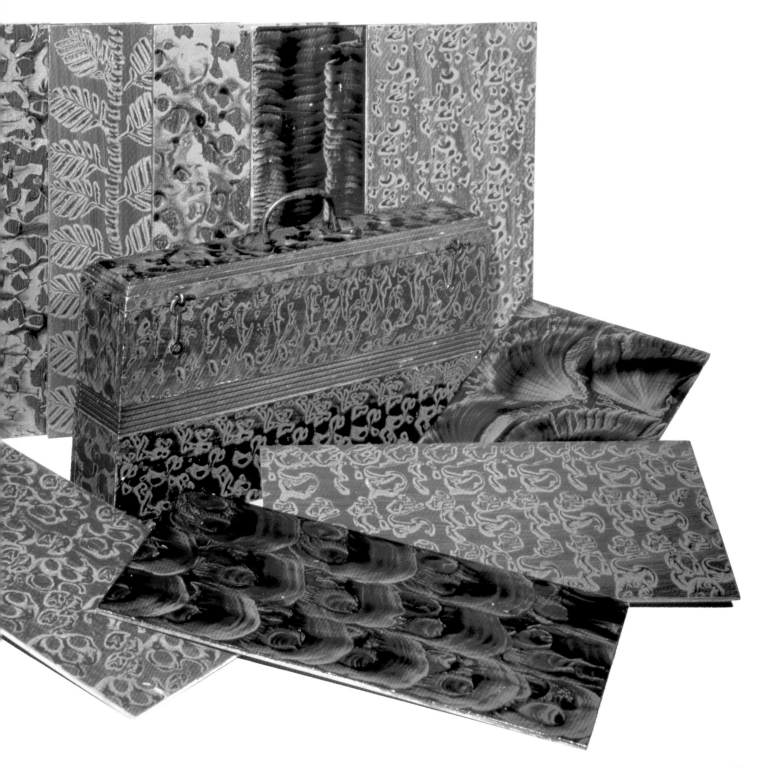

Trinket Box with Eagle Decoration
Artist unknown
New England; 1820–1840
Painted and decorated wood with
 grained interior; $6\frac{3}{8} \times 14\frac{7}{8} \times 8\frac{1}{8}$ in. deep
Eva and Morris Feld Folk Art
 Acquisition Fund. 1981.12.21

From the seventeenth through the
nineteenth centuries, Americans kept
their belongings in many different
types of boxes. This "trinket" box
contains nine small compartments for
storage. The interior has been sponge-
decorated yellow and brown.

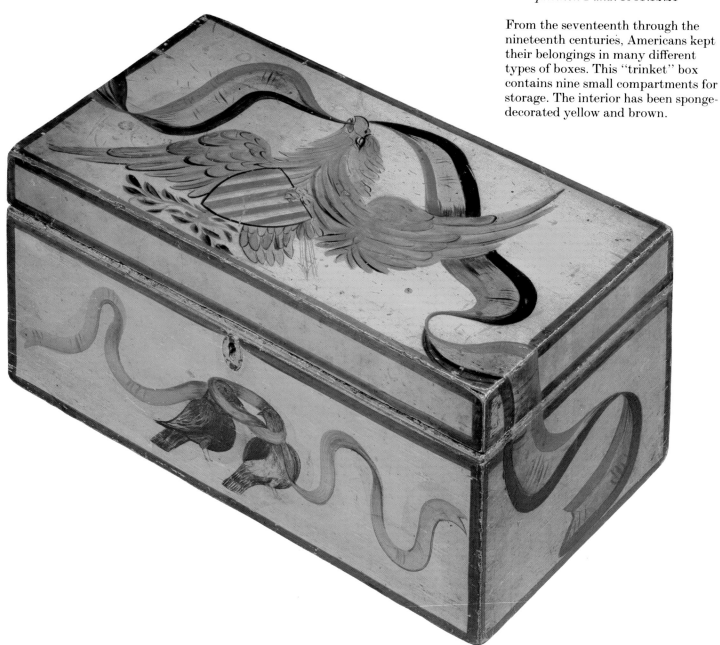

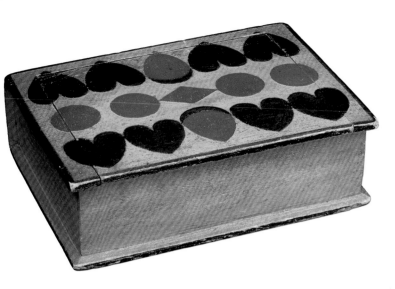

40
Painted Box
Artist unknown
Pennsylvania; c.1835
Painted wood; $1\frac{3}{4} \times 5\frac{1}{4} \times 3\frac{5}{8}$ in.
Bequest of Samuel S. Meulendyke.
 1986.5.2

This miniature box was made in the
shape of a book, a common form.
Often, eighteenth- and nineteenth-
century boxes in this form were made
to hold prayer books. While a more
elaborate and expensive box might be
decorated with inlay or carving, this
one has painted geometric decorations.

41
Trinket Box with Portraits
Artist unknown
New England; 1825–1835
Watercolor, pencil, pen and ink on
 paper panels under glass, wood,
 brass; $4\frac{1}{2} \times 8 \times 5\frac{1}{8}$ in. deep
Museum of American Folk Art purchase.
 1981.12.17

The existence of a number of boxes
with similar paintings and construction
suggests that they might have been
made by young ladies as school
projects, or that the idea was published
in a magazine.

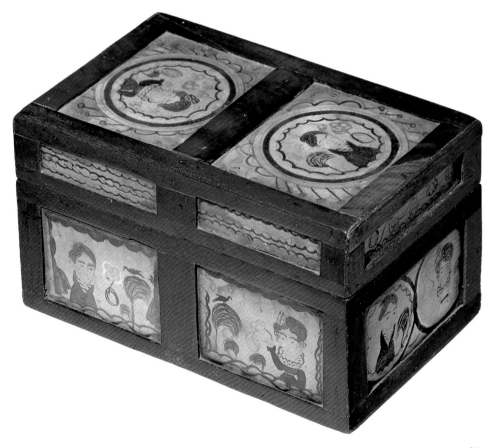

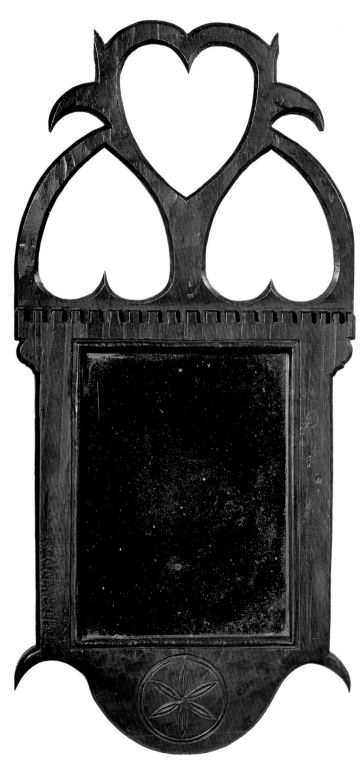

42
Mirror with Carved Hearts
Artist unknown
Possibly Pennsylvania; 1750–1780
Carved and painted pine, mirror glass;
 $20 \times 9\frac{3}{8} \times 1\frac{1}{8}$in. deep
Gift of the Amicus Foundation, Inc.
 1981.12.18

Although a majority of the mirrors in
use in eighteenth-century America
were imported from Europe, there was
some local manufacture. An almost
identical looking glass from Bucks
County, Pennsylvania, is in the
collection of the Philadelphia Museum
of Art.

43

Hanging Candle Box
Artist unknown
Connecticut River Valley; 1790–1810
Carved and painted wood;
$24\frac{5}{8} \times 12\frac{3}{4} \times 5\frac{3}{8}$ in. deep
Museum of American Folk Art purchase.
1981.12.11

The population of the Connecticut
River Valley in the late eighteenth and
early nineteenth centuries was fairly
homogeneous, principally of English
extraction. This is reflected in the
decorative carved motifs on this piece
which show the influence of an English
medieval carving tradition. These
motifs in combination with hearts
often denote a Connecticut origin, but
the rayed pinwheel, star, and flower
are also found in Massachusetts.

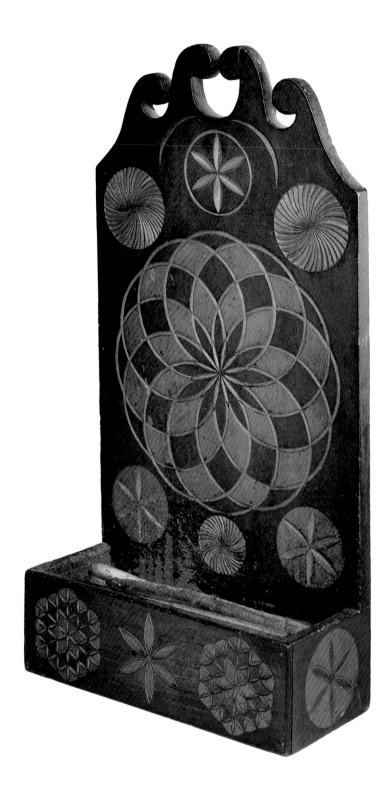

44
Queen Anne Secretary
Artist unknown
New England; 1760–1780
Carved, painted, and decorated maple
 and pine; $67\frac{3}{4} \times 37 \times 16\frac{3}{4}$in. deep
*Eva and Morris Feld Folk Art
 Acquisition Fund. 1981.12.1*

Flat-top secretaries are primarily
country pieces as most were made by
cabinetmakers unable or unwilling to
construct complicated bonnet tops or
broken pediments. The decoration on
this piece, a mottled finish with a tree
and plants on the fall front, makes it
distinctive.

45
Dower Chest with Mermaid Decoration
Artist unknown
Pennsylvania; dated 1790
Painted and decorated pine, iron;
$24\frac{3}{4} \times 50\frac{1}{2} \times 23\frac{3}{4}$in. deep
Museum of American Folk Art purchase.
1981.12.4

Dower chests were made as gifts for
brides and frequently were inscribed
with the woman's name and the date
on which it was presented.
The mermaid on this chest is a
German motif, symbolizing the
duality of Christ. A bottom drawer
is missing from this piece.

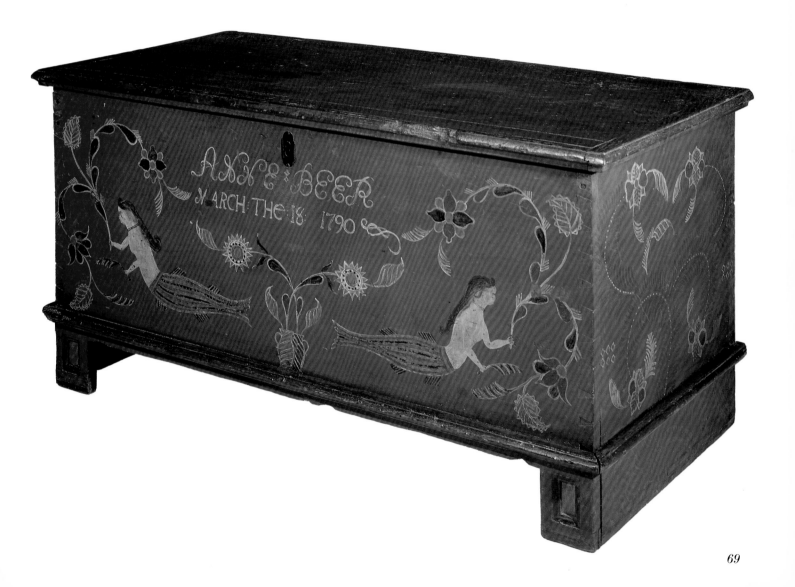

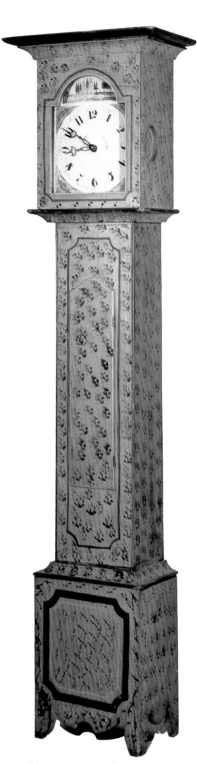

46
Tall Case Clock

Artist unknown; dial signed
 "L. W. Lewis"
Probably Connecticut; 1810–1835
Painted and decorated pine case, iron
 works; 87 × 21½ × 12¾in. deep
*Eva and Morris Feld Folk Art
 Acquisition Fund. 1981.12.22*

The "L. W. Lewis" who signed the face
of this clock might be Levi Lewis of
Bristol, Connecticut, who, from
1809–1823, was in partnership with
Joseph Ives, one of the pioneers in the
use of the mainspring in America.
The case was probably
made by a local
cabinetmaker in
accordance with
the wishes of
the customer.
The decorative
pattern on this
clock has been
called "paw printed;"
it was probably created
with a sponge, crumpled
paper, or cloth.

47
Federal Sideboard Table

Artist unknown
New England; 1820–1835
Grain painted and decorated wood,
 brass knobs; 34⅞ × 26 × 20in. deep
*Eva and Morris Feld Folk Art
 Acquisition Fund. 1981.12.6*

This country table was painted to
simulate the fine woods and medallion
insets found in high style furniture of
the Federal period. A piece of country
furniture is often dated later than its
urban counterpart. This is because it
took time for a style to reach rural
areas.

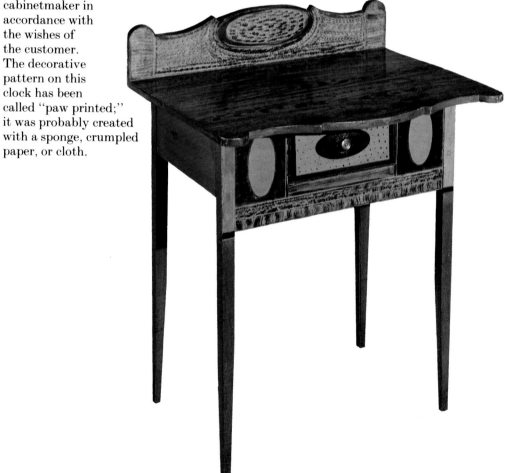

48
Chest of Drawers

Possibly Johannes Mayer (1794–1883)
Mahantango Valley, Pennsylvania;
 dated 1830
Painted and decorated pine, brass;
 $47\frac{1}{2} \times 43\frac{3}{8} \times 22$ in. deep
Museum of American Folk Art purchase.
 1981.12.3

The Mahantango Valley of
southeastern Pennsylvania was
settled late in the eighteenth
century by second generation
Germans from other southeastern
Pennsylvania communities. From
approximately 1798 to about
1840, a distinct body of
decorated furniture was produced
in the valley. This chest and a
number of other similar examples
are believed to have been made
and decorated by Johannes
Mayer of Upper Mahanoy
Township. Mayer's home, which
still stands, contains the identical
hand wrought molding and trim
as is found on these chests.

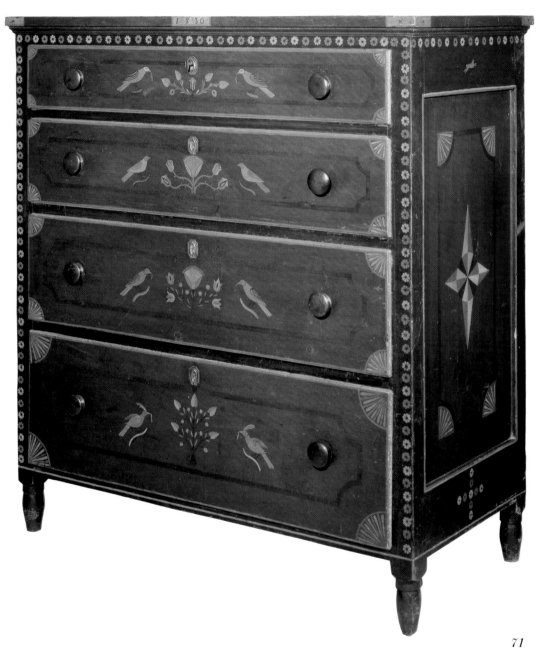

49
Worktable

Artist unknown
New Hampshire; 1810–1825
Painted tiger maple;
 29 × 19 × 18in. deep
Promised anonymous gift

Young ladies at seminaries were
usually taught watercolor painting
as part of their curriculum. In New
England, parents sometimes bought
boxes or tables from cabinetmakers
and gave them to their daughters to
demonstrate their painting skills.
The building depicted on the top of
this table is the State House in
Concord, New Hampshire.

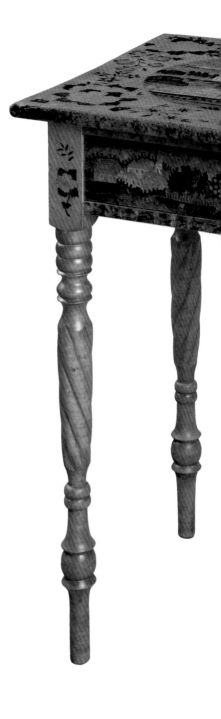

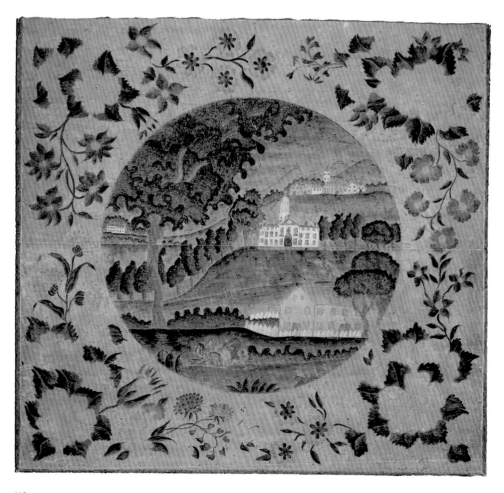

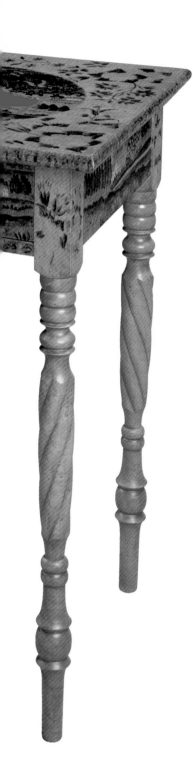

50
Painted Mantel
Artist unknown
Somerset County, Pennsylvania;
 c. 1830
Painted and grained pine and poplar;
 $56 \times 57\frac{1}{4} \times 7\frac{1}{4}$ in. deep
Promised anonymous gift

This mantel has been decorated with a
combination of techniques, including
combing, sponging, and fingertip
painting.

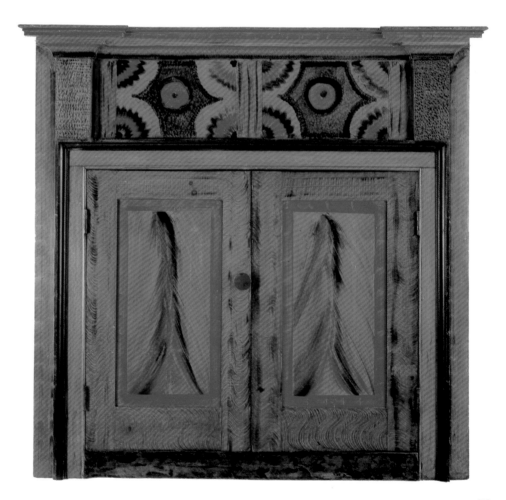

SCULPTURE AND THREE DIMENSIONAL WORKS OF ART

Almost as soon as permanent settlements were established in the New World, the folk sculptor found a substantial demand for his efforts. Carved religious figures—*bultos*—were important in church and domestic life in the southwestern Spanish Colonial settlements. Usually fashioned from local cottonwood and then covered with gesso and painted, these saints, angels, crucifixions, and other Biblical images are the continuation in America of a Spanish Baroque art form. The works produced in the territory known as New Mexico, however, tended to be freer, bolder, and more abstract than their Spanish and Mexican counterparts.

The tradition of the *santero* continues in the Southwest today. But, while saints and other religious figures are still occasionally carved and painted, artists have found a wider popular market making animals out of the same materials. Felipe Benito Archuleta, who began to carve at age fifty-four in 1974, is generally recognized as the patriarch of this new school of artisans. After many years at a variety of jobs, including carpenter, farmer, stonemason, and cook, Archuleta was searching for a new direction when the message came.

One time I was bringing my groceries and I ask God for some kind of a miracle, some kind of a thing to do, to give me something to make my life with … some kind of a thing that I can make. So I started for about three days, I started carving after that. And they just come out of my mind after that.[1]

In the East, carved stone monuments and gravemarkers are the earliest dated examples of American folk sculpture. Groups of gravemarkers with stylistic similarities indicate that stonecutters working in close proximity in the eighteenth century borrowed design concepts from one another and developed a common style of embellishment. This stonecutting tradition changed with popular taste as new ideas about design were transported to America by immigrants throughout the Colonial and Federal periods. The stonecutters of Colonial New England carved gravestones that bore stark symbols of death and resurrection: hollow-eyed death masks, skulls, and emptying hourglasses. Gradually, these macabre images were replaced by less menacing angels, and, by the end of the eighteenth century, portraits of the deceased (either abstract or realistic) were used in some areas instead of symbolic figures. By the mid-nineteenth century, most stonecutters were forced from their profession when machine technology began to replace handcraftsmanship.

Woodcarvings for ship decorations are another form of sculpture that has

1. Christine Mather and Davis Mather, *Lions and Tigers and Bears, Oh My! New Mexican Folk Carvings* (Corpus Christi, Texas, 1987), p.13.

a long tradition in America. Throughout the seventeenth century and the first half of the eighteenth century, Colonial figureheads often followed English prototypes and were in the shape of "lyons" and other "beasts." Sometimes they followed the ancient tradition of representing the guardian spirits of the ship they guided. By the end of the eighteenth century, however, human figures, often symbolizing the vessel's name or portraying the captain's or owner's wife or daughter, had become the most popular form of American figurehead.

These were not the only carved embellishments aboard sailing ships. After the figureheads, the chief category of marine decoration was the sternboard, a broad, flat surface, fitted to the back of the ship, that frequently sported the carving of an eagle. When steam-powered vessels began to replace sailing ships in the mid-nineteenth century, ship carvers lost an important segment of their business. The projecting prow with its elegant figurehead no longer had a place. To make up for this lost commerce, some ship carvers turned to creating elaborate inboard ornaments, such as pilot-house eagles and paddle-box decorations, as well as shop figures and trade signs, especially for those businesses that served the shipping and shipbuilding industries.

The trade sign took many forms in early America. When education was a privilege and literacy rare, the ideal trade sign immediately caught the attention of a passerby and, because of its design, was totally self-explanatory. Folk artists, sometimes including the itinerant portrait painters, created signs that bore pictures that visually explained the name of the establishment or the services to be found within. As early as 1645, the town of Salem, Massachusetts, required that taverns display signs for the convenience of travelers. These signs usually carried pictures or lettering on both sides and were hung from a tall post at right angles to the road, so as to be visible to travelers approaching from either direction.

Three-dimensional carved trade signs were often produced in the same workrooms as the figureheads and other ship decorations and usually displayed the same broad-planed carving style that typified American figureheads. The best-known of all American trade signs is the cigar-store Indian. From the middle of the nineteenth century to the turn of the twentieth century, no self-respecting tobacconist would have considered opening up shop without a figure of some kind to stand by the front door. Most often, these were Indians, although other figures—including soldiers, sailors, fashionable ladies, popular heroes, Turks and Egyptians, characters out of literature, and even patriotic symbols such as Uncle Sam—were also

used to advertise cigar stores and other businesses. The heyday of the cigar-store Indian and other sidewalk trade signs was from the 1850s to about 1900. Finally, the introduction of electric signs, which could advertise a business after dark, led to the decline of the carved trade figure.

While technological progress may have contributed to the decline of shop-made advertising figures, individual artists throughout the country carried on the tradition. Using found objects, donated cast-offs, mechanical devices, and whatever materials are at hand, folk artists in the twentieth century continue to make outdoor advertising displays to attract attention to roadside businesses. Often, their homes or businesses are so constructed as to be considered works of art in themselves and are called folk-art environments.

During the second half of the nineteenth and the early twentieth centuries, woodcarvers, many of them German immigrants employed in shops located primarily in New York and Philadelphia, produced carousel horses, circus wagons, and other ornamented, utilitarian carvings. Like the cigar-store figures, these carvings were done by hand, but using assembly-line production techniques so that more than one artisan would be employed in the manufacture of a piece. Generally, a master carver would draw the pattern for an animal, then carpenters would assemble the basic block form of the body. Each carver would bring his own style to the detailing required to create an exciting figure. Hand-carved wooden carousel figures—lions, rabbits, camels, and a menagerie of other animals besides the multitude of horses—continued to be made in great numbers until the Great Depression forced most of the major companies to either shut down or sharply curtail their production. Unfortunately, the figures were expensive to produce and maintain, and, eventually, metal, plastic, and fiberglass animals fashioned in molds replaced the hand-carved beasts.

Like the carousel animals, weathervanes are a form of folk art that, although originating in Europe, reached its greatest development in America. There are several basic types of weathervanes: handcrafted silhouette and three-dimensional wooden vanes; handcrafted silhouette and three-dimensional metal vanes; and factory produced vanes. Few of the handcrafted weathervanes made in America as early as the last quarter of the eighteenth century are still extant. Factory-made vanes began to be produced in the middle of the nineteenth century. The factory vanes were made by carving a wooden pattern and then fashioning a metal mold from it. A craftsman would hammer thin sheets of copper into the metal mold and create various parts of the body of a vane. These were then soldered

together to form a finished piece. In time, technology developed to the point that it became possible to stamp out weathervane parts and hand-craftsmanship—and artistic value—disappeared from the process.

Like much folk sculpture, weathervanes had functional as well as decorative purposes. A vane could be used as a trade sign, indicating the type of business housed within the building it topped. Or a farmer might commission a weathervane in the shape of an animal raised on the farm. And church steeples—easily identified from a distance—were usually topped by Chrisian symbols: the rooster, the fish, and the angel Gabriel. But most importantly, a weathervane was used to indicate the direction of the wind. Farmers, sailors, travelers, and anyone whose work depended on the weather used weathervanes as forecasters. If, for example, an east wind means rain, as it does in much of northeastern America, then a weather-vane pointing east will prevent a farmer from taking the horses out to plow, and possibly losing their shoes in the mud.

Although some eighteenth-century European examples are known, the whirligig also reached its fullest development in America. However, no one can be sure when the first American whirligig or windtoy was constructed—because of their fragility, few whirligigs fashioned before the second half of the nineteenth century have survived. One of the earliest references to such a device was made by Washington Irving in his 1819 story, "The Legend of Sleepy Hollow:"

Thus while the busy dame bustled about the house, or plied her spinning-wheel at one end of the piazza, honest Balt would sit smoking his evening pipe at the other, watching the achievements of a little wooden warrior, who armed, with a sword in each hand, was most valiantly fighting the wind on the pinnacle of the barn.[2]

The idea for the whirligig can be traced to two distinct prototypes: articulated dolls and windmills. Single-figure, full-bodied whirligigs with propeller-type arms were, like articulated dolls, carved from a block of wood or assembled from various parts cut from a board or thin slab. More complex examples with many parts are powered by a pinwheel-like propeller that catches the wind and, through the action of a series of gears and connecting rods, activates the figure or figures.

Archaeologists have determined that waterfowl decoys were probably first used by American Indians in the Southwest. Combining tightly-bound reeds with feathers, native Americans living in what is now Nevada created

2. Washington Irving, "The Legend of Sleepy Hollow" in *The Sketch Book of Geoffrey Crayon, Gent.*, reprinted in *The Complete Works of Washington Irving,* Richard Dilworth Rust, general editor (Boston, 1978), p.282.

a remarkable imitation of a canvasback duck c.1000 A.D., and perhaps earlier. Indians in eastern North America stacked small stones on top of larger ones to form visual imitations of resting ducks, which would lure waterfowl within striking range of the bow and arrow. Early American colonists quickly recognized the value of the decoy and began to use it— by 1840, birds carved from wood (for permanence) were widespread. In Europe, caged birds were used to attract wildfowl: the word "decoy" is believed to derive from the Dutch for "the cage."

During the last half of the nineteenth century the demand for food, improved firearms, and a seemingly inexhaustible supply of birds gave rise to the sport and business of hunting wild ducks with floating decoys and shorebirds with "stick-ups." Regional types of decoys developed because of local hunting conditions and it became financially profitable to manufacture, in specialized factories, wooden decoys that could be marketed at a price between $9 and $12 per dozen. The Mason's Decoy Factory in Detroit, Michigan, (active 1896–1924), was the largest and most successful of this mostly cottage industry. The factory-produced bodies were turned on a lathe, but the finishing work, including the head and painting, were all still done by hand. Many hunters, however, continued to prefer the totally handmade and painted birds made by individual carvers, who were often also hunting guides, and specialized in the species of their region.

Eventually, the slaughter of wildfowl reached such proportions that a number of species disappeared altogether. By the end of the nineteenth century, conservationists were urging control of hunting and finally, in 1918, Congress passed legislation that put an end to the shooting of wildfowl for commercial purposes. The shooting of shorebirds is still outlawed today, but decoys are made and used for legal hunting of other wildfowl by sportsmen. However, the best early examples are now collected as examples of folk sculpture rather than for their efficacy in attracting birds.

From Alaska to Maine, and especially in the Midwest, upper New York State, New England and Canada, decoys were also used for ice spear-fishing in frozen freshwater lakes and streams. These hand-carved and painted lures range from a few inches to several feet long and can also be traced to native American prototypes. Typically, a fisherman would make a hole in the ice, then place a small shack over the hole. Usually, the shack is painted black inside to enable the fisherman to see better through the hole. The decoy is lowered through the hole and when curious fish—bass, carp, trout,

pike, and a variety of other species—swim over to investigate, they are speared by the waiting fisherman.

Professional carvers began making fish decoys about 1900, and they are still being made today. Like wildfowl decoys, some fish decoys are purely decorative. Most folk art enthusiasts, however, prefer the working decoys that are also beautiful examples of sculpture.

Until the time of the Industrial Revolution, probably no type of folk art was created in such prodigious numbers as utilitarian objects made of clay. The potter was an important member of every community, and while most of his output was made for hard, everyday use, many potteries also produced fancier, decorated objects intended as presentation pieces or for use on special occasions. Redware pie plates and other forms were often commissioned as gifts among the Pennsylvania Germans, while cobalt-blue decorated works of stoneware were popular in the Northeast.

Some artisans fashioned delightful and even frivolous pieces to fit the country woman's craving for the imported ceramic ornaments she could not afford. Also popular among rural populations who desired decorative objects in their homes was chalkware, often called the "Poor Man's Staffordshire," and frequently made in much the same forms as the European examples. Chalkware figures, actually made of plaster of Paris but called "chalk" because they would leave a white mark when touched, were produced in molds but individually hand painted. They were often made by German and Italian immigrants who drew on the traditions of their homelands, and were frequently peddled door to door.

Some of the most beautiful pieces of utilitarian folk sculpture came from the highly-talented hands of the members of America's communal settlements. From the early days of the New World, thousands of men and women entered into a wide variety of communal ventures. Most often motivated by a commitment to sectarian religion or to the burning call for social reform, they built villages which dotted the rural landscape.

Frequently, these settlements served as models of self-sufficiency, efficient community organization, and human social consciousness, and they often preserved Old World cultural patterns and folk traditions. By its very nature the communal society generally tended to limit the view of the world and existed within self-erected boundaries. Many of these communities were places of spiritual life and art for art's sake was ignored or of little concern.

Of the many communal societies, none was as important, lasted as long, or contributed so much to the American experience as the Shakers, or the

United Society of Believers in Christ's Second Appearing, who built more than twenty villages scattered from New England to Indiana in the late eighteenth and early nineteenth centuries. Members of the Shaker Society were drawn from numerous cultural and socioeconomic backgrounds. In this mix of peoples there emerged a progressive and life-affirming system which produced a creative spirit among the faithful.

The impact of the Shaker aesthetic led to the elimination of "superfluities" in life and in craftsmanship and to the production of furniture, tools, household accessories, and other objects that are renowned today for their beautiful yet simple design and their functionality. Celibacy, the equality of men and women in communal life, and the strong sense of living close to the "other world" also had their effect on Shaker artistic expression and artisanship. The paradox of simplicity in Shaker architecture and furniture and of extravagance in Shaker inspirational drawings establishes two poles of creativity between which an extraordinary outpouring of fine handcraftsmanship existed. The superb design inherent in the Shaker experience has made a lasting imprint on American folk art.

Religion has continued to be a major influence on folk sculptors in the twentieth century. Images of saints, crucifixions, angels, Adam and Eve, and other Biblical personages and events are made as decorations for houses of worship or for personal use.

More common in this century, however, are three-dimensional objects that serve no function at all, other than to satisfy the creative urge of the maker and, perhaps, to please the viewer. In an age when toys, tools, architectural ornaments, and most of the traditional forms of folk sculpture are mass produced, artists have found new ways to express themselves. Some have a desire to build an entire environment or transform the building they inhabit. Others take inspiration from traditional ideas, such as canes, whirligigs, or weathervanes, then create their own objects with little regard for the original purpose of such pieces. And some take inspiration from the materials they find in their daily lives, including automobile parts or cardboard boxes. No matter what form their expression takes, however, it is clear that sculpture remains an important outlet for folk artists in the twentieth century.

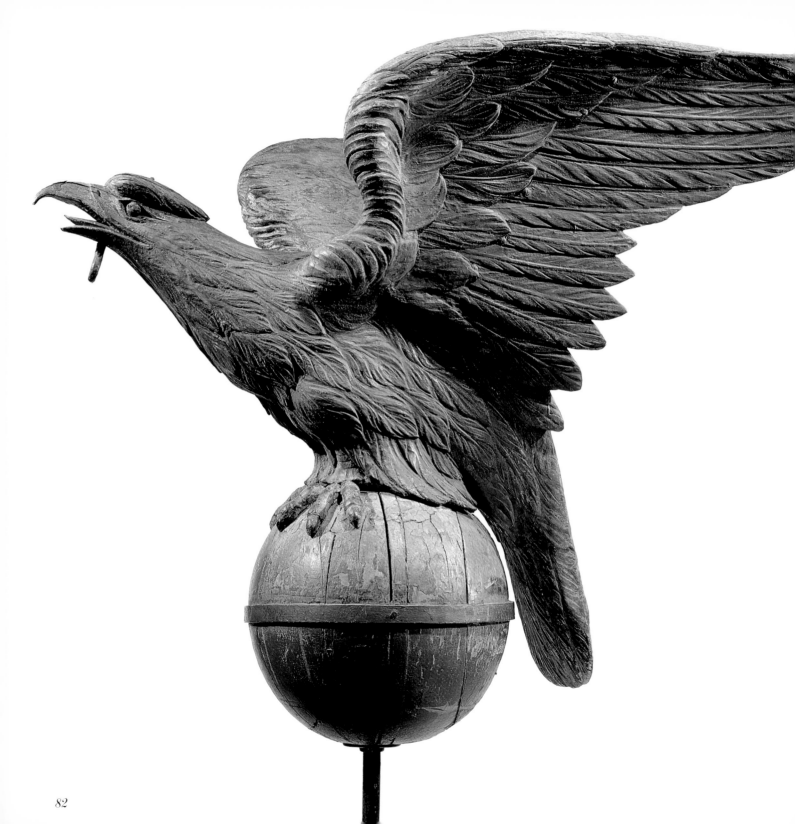

51
Architectural Ornament: Eagle
Artist unknown
Pennsylvania; c.1905
Carved wood, iron;
 $69\frac{7}{8} \times 44 \times 50$ in. deep
Gift of William Engvick. 1966.2.1a and b

This eagle once topped the Fraternal
Order of Eagles Lodge in Columbia,
Pennsylvania. It stands on a globe,
which is supported by a metal rod and
a carved wooden base.

52
Flag Gate
Artist unknown
Jefferson County, New York; c.1876
Polychromed wood, iron, brass;
 $39\frac{1}{2} \times 57 \times 3\frac{3}{4}$in. deep
Gift of Herbert Waide Hemphill, Jr.
 1962.1.1

Both sides of this gate are painted
as representations of the American
flag, possibly inspired by the 1876
celebration of the American centennial.
The gate was originally part of the
Darling Farm in Jefferson County,
New York.

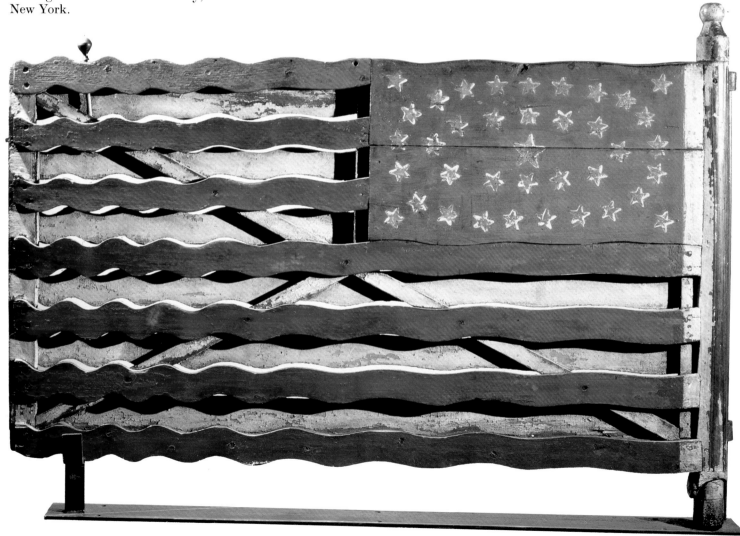

53
Weathervane: Eagle with Shield
Artist unknown
Massachusetts; 1800–1810
Cast bronze; 36 × 43½ in.
*Gift of Mr. and Mrs. Francis
 S. Andrews. 1982.6.4*

With the adoption of the Great Seal of the United States in 1782, the eagle became a popular design motif. This weathervane appears to be a transitional piece between the previously popular phoenix form and the evolving eagle. The six-pointed stars found on the shield were favored in the latter part of the eighteenth century.

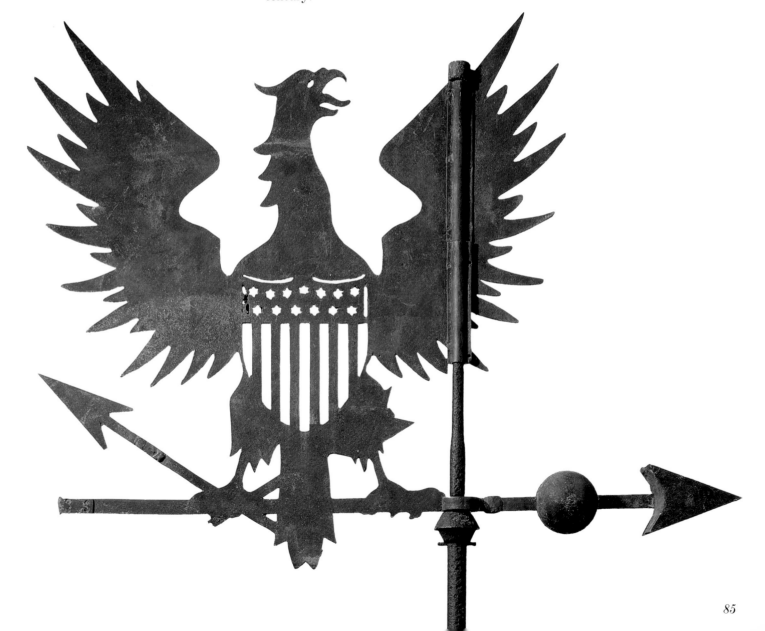

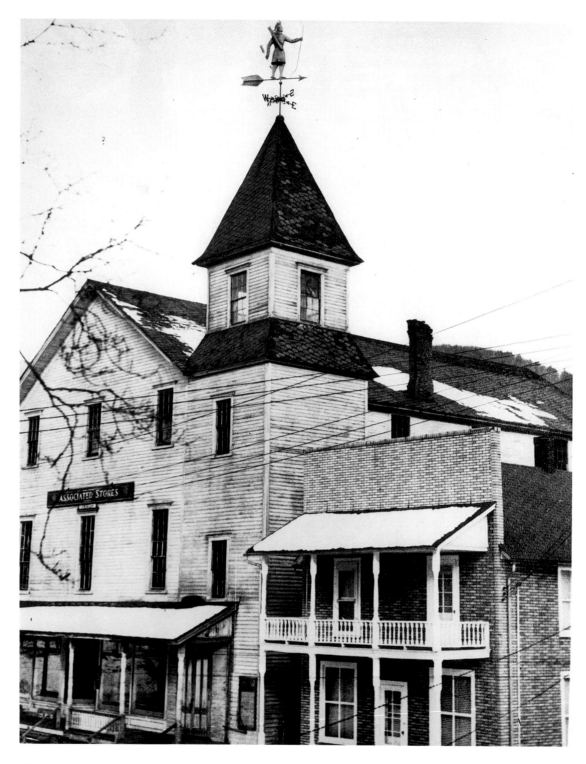

54
Weathervane: St. Tammany
Artist unknown
East Branch, New York;
 mid-nineteenth century
Molded and painted copper;
 $10\frac{1}{2} \times 103 \times 12$in. deep
Museum of American Folk Art purchase.
 1963.2.1

This weathervane originally stood atop
a lodge building in East Branch, New
York (*left*), where it served as a symbol
of the organization known as
"The Improved Order of Redmen."
This fraternal society adopted
Indian customs and dress and pledged
allegiance to the ideals of "Tammany,
Chief of the Delawares," a semi-
mythical personage revered in Colonial
America for his eloquence and courage.
The legendary Indian Chief Tammany
became a symbol of nationalism even
before the Revolution ended. Calling
him Saint Tammany, American
soldiers went into battle under his
banner to fight the soldiers protected
by Saints Andrew and George.

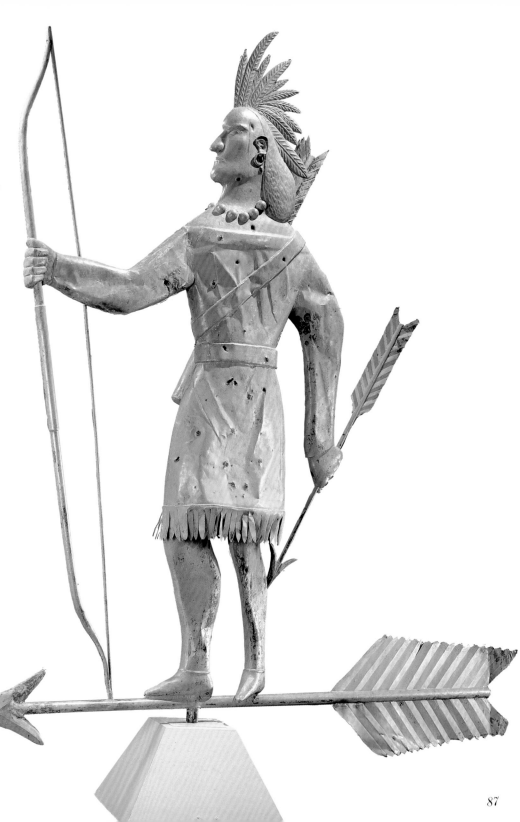

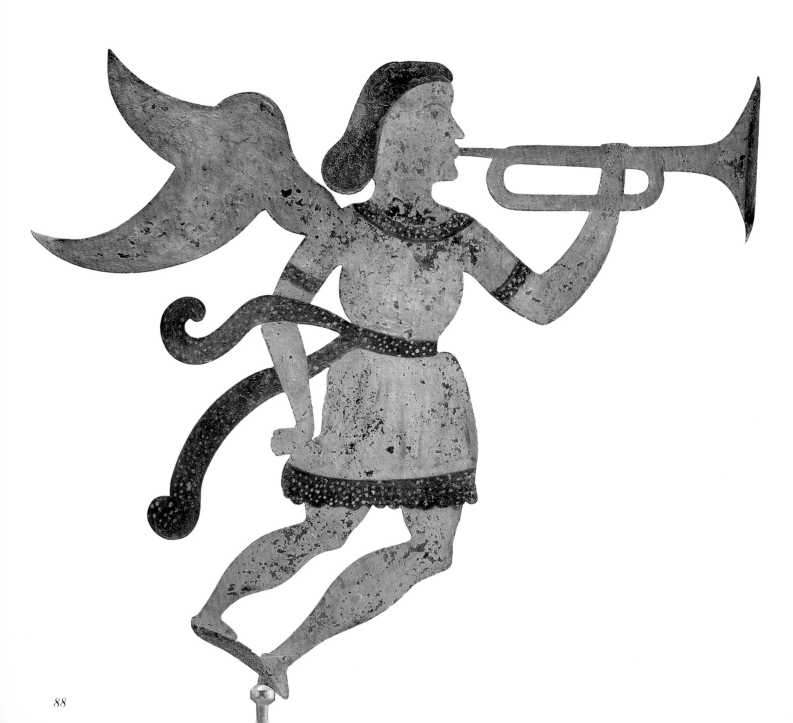

55
Weathervane: Archangel Gabriel
Artist unknown
American; c.1840
Painted sheet metal;
 $35 \times 32\frac{1}{2} \times \frac{1}{4}$ in. deep
Gift of Mrs. Adele Earnest. 1963.1.1

Because weathervanes were made to
be seen from a distance, silhouetted
against the sky, their forms are often
exaggerated. Proportions are
frequently out of scale for reasons of
clarity and effect.

56
Weathervane: Sea Serpent
Artist unknown
New England; c.1850
Painted wood, iron;
 $16\frac{1}{2} \times 23\frac{1}{4} \times 1$ in. deep
Museum of American Folk Art purchase.
 1981.12.13

The art of weathervane making was
most highly developed in America.
Certain themes were favored at
different times and in different regions.
The images conjured up by the sea
serpent were especially appealing to
coastal areas and were often used by
whalers in their scrimshaw carvings.
The mid-nineteenth-century
"sightings" of such creatures as the
Loch Ness Monster also inspired artists
to use mythological and fantastic
creatures in weathervanes and other
functional and artistic expressions.

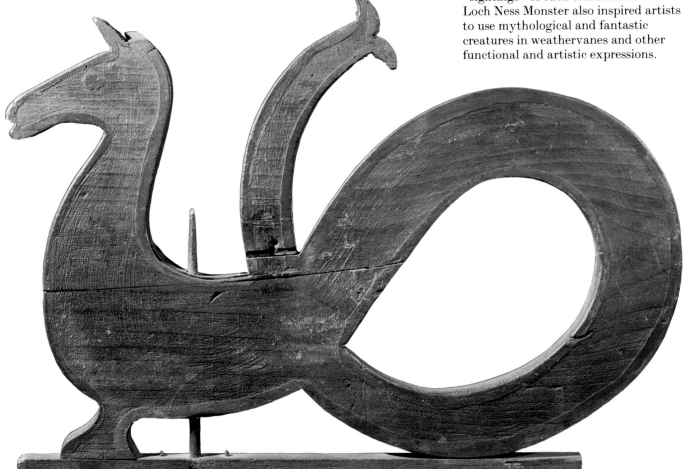

57
Whirligig: Uncle Sam Riding a Bicycle
Artist unknown
Northeastern United States;
 1880–1920
Carved and polychromed wood, metal;
 $37 \times 55\frac{1}{2} \times 11$ in. deep
*Promised bequest of Dorothy and Leo
 Rabkin. P2.1981.6*

The American flag is painted on one
side of this whirligig's tail and the
Canadian flag on the other, suggesting
that it may have been made in a
border area. The character of Uncle
Sam was ''born'' during the War of
1812, but it was Thomas Nast, the
political cartoonist, who is credited
with creating the Lincoln-influenced
version that is popular today.

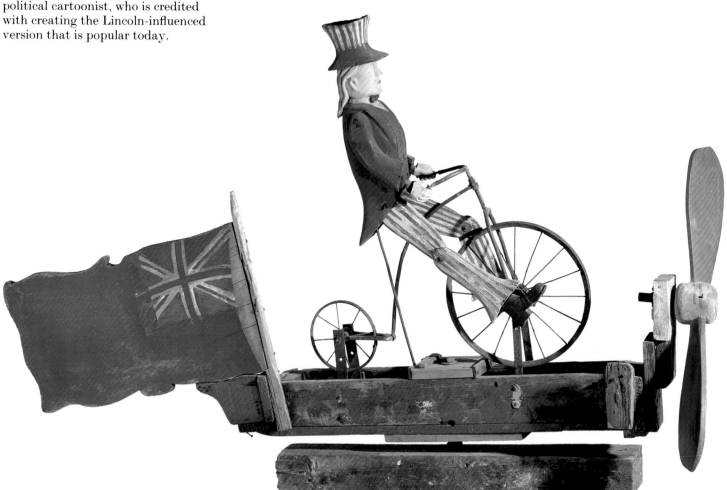

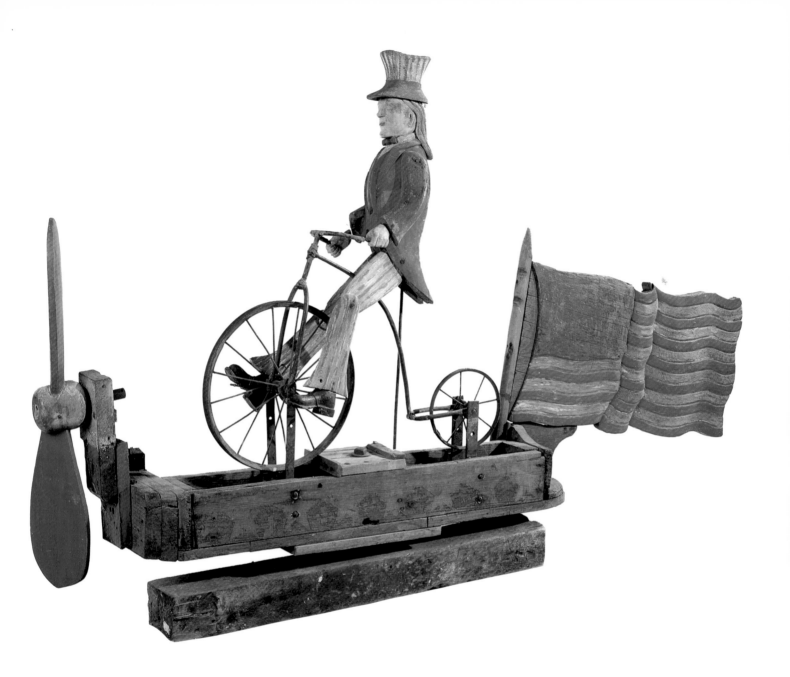

91

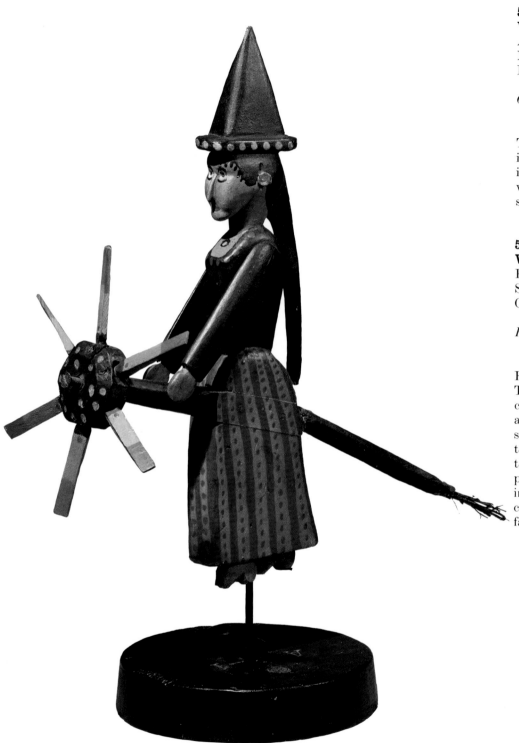

58
Whirligig: Witch on a Broomstick
Artist unknown
New England; 1860–1880
Polychromed wood, twigs, metal;
$12\frac{1}{4} \times 12\frac{1}{4} \times 5\frac{1}{4}$ in. deep
Gift of Dorothy and Leo Rabkin.
1987.13.1

The broom this witch is riding on
is topped by a propeller that turned
in the wind. Such a device allowed
viewers to gauge wind velocity without
stepping outdoors.

59
Whirligig: Early Bird Gets the Worm
Possibly Jack Mongillo (c. 1879–1973)
Salamanca, New York; c. 1920
Carved and polychromed wood, wire;
$42\frac{1}{2} \times 36\frac{5}{8} \times 16\frac{1}{4}$ in. deep
Promised bequest of Dorothy and Leo
Rabkin. P2.1981.5

Each section of this whirligig moves:
The platform supporting the
cardplayers revolves; two men play on
a seesaw; workers operate a two-man
saw; three men jump industriously on
the upper platform, and all the while
the early bird chases the worm. The
possible maker was an Italian
immigrant who came to America
c. 1900. He spent most of his life as a
farmer in upstate New York.

92

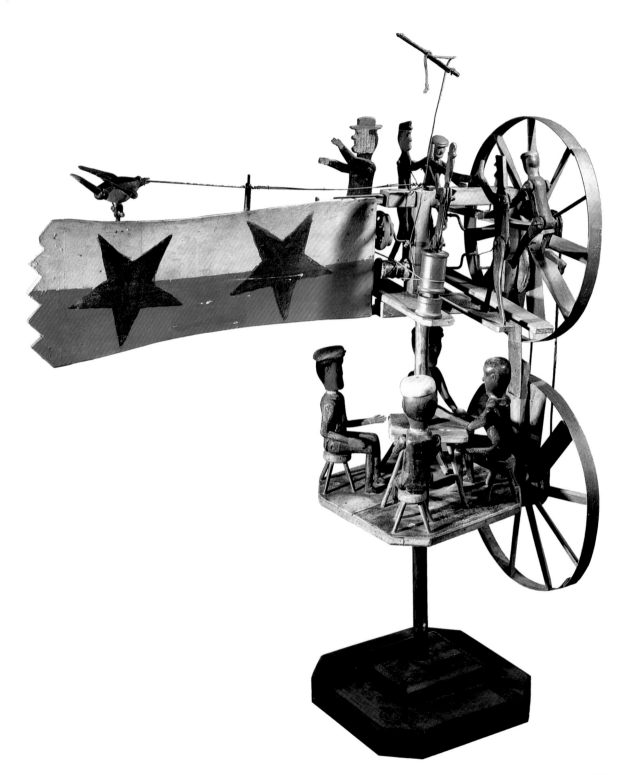

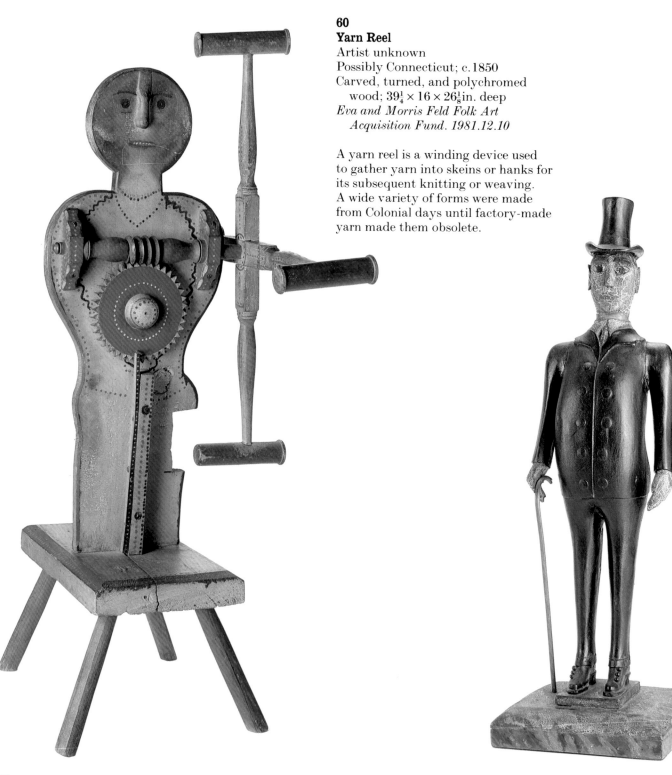

60
Yarn Reel
Artist unknown
Possibly Connecticut; c.1850
Carved, turned, and polychromed
 wood; $39\frac{1}{4} \times 16 \times 26\frac{1}{8}$ in. deep
Eva and Morris Feld Folk Art
 Acquisition Fund. 1981.12.10

A yarn reel is a winding device used
to gather yarn into skeins or hanks for
its subsequent knitting or weaving.
A wide variety of forms were made
from Colonial days until factory-made
yarn made them obsolete.

61
Man in a Top Hat with a Cane
Artist unknown
Northeastern United States; c.1890
Carved and painted wood figure,
 painted and smoke-decorated base;
 $23\frac{1}{2} \times 7\frac{1}{2} \times 7\frac{1}{2}$in. deep
Joseph Martinson Memorial Fund,
 Frances and Paul Martinson.
 1981.12.5

While several figures of this type are
known, their functional use, if any, has
yet to be determined.

62
Father Time
Artist unknown
Mohawk Valley, New York; c.1910
Carved and polychromed wood, metal,
 hair; $52\frac{1}{8} \times 13\frac{7}{8} \times 14\frac{1}{2}$in.
Gift of Mrs. John H. Heminway.
 1964.2.1

This carving was once articulated so
that the right arm moved and the
sickle hit the suspended bell. The
original purpose of this figure remains
undetermined.

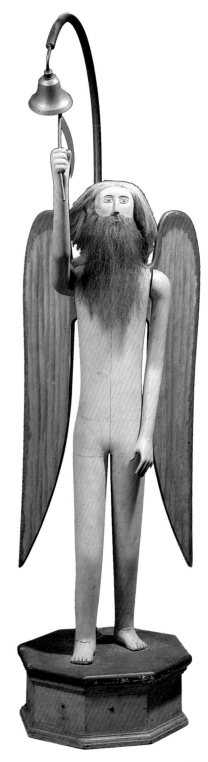

95

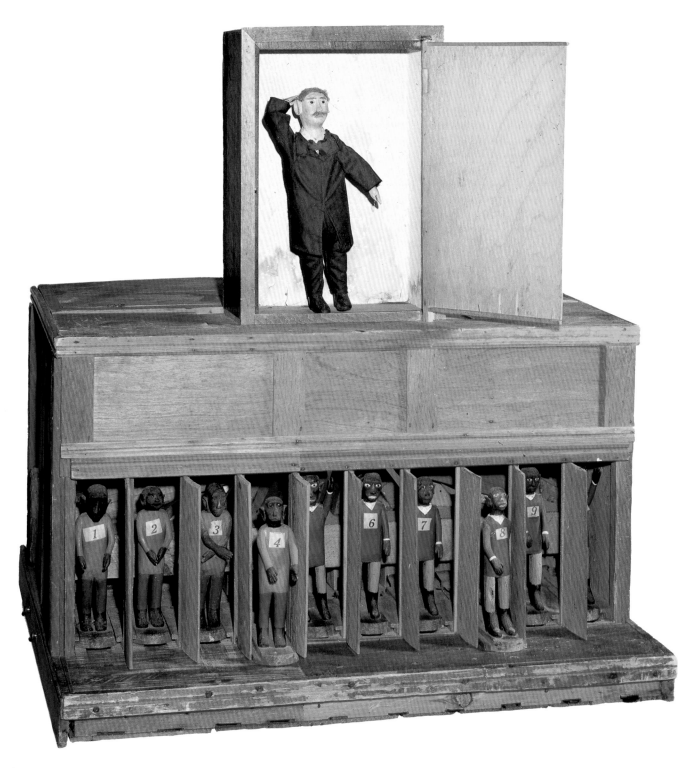

63
Game of Chance: Auctioneer and Slaves
Artist unknown
American; c.1850
Painted wood, metal, cotton, paper;
 $27 \times 24\frac{5}{8} \times 22\frac{5}{8}$in. deep
*Promised bequest of Dorothy and Leo
 Rabkin. P2.1981.2*

This gambling device features ten gates
with doors which hold figures of ten
black men fastened by nails to sliding
platforms. The device operated not
unlike a modern roulette wheel: heavy
marbles or lead balls would drop down
a chute, bounce on a spring, and cause
one of the figures to eject from his gate.
A bell was rigged to ring when the
"winning" slave appeared.

64
Phrenological Head
Attributed to Asa Ames (1823–1851)
Evans, Erie County, New York;
 1847–1850
Polychromed pine; $16\frac{3}{8} \times 13 \times 7\frac{1}{8}$in.
Bequest of Jeanette Virgin. 1981.24.1

The late-eighteenth-century movement
known as phrenology was popularized
in America through the proselytizing
talents of Orson Squire Fowler and his
brother Lorenzo Niles Fowler.
Phrenologists believed that the skull
could be organized into thirty-seven
"faculties," each exerting control over
a different area of behavior. This bust-
length portrait of a young girl was
carved by Asa Ames who is best known
for his sculpted portraits of children.
The head of this piece is decorated with
a colorful map of the thirty-seven
functions as illustrated by the Fowler
brothers in their many publications.

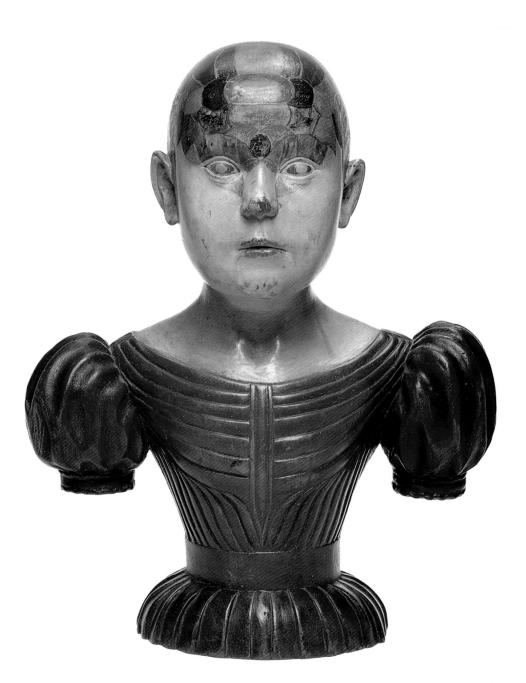

65
Carved Eagle with Outspread Wings
Wilhelm Schimmel (1817–1890)
Carlisle, Pennsylvania; 1870–1890
Carved pine, painted and gessoed;
 20 × 41 × 6½ in. deep
Gift of Mr. and Mrs. Francis S.
 Andrews. 1982.6.10

Wilhelm Schimmel was an itinerant
carver who traded his whittled birds
and animals for food, drink, and
shelter. He emigrated from Germany
some time after the Civil War and lived
in Cumberland Valley near Carlisle,
Pennsylvania, finally dying in the
Cumberland Valley Alms House.
Schimmel carved a menagerie of
parrots, chickens, roosters, lions, dogs,
and a few people, but he is best known
for his eagles, which range from toy
size to one with a wing span of almost
four feet.

66
Pair of Bird Trees
Artist unknown
Pennsylvania; c.1875
Carved and polychromed wood, wire;
 15⅞ × 6¾ in. diam.; 16⅝ × 6⅞ in. diam.
Gift of Mr. and Mrs. Austin Fine.
 1981.12.19 and 1981.19.20

Whimsical bird trees were popular
among the Pennsylvania Germans.
These examples, which retain their
original paint, probably served as
mantle decorations.

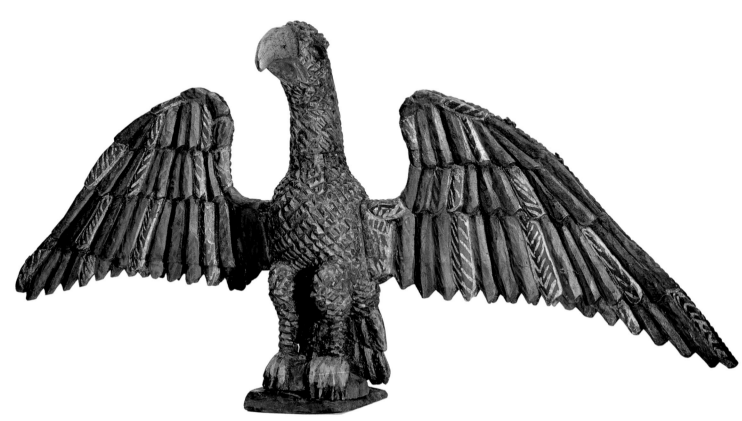

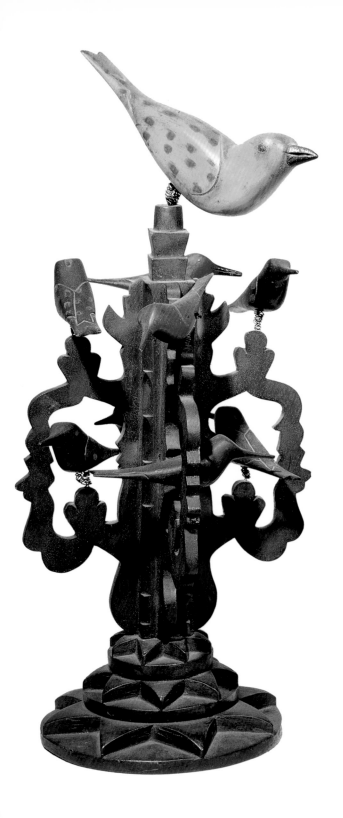
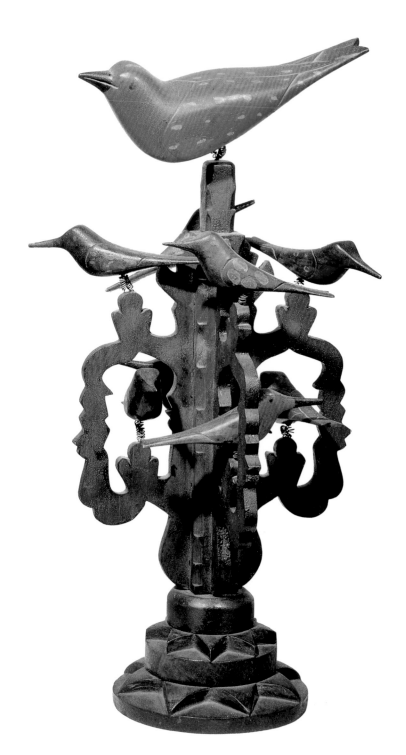

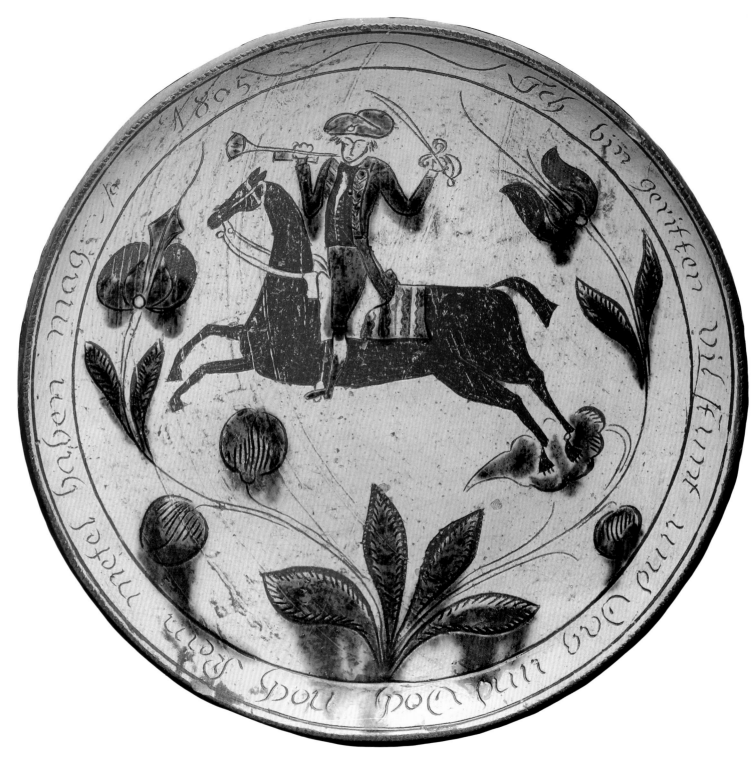

67
Sgraffito Plate
Johannes Neesz (1775–1867)
Tylersport, Montgomery County,
 Pennsylvania; dated 1805
Redware; 12 in. diam.
Promised anonymous gift

The sgraffito technique involves laying
one color of slip glaze on top of another
of a different color. A decorative design
is produced by scratching through the
outer layer of slip. The phrase written
on this plate translates: *"I have ridden
many hours and days and yet no girl am
able to have."*

68
Horse and Rider
Artist unknown
Pennsylvania; 1850–1875
Glazed redware; $8 \times 5\frac{3}{4} \times 2\frac{1}{2}$ in. deep
Promised anonymous gift. P79.203.1

Ceramic ornaments such as this were
produced by local potteries in America
to compete with the more expensive
European ornaments. Redware was
commonly found in Pennsylvania and
New England.

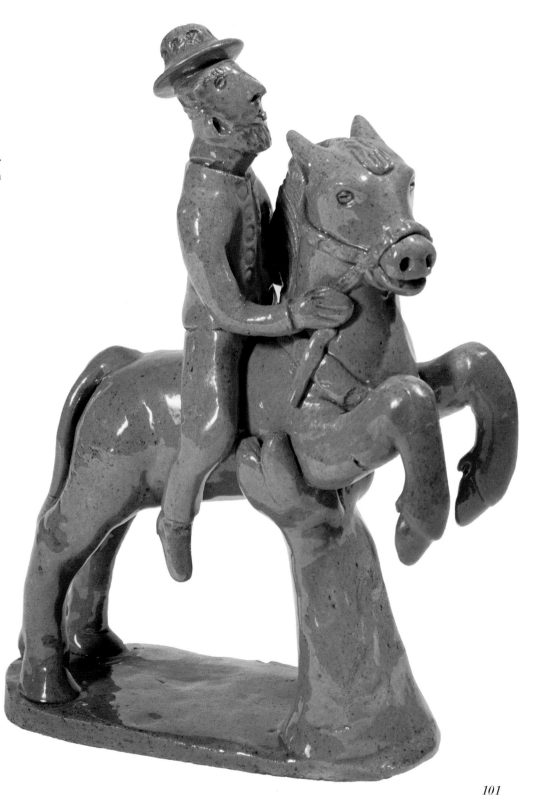

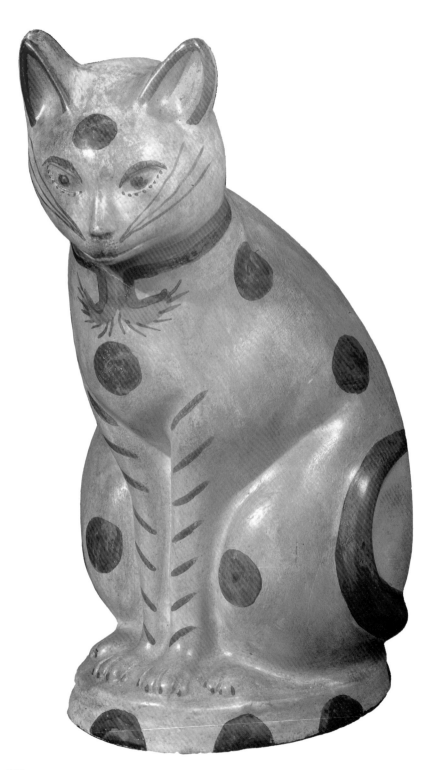

69
Seated Cat
Artist unknown
American; 1860–1900
Polychromed chalkware;
$15\frac{5}{8} \times 8\frac{3}{4} \times 10\frac{1}{8}$ in. deep
Gift of Effie Thixton Arthur. 1963.3.1

No two pieces of chalkware are exactly
alike, as each was individually painted.
Early chalkware was decorated with oil
paint; later pieces with watercolors.
Most early chalkware is hollow and
much lighter than the solid cast pieces
of the late Victorian era.

70
Nodding Head Goat
Artist unknown
American; 1860–1900
Polychromed chalkware, wire;
$7\frac{5}{8} \times 9 \times 3\frac{3}{8}$ in. deep
Bequest of Effie Thixton Arthur.
1980.2.24

Chalkware is actually made from
gypsum, a mineral used in the
manufacture of plaster of Paris.
Chalkware figures made in molds were
the simplest, least expensive solution
to the demand for decorative objects
by the middle class homemaker in both
Europe and America. Many of the
designs commonly associated with
chalkware were first seen in earlier
English earthenware figures and
include animals, birds, fruit
arrangements, and contemporary
celebrities.

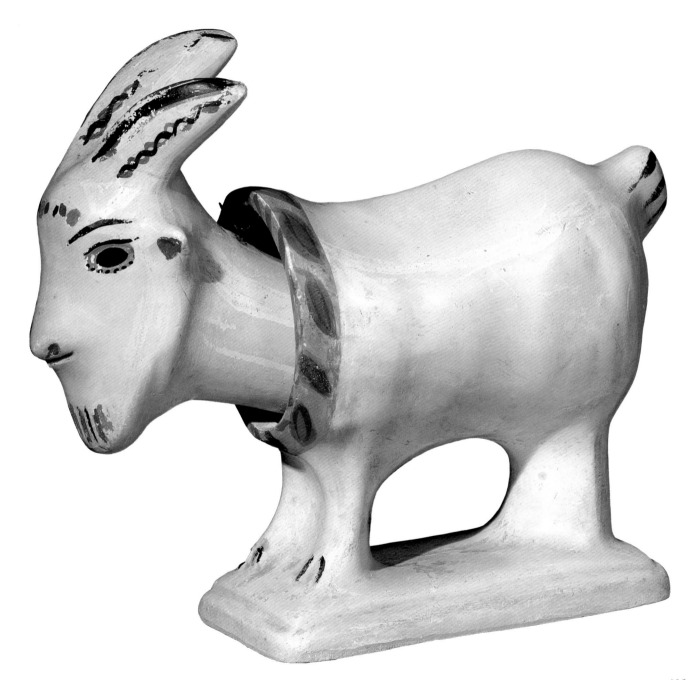

71
**Trade Sign: E. Fitts Jrs. Store and
 Coffeehouse**
Artist unknown
Vicinity of Shelburne, Massachusetts;
 dated 1832
Polychromed wood, wrought iron;
 image, oval: $22\frac{3}{8} \times 34\frac{1}{2}$ in.
*Gift of Margery and Harry Kahn.
1981.12.9*

A trade sign like this would be set on a
pole by the road so that it could be
visible to passersby from both
directions.

72
Fireboard
Artist unknown
Somerset County, Pennsylvania;
 1830–1840
Carved and polychromed pine;
 $43\frac{1}{4} \times 47\frac{1}{8} \times 7$ in. deep
*Museum of American Folk Art purchase.
1981.12.12*

A fireboard is a decorative device used
to seal off the fireplace during the
summer months. This example was
either attached to the fireplace frame
or stood on a wooden base.

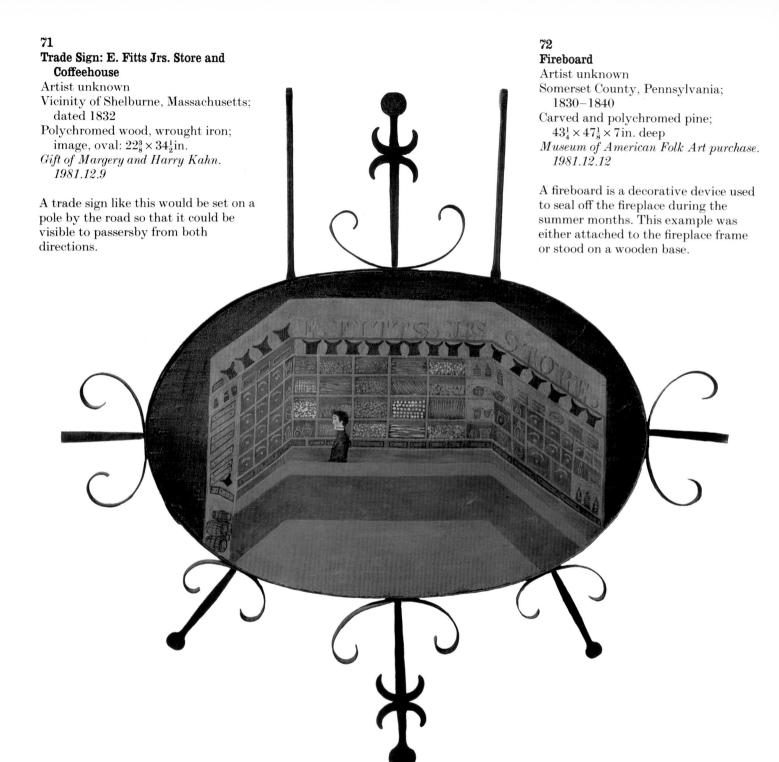

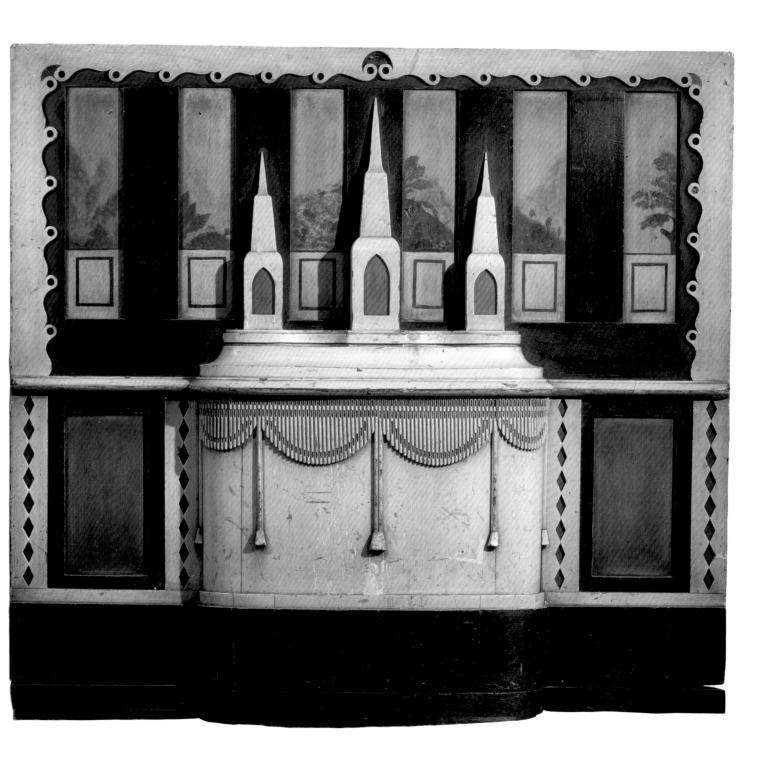

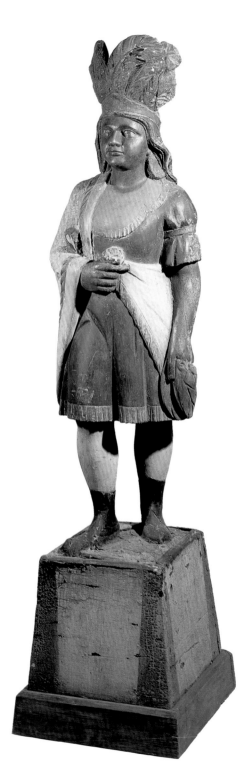

73
Cigar Store Indian: Rose Squaw
Samuel Robb (1851–1928)
New York City; 1877–1880
Polychromed wood; $66\frac{1}{2} \times 17 \times 19\frac{1}{4}$ in.
Gift of Sanford and Patricia Smith.
1981.15.1

The Robb carving shop in New York
City employed many carvers who
fashioned a wide variety of advertising
and trade figures, including the well-
known cigar-store Indians. Most of
these figures were mounted on bases,
usually equipped with wheels so they
could be easily moved outside the shop
in the morning and back inside at night.

74
Carousel Horse with Lowered Head
Charles Carmel (1865–1931)
Brooklyn, New York; c.1914
Carved and polychromed wood, glass
jewels, horsehair;
$58\frac{5}{8} \times 63 \times 14\frac{7}{8}$ in. deep
Gift of Laura Harding. 1978.18.1

Charles Carmel of Brooklyn, New
York, was one of the carvers of the
"Coney Island Style" of carousel
animals. The horses and other animals
created in this style reflected the glitter
and flamboyance of America's pre-
eminent amusement center. Figures
by these New York carvers are
stylized, rather than realistic, and
often have exciting expressions, flaring
nostrils, and exaggerated poses. Most
are generously decorated with colorful
faceted or mirrored jewels.

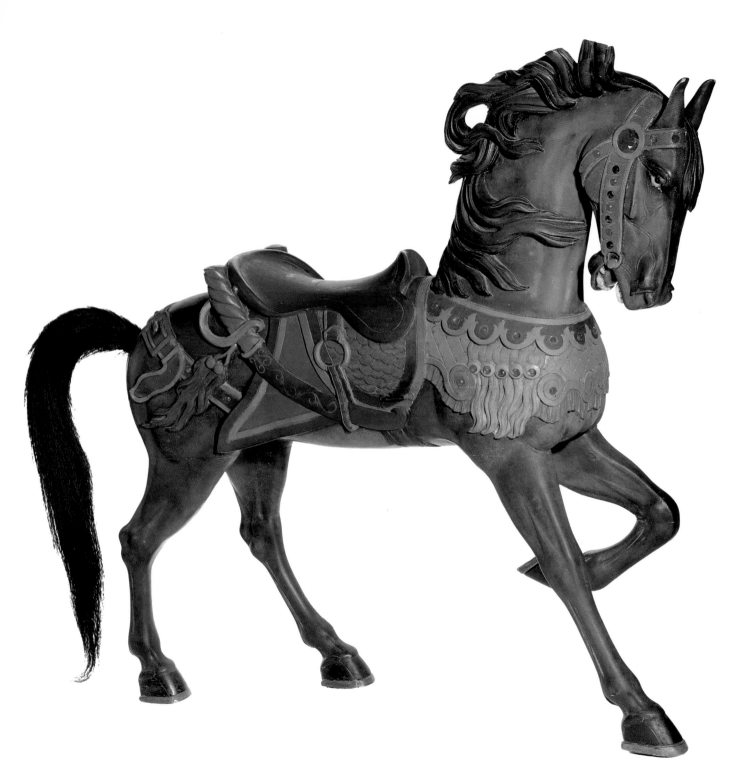

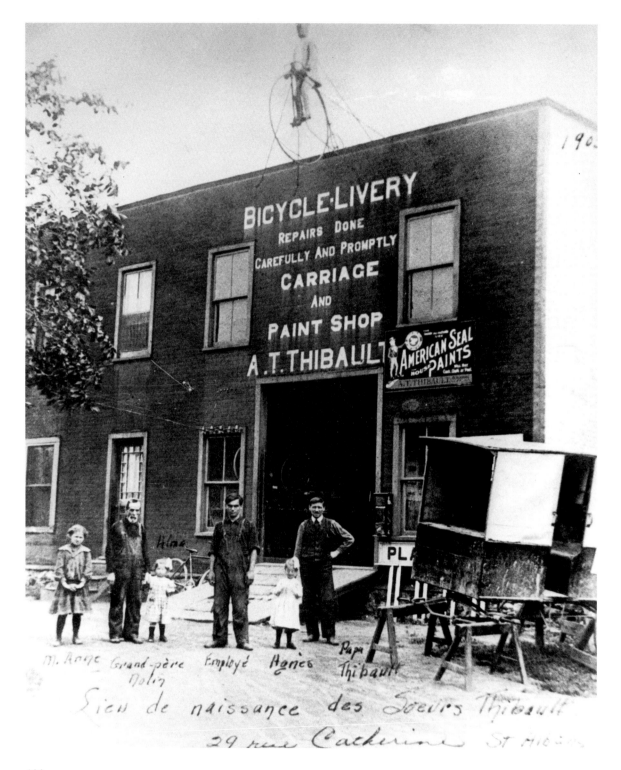

BICYCLE-LIVERY
REPAIRS DONE
CAREFULLY AND PROMPTLY
CARRIAGE
AND
PAINT SHOP
A.T.THIBAULT

AMERICAN SEAL
HOUSE PAINTS

190?

M. Anne Grand-père Employé Agnès Papa
 Nolin Thibault

Lieu de naissance des Soeurs Thibault

29 rue Catherine St Hi...

75
Trade Sign: Bicycle, Livery, Carriage and Paint Shop

Amidée T. Thibault (1865–1961)
St. Albans, Vermont; c.1895
Wood, Columbia bicycle;
 84 × 66 × 36 in. deep
Gift of David L. Davies. 1983.24.1

Amidée Thibault was born in Quebec and by the age of seventeen he was carving crosses for the Temperance Society of the Parish of Notre Dame de Stanbridge and helping his uncle carve church pews. In 1895 he moved with his young wife to St. Albans, Vermont, where he opened a bicycle and carriage repair shop (*left*). This trade sign was carved from wood laminated together for strength and made to withstand the high winds of Lake Champlain. The bicycle is an actual Columbia high-wheeler. When the building was renovated in 1920, the sign was removed.

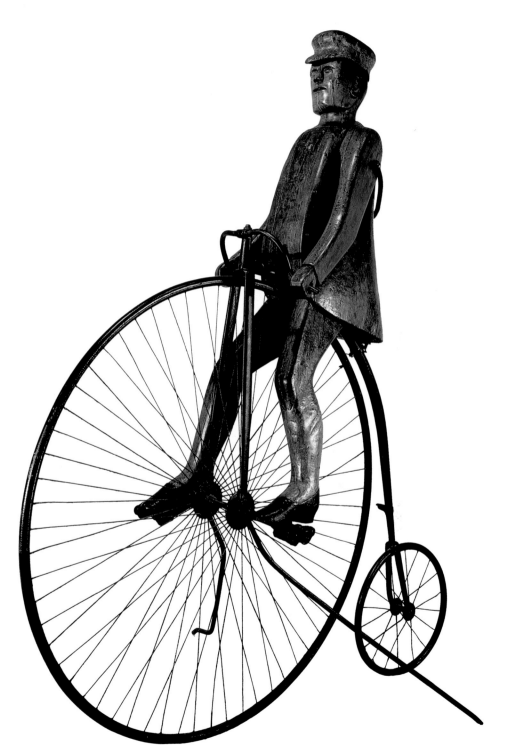

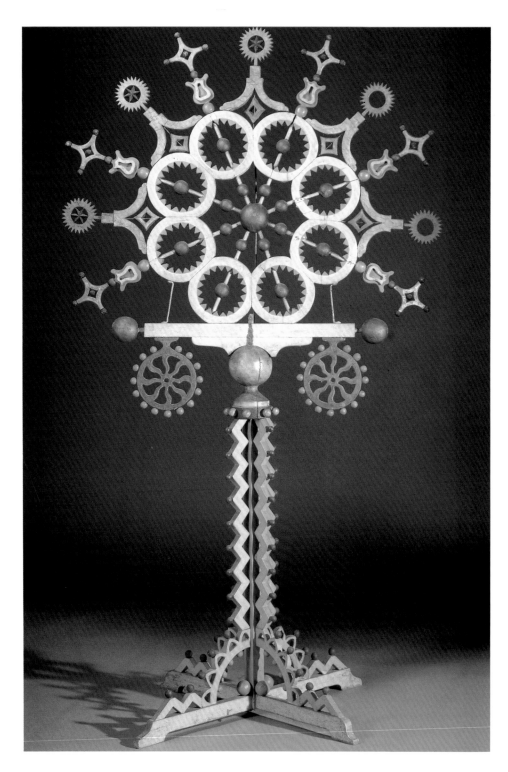

76A
Sunburst

John Scholl (1827–1916)
Germania, Pennsylvania; 1907–1916
Wood, paint, metal, wire;
 71 × 38 × 24¼ in. deep
Gift of Cordelia Hamilton in recognition of research, work, and continued meritorious contributions in the field of eighteenth- and nineteenth-century folk art by Mrs. Adele Earnest, founding member of the Museum. 1982.8.1

Born in Württemberg, Germany, John Scholl moved to the United States at age twenty-six and settled in Schuylkill County, Pennsylvania, a center of the anthracite coal industry. By 1870, he had moved to Germania where he worked as a carpenter. After his retirement at age eighty, Scholl started making the carvings for which he is best known, using architectural pieces available to him as a carpenter. Scholl was so attached to his carvings that he seldom sold or gave any away. In his later years, Scholl opened the parlor of his home to the public as a museum to display his own works.

76B
Photograph of John Scholl
Artist unknown
Germania, Pennsylvania; c.1900
Photograph; $18\frac{1}{2} \times 12\frac{1}{2}$ in.
Gift of Cordelia Hamilton, Dr. and Mrs.
Lester Blum, Murray Eig, and
William Engvick. 1967.1.2

This photograph of John Scholl, taken
when he was approximately eighty
years old, shows him seated on a wood
pile at his farmstead in Germania,
Pennsylvania.

76C
Box of Tools
Owned by John Scholl
Germania, Pennsylvania; c.1900
Iron and wood;
box: $11\frac{3}{4} \times 9 \times 6\frac{7}{8}$ in. deep
Gift of Cordelia Hamilton, Dr. and Mrs.
Lester Blum, Murray Eig, and
William Engvick. 1967.1.3

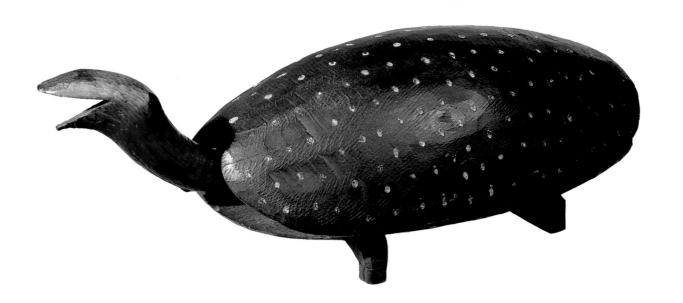

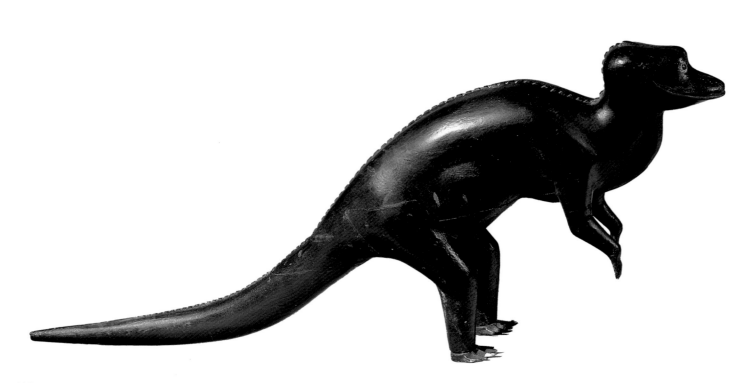

112

77
Turtle
Artist unknown
American; nineteenth century
Carved and painted wood;
$7\frac{1}{4} \times 20\frac{5}{8} \times 7\frac{5}{8}$in. deep
*Gift of Herbert Waide Hemphill, Jr., in
the name of Neal Adair Prince.
1964.1.2*

Similar examples with flat backs were
made to be used as footstools. Since
this turtle has a rounded back, it is
likely that it was made as a decorative,
whimsical piece.

78
Dinosaur
Fred Alten (1872–1945)
Wyandotte, Michigan; 1915–1925
Carved and painted wood;
$9\frac{3}{8} \times 24\frac{5}{8} \times 3\frac{1}{2}$in. deep
*Gift of Mr. and Mrs. Joseph A. Dumas.
1977.2.1*

The child of German immigrants, Fred
Alten lived the first part of his life in
Ohio, where he worked in his father's
foundry. In 1912 he moved to
Michigan and worked at a variety of
occupations, including laborer, piano
mover, and carpenter. Alten was an
introverted man who spent all his
spare time in a woodshed carving his
animals in solitude. In 1975, Alten's
entire life's work was found in a garage
where it had remained unnoticed for
thirty years. Also in the garage was a
copy of *Johnson's Household Book of
Nature*, the inspiration for Alten's
carvings of modern and prehistoric
animals.

79
Cat Bootscraper
Artist unknown
American; c.1900
Cast iron; $11\frac{3}{8} \times 17\frac{1}{2} \times 3$in. deep
*Gift of the Friends Committee of the
Museum of American Folk Art.
1979.22.1*

During the nineteenth century cast
iron became a popular and relatively
inexpensive material for the
manufacture of a wide variety of
utilitarian objects, including
bootscrapers and door stops.
Generally, a carver would fashion
a wooden pattern, which in turn
would be used to produce a metal
mold. The mold made the multiple
production of identical objects
possible. These were then usually hand
painted.

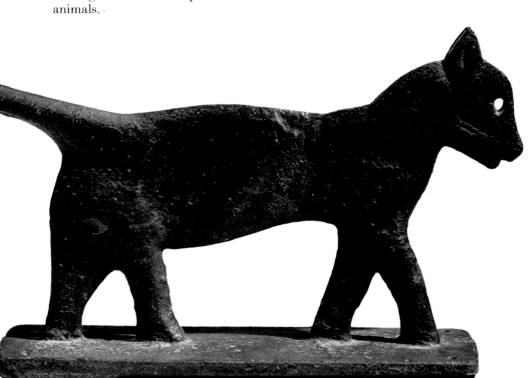

80
Decoy: Black Duck (Right)
Charles E. "Shang" Wheeler
 (1872–1949)
Stratford, Connecticut; c.1930
Painted wood and cork, glass;
 $5\frac{7}{8} \times 18 \times 6\frac{3}{4}$in. deep
Gift of Alastair B. Martin. 1969.1.15

While best known as a decoy maker,
"Shang" Wheeler also carved life-size
fish, ship half-models, and lifelike
decorative birds. All of these tasks,
however, were pastimes to fill in spare
moments during the long days he spent
as manager of an oyster–farming
business in Stratford. This working
decoy was used on the exposed mud
flats of Connecticut.

81
Decoy: Broadbill Drake (Below left)
David K. Nichol (1890–1977)
Smith Falls, Ontario, Canada; c.1900
Painted wood, glass, lead, leather;
 $5\frac{1}{2} \times 13\frac{1}{2} \times 6\frac{1}{4}$in. deep
Gift of Alastair B. Martin. 1969.1.82

Canadian carvers in Smith Falls echoed
Quebec decoy makers in their elaborate
portrayal of feathering.

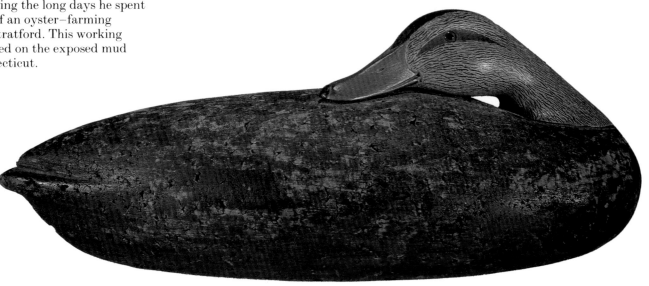

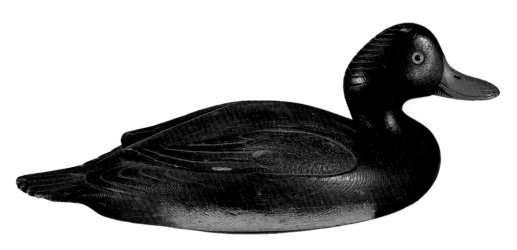

82
Decoy: Pintail Drake
Steve Ward (1895–1976) and Lem
 Ward (b.1896)
Crisfield, Maryland; c.1935
Polychromed wood, glass;
 $8 \times 18 \times 6\frac{1}{2}$in. deep
Gift of Alastair B. Martin. 1969.1.4

Decoys carved by Steve Ward and
painted by his brother Lem are
reknowned for their realistic character.
Originally barbers in Crisfield,
Maryland, the Ward brothers became
known for their working decoys during
the Depression, when hunting was one
of the best ways to put food on the
table. In the 1950s, when hunting
declined, the brothers turned to
making ornamental birds.

83
Decoy: Canada Goose
Ira Hudson (1876–1949)
Chincoteague Island, Virginia; c.1920
Painted wood; $11\frac{1}{4} \times 25\frac{1}{2} \times 8$in. deep
Gift of Alastair B. Martin. 1969.1.13

Ira Hudson, who may have made as
many as twenty-five thousand decoys,
as well as decorative bird and fish
carvings, was Virginia's most
important and prolific decoy maker.
Hudson created in a number of
different styles, often adjusting his
work to the price a customer was
willing to pay.

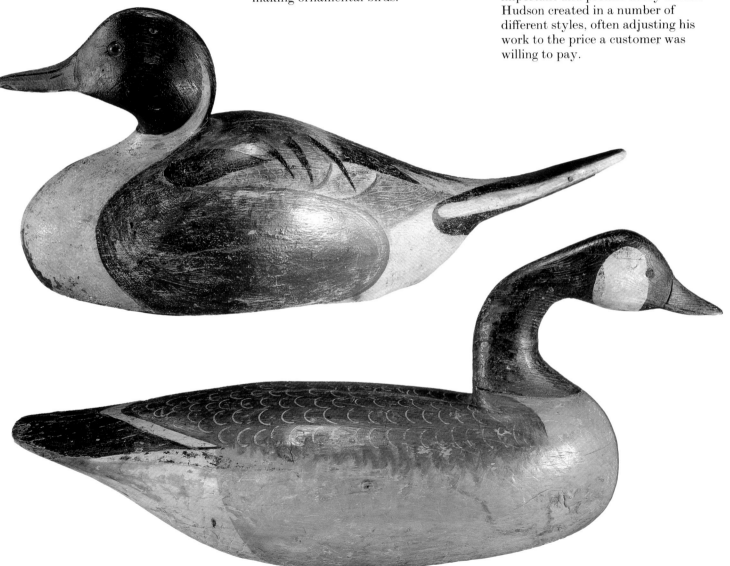

84
Decoy: Black-Bellied Plover
A. Elmer Crowell (1862–1951)
East Harwich, Massachusetts; c.1910
Painted wood, glass;
$5\frac{5}{8} \times 10 \times 2\frac{7}{8}$ in. deep
Gift of Alastair B. Martin. 1969.1.94

Crowell is the acknowledged master of American decoy makers, especially acclaimed for his painting of birds. He originally made working decoys but, after shorebird gunning was outlawed in 1918, Crowell shifted to carving decorative shorebirds for display. Shorebird decoys like this plover are known as ''stick-ups'' since they were placed on sticks along the beaches or marshes to lure the live birds to the close range of hunters.

85
Decoy: Dowitcher
William Bowman (1824–1926)
Possibly Bangor, Maine area; c.1890
Painted wood, glass;
$5\frac{1}{2} \times 10\frac{1}{2} \times 2\frac{5}{8}$ in. deep
Gift of Alastair B. Martin. 1969.1.102

William Bowman was a Maine millman who hunted in the Long Island marshes. His carvings of shorebirds are among the best ever made, and it has been said that only Elmer Crowell was a better shorebird painter. Bowman imbued his birds with many realistic details, including German taxidermists' eyes, exquisitely carved wing tips and other refinements, and a sophisticated paint palette.

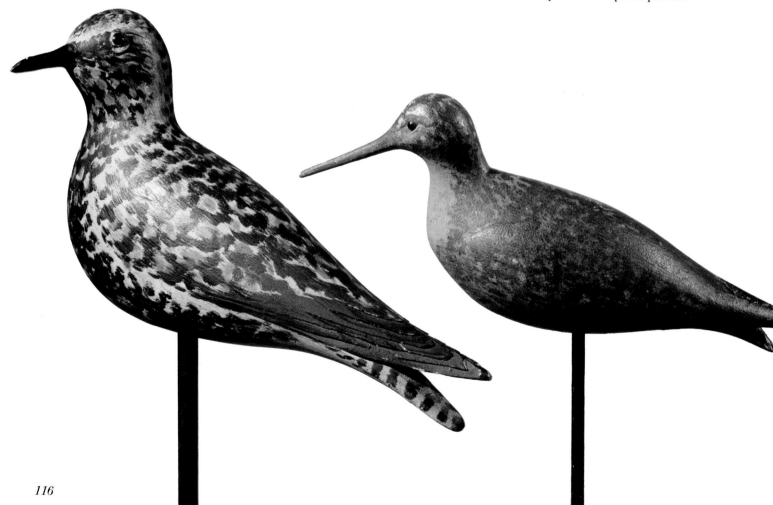

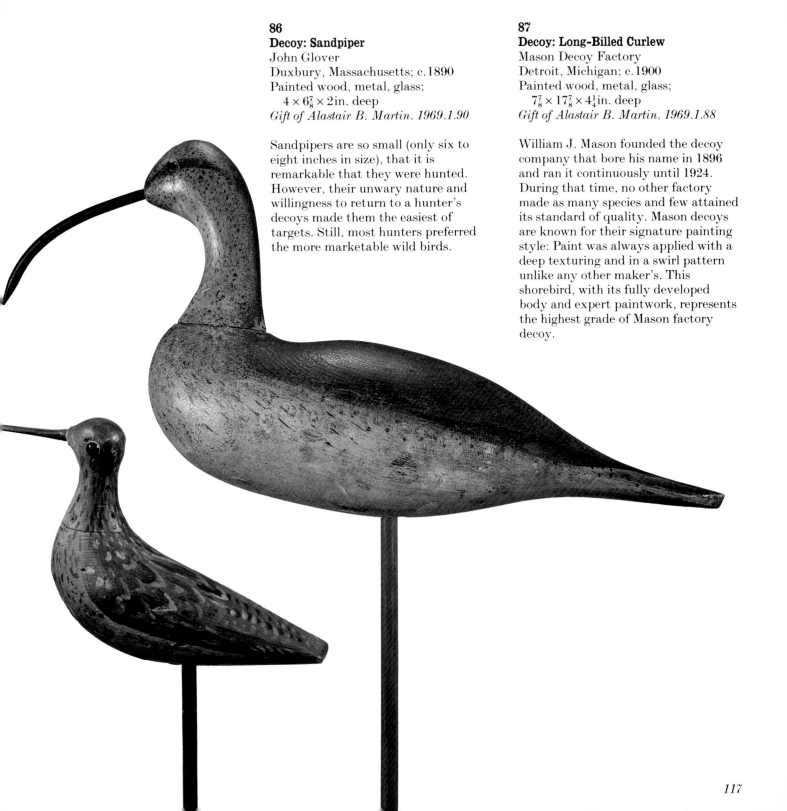

86
Decoy: Sandpiper
John Glover
Duxbury, Massachusetts; c.1890
Painted wood, metal, glass;
 $4 \times 6\frac{7}{8} \times 2$ in. deep
Gift of Alastair B. Martin. 1969.1.90

Sandpipers are so small (only six to
eight inches in size), that it is
remarkable that they were hunted.
However, their unwary nature and
willingness to return to a hunter's
decoys made them the easiest of
targets. Still, most hunters preferred
the more marketable wild birds.

87
Decoy: Long-Billed Curlew
Mason Decoy Factory
Detroit, Michigan; c.1900
Painted wood, metal, glass;
 $7\frac{7}{8} \times 17\frac{7}{8} \times 4\frac{1}{4}$ in. deep
Gift of Alastair B. Martin. 1969.1.88

William J. Mason founded the decoy
company that bore his name in 1896
and ran it continuously until 1924.
During that time, no other factory
made as many species and few attained
its standard of quality. Mason decoys
are known for their signature painting
style: Paint was always applied with a
deep texturing and in a swirl pattern
unlike any other maker's. This
shorebird, with its fully developed
body and expert paintwork, represents
the highest grade of Mason factory
decoy.

88
Fish Decoy
Artist unknown
Midwest; early twentieth century
Painted wood, metal;
$10\frac{3}{4} \times 41\frac{1}{4} \times 6\frac{3}{8}$ in. deep
Promised anonymous gift. P78.211.4

Most fish decoys are carved of wood,
usually white pine, and contain a
cavity filled with molten lead for
"sinkability." Fins were often recycled
from old tin tobacco cans. Almost all
decoys were painted, usually to
resemble the fish they imitated.

89
Crucifix
Chester Cornett (1912–1981)
Dwarf County, Kentucky; c.1968
Polychromed wood; 96 × 48in.
Gift of Pam and James Benedict.
1983.28.1

Cornett's large-scale sculpture of Christ
on the cross was inspired by a
visionary experience. In 1968, Cornett
dreamed that a flood was going to
submerge all of eastern Kentucky.
To save himself, he built a large ark
with room for passengers and a
sculpture of Christ on the cross affixed
to the bow. When the flood did not
occur, Cornett moved out of the ark
and back into his house. Shortly
afterwards, however, the creek behind
his house overflowed and carried the
ark away. The sculpture was recovered
and eventually reworked into its
present form.

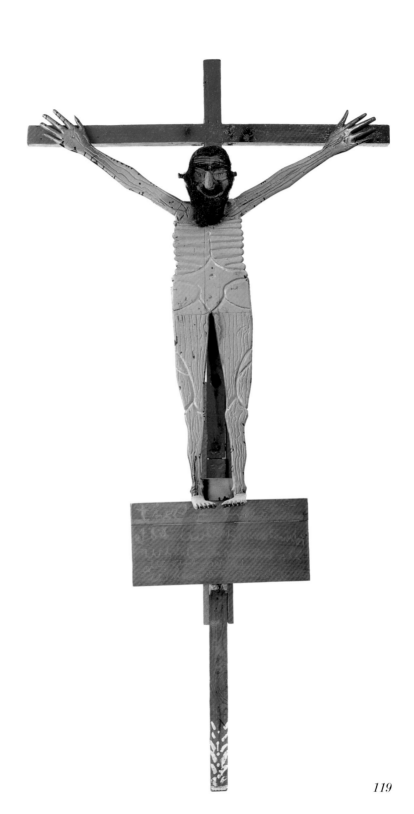

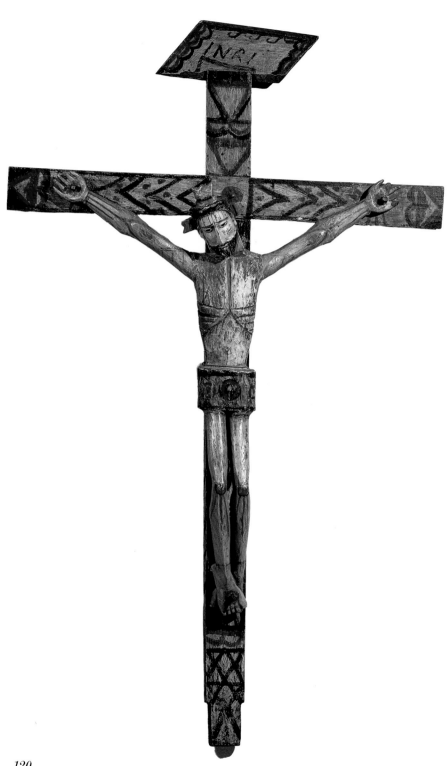

90
Bulto
Attributed to José Benito Ortega
 (1858–1941)
La Cueya, New Mexico; 1870–1900
Gessoed and polychromed wood, iron,
 leather; $45 \times 27\frac{3}{8} \times 4\frac{3}{4}$ in. deep
Anonymous gift. 1976.2.1

The bultos carved by José Benito
Ortega are characterized by abstract
bodies combined with more realistic-
looking heads. In spite of Ortega's
deliberate stylization of form and
detail, many of his bultos resemble
living people of Spanish descent in
New Mexico.

91
Saint John the Baptist
John Perates (c.1895–1970)
Portland, Maine; c.1940
Carved, polychromed, and varnished
 wood; $49\frac{1}{4} \times 27\frac{1}{2} \times 5\frac{1}{2}$ in. deep
Gift of Mr. and Mrs. Edwin Braman.
 1983.12.1

John Perates emigrated from Greece to
America in 1912. He had been trained
as a carver by his grandfather and
carried with him the Byzantine
aesthetic and Orthodox faith of his
homeland. He established himself as a
cabinetmaker in Portland, Maine, and
studied the Bible in quiet moments.
Sometime in the 1930s he began to
carve the large icons of religious figures
and events based on the life of Christ
that he intended for use in the local
Greek Orthodox church. Few of the
panels were ever placed in the church
but Perates continued carving for
approximately thirty years. The panels
derive from the Greek and Byzantine
icon tradition but are also reflective of
the New England life Perates found
when he emigrated.

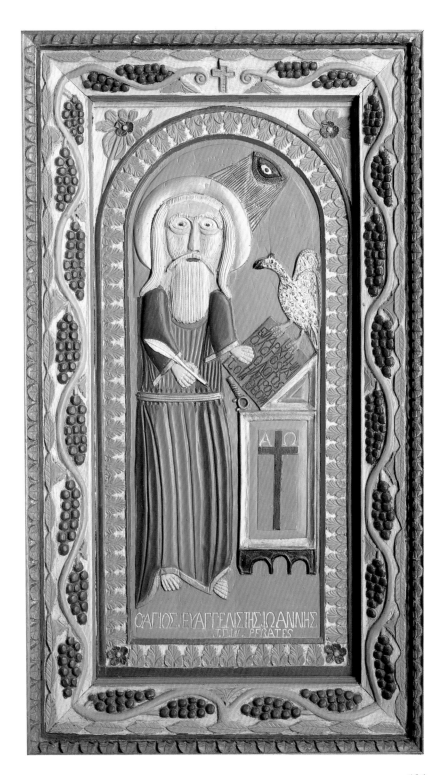

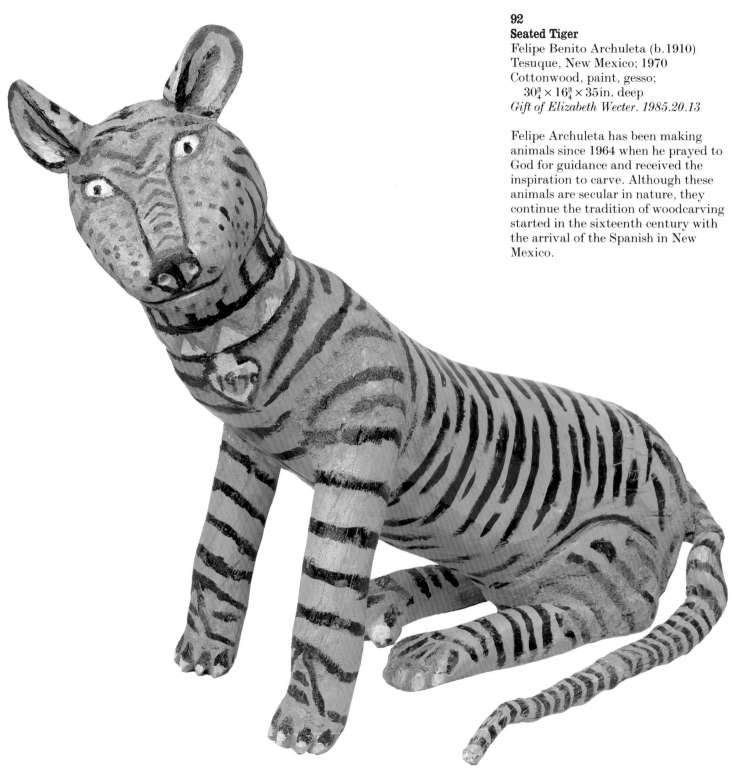

92
Seated Tiger
Felipe Benito Archuleta (b. 1910)
Tesuque, New Mexico; 1970
Cottonwood, paint, gesso;
$30\frac{3}{4} \times 16\frac{3}{4} \times 35$ in. deep
Gift of Elizabeth Wecter. 1985.20.13

Felipe Archuleta has been making
animals since 1964 when he prayed to
God for guidance and received the
inspiration to carve. Although these
animals are secular in nature, they
continue the tradition of woodcarving
started in the sixteenth century with
the arrival of the Spanish in New
Mexico.

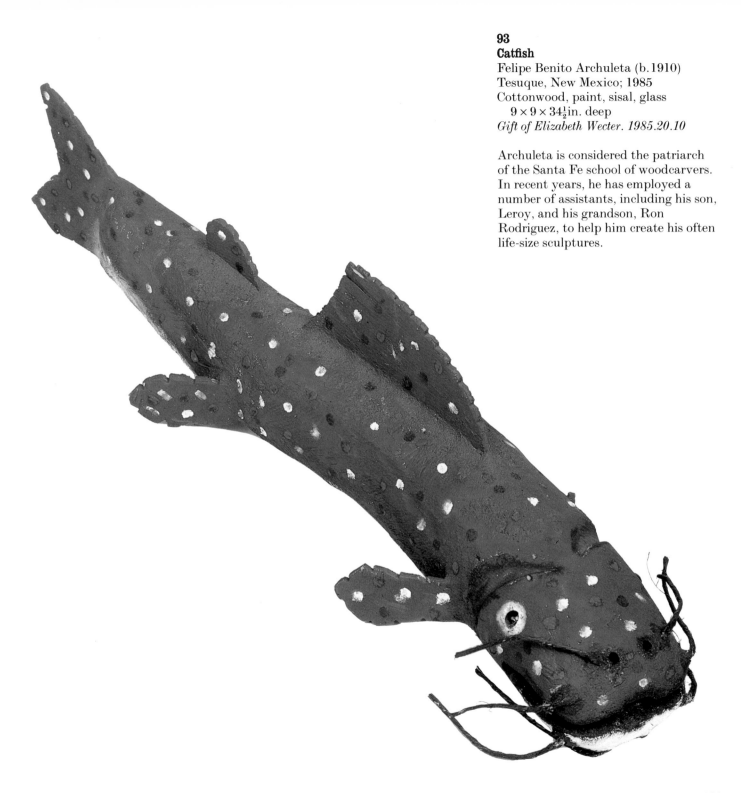

93
Catfish
Felipe Benito Archuleta (b. 1910)
Tesuque, New Mexico; 1985
Cottonwood, paint, sisal, glass
$9 \times 9 \times 34\frac{1}{2}$ in. deep
Gift of Elizabeth Wecter. 1985.20.10

Archuleta is considered the patriarch
of the Santa Fe school of woodcarvers.
In recent years, he has employed a
number of assistants, including his son,
Leroy, and his grandson, Ron
Rodriguez, to help him create his often
life-size sculptures.

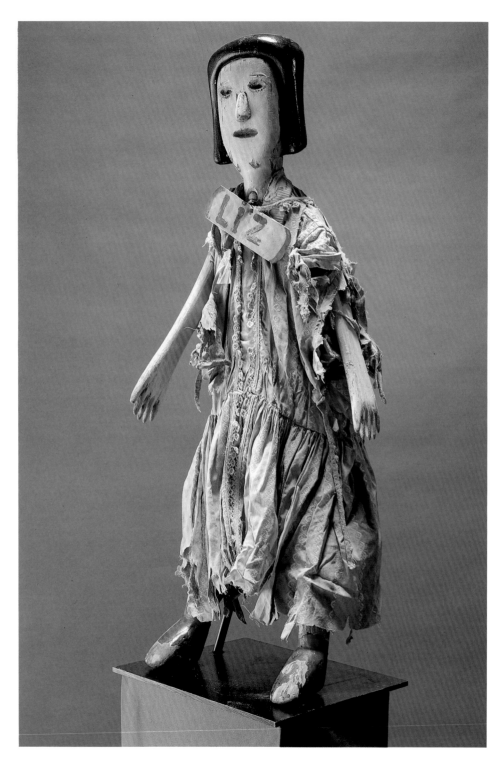

94 & 95
Possum Trot Figures: "Liz" and
 "Blond Girl"
Calvin Black (1903–1972) and Ruby
 Black (1915–1980)
Yermo, California; c.1955
Carved and painted redwood;
 "Liz": 33 × 10 × 7 in. deep;
 "Blond Girl": 34 × 11½ × 6 in deep
Gift of Elizabeth Ross Johnson.
 1985.35.8 and 1985.35.4

In 1953, Cal and Ruby Black moved to
the Mojave Desert in California where
they opened a rock shop. Soon
afterward, they began to create
"Possum Trot," a miniature
amusement park that they hoped
would attract customers to their
business. The premier entertainment
at Possum Trot was the Bird Cage
Theater and its "fantasy doll show,"
starring approximately seventy figures
carved, painted, named, and operated
by Cal and dressed by Ruby.

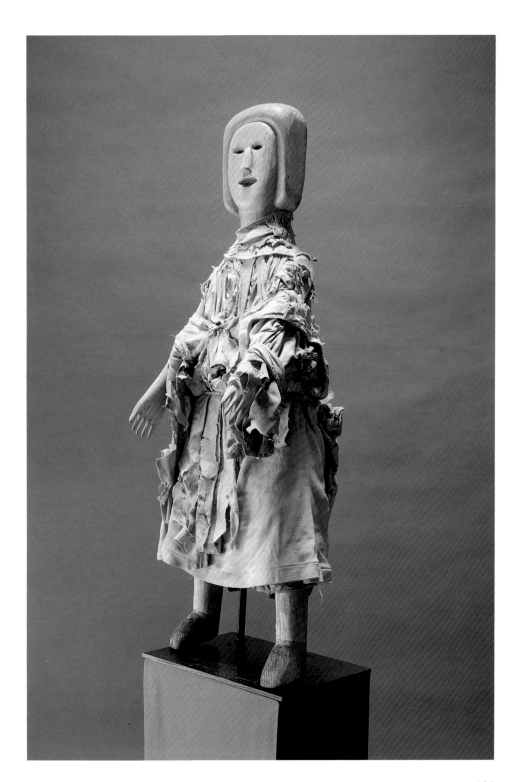

96
Spool Stand
Unidentified Shaker
American; 1920–1950
Maple, stuffed cotton, metal,
 candlewax; $5\frac{7}{8} \times 5\frac{5}{8}$in. diam.
Gift of Robert Bishop. 1985.37.8

Spool stands such as this were
manufactured at several northeastern
Shaker communities. Although
occasionally used within the
community, their chief function was as
an item for sale in Shaker shops. Spool
stands often included emery, beeswax,
and a needlebook tied with ribbons.

97
Braided and Knit Rug
Unidentified Shaker
New York State;
 late nineteenth century
Cotton and wool; 44in. diam.
Gift of Robert Bishop. 1984.36.1

The Shakers produced rugs both
for their own use and for sale to the
outside world. Besides braided and
knit rugs, the Shakers also made
crocheted and shag examples,
sometimes combining more than
one technique in a single piece.
The creation of these rugs provided
their makers with an opportunity
to use small scraps of fabric.

98
Tripod Base Round Stand
Unidentified Shaker
Probably Mount Lebanon, New York;
 1850–1875
Cherry; $26 \times 20 \times 19\frac{3}{4}$ in. deep
Promised gift of Robert Bishop.
 P78.604.2

The design of the Shaker round stand
is based on Federal tables made at the
beginning of the nineteenth century.
Shaker designs tended to be
conservative and changed little
throughout most of the nineteenth
century.

99
Rocking Chair
Unidentified Shaker
Mount Lebanon, New York;
 1850–1875
Maple, woven tape seat;
 $45 \times 24\frac{7}{8} \times 25\frac{3}{4}$ in deep
Promised gift of Robert Bishop.
 P78.601.2

Although the Shakers did not invent
the rocking chair, they are credited
with developing its design and
promoting its use. At first, Shaker
rockers were made for the aged and
infirm. But the comfort of the chairs
had widespread appeal and since there
were no prohibitions in their religion
regarding comfort, the rockers were
soon made for general use in the
dormitories.

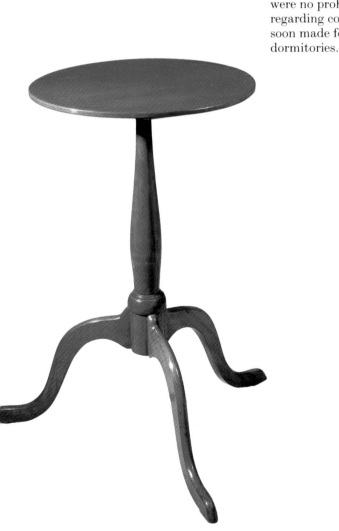

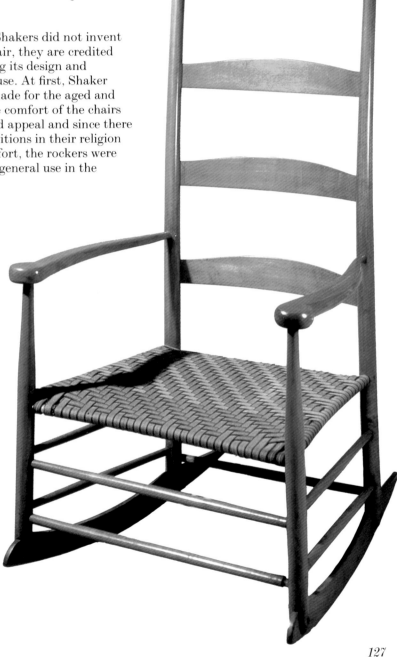

TEXTILES AND NEEDLEWORK

Textiles and needlework commonly considered in the folk tradition include quilts, coverlets, and other handmade bedcovers; samplers and needlework pictures; hooked and braided rag rugs; as well as a variety of miscellaneous handcrafts that were used to cover tables, windows, floors, and, sometimes, the human form.

Bedcovers are the largest category of American textiles, and by the end of the eighteenth century included bed rugs, linsey-woolsey coverlets, printed whole-cloth spreads, hand-embroidered or loomed candlewick spreads, woven coverlets, and, most familiar today, the three basic types of quilts: the whole-cloth quilt, the pieced quilt, and the appliqué quilt.

The bed rug, a handsome wool textile once mistaken for a floor covering, was made in the New World during the eighteenth and early nineteenth centuries. Home-woven woolen cloth or linen served as the base fabric on which bold designs (such as the Tree of Life), often borrowed from imported Indian palampores, were worked in wool with a wood or bone needle. The majority of bed rugs were made with a running stitch and the surface was sometimes sheared. The bed rug, found in New England, is one of the rarest types of American bedcovers.

Linsey-woolsey is a coarse, loosely woven fabric generally made with a linen or cotton warp and a wool weft. The name linsey-woolsey is derived from Middle English "lynsy wolsye," referring to "Lindsay," a village in Suffolk, England, where the fabric originated. Bedcoverings made of this rough fabric are almost always quilted, and they represent perhaps the earliest form of quilting in the American colonies.

Because of the warmth they provided, linsey-woolsey spreads were most popular in the North. The flax used to make the linen was a local product, for nearly as soon as the first colonists cleared their land, flax seeds were sown. The process of turning flax into linen was long and complex, involving many steps. It is understandable, therefore, why textiles were so treasured and valuable in the American colonies.

During the late seventeenth and the eighteenth centuries, the American desire for imported East Indian printed cotton fabrics reflected the influence of English taste. Ships of English and Dutch trading companies returned from the East to English seaports, laden with block-printed cottons in vibrant colors. Many of these fabrics reached the American colonies, where textile manufacture had been discouraged— and for some time actually forbidden—by the mother country. These imported fabrics and, by the end of the eighteenth century, American-made printed cottons, were used for making bed hangings, curtains and valances, and whole-cloth

spreads. Soon after the opening of the nineteenth century, mass-produced roller-printed or "factory goods" made in American mills greatly reduced the cost of printed fabrics and increased the number of patterns available to the middle-class homemaker.

Other types of American bedcovers have enjoyed great popularity through the centuries as well. Candlewick bedspreads were made in two ways. The first was hand-embroidered. The second was woven on a loom. The hand-embroidered spreads usually had a linen or sometimes cotton background that was embellished with elaborate floral or stylized designs executed with candlewicking—a coarse cotton thread or roving, very like that used for the wicks of candles. They demonstrate a freedom of design that was unachievable by the weaver who executed the loomed examples that became popular in America about 1820. The weaver picked up predetermined loops of candlewicking from the flat weaving on the loom with a "reed" that secured the loops while he treadled the warp encircling the wicking. For variation the weaver might use reeds of varying diameters allowing him to create a visual contrast between a deep pile and low pile design. Presumably, most of the woven candlewick bedspreads were made by professional weavers. This is also true of many of the loomed woolen coverlets.

There are five main types of American coverlets: the geometric patterned plain weave, the overshot, the double-weave, the "summer and winter," and the fancier Jacquard. The earliest coverlets were probably brought from Europe as household goods. When they wore out, they were replaced by pieces of domestic production. Two– and four-harness looms were made of hand-hewn logs and used in homes in the late eighteenth and early nineteenth centuries, but patterns requiring more than four shafts were largely the domain of the professional weaver. It was once believed that the professional weaver traveled from town to town, bringing his loom with him. However, it has now been determined that the looms were too bulky to be broken down and re-assembled frequently. It is more likely that the weaver, if he did travel, did so to collect the housewives' spun wool, which he then carried back to his shop. The housewife selected patterns from a weaver's pattern book, so that the finished effort was a collaborative product between a professional weaver and his client. In some other instances, a weaver might use a loom that was kept assembled in the community he visited.

The Jacquard attachment, with its series of punched cards, dramatically altered the production of coverlets after its introduction to America in the

mid-1820s. This device allowed the professional weaver to create non-geometric patterns quickly and easily, without an assistant, and made coverlets available to a much greater population. The cost involved in creating such a bedcover, however, still kept them in the realm of luxury items for most households.

The stenciled bedspread was another popular type of bedcover. During the first half of the nineteenth century, a taste developed for painted and stenciled furniture, walls, floors, and bedspreads. Nearly all surviving examples of stenciled cotton bedspreads were made without a backing or lining. It seems almost certain that stenciled spreads were created by women at home and were never produced in large quantities. The flower-and-fruit, still life designs used by young ladies for "theorem" paintings stenciled on velvet or paper were also popular with the bedcover stenciler. The motifs on these bedspreads were usually made up of several small stencils, each contributing part of the overall design.

The great number of American women who made quilted bedcovers by piecing together remnants from worn-out clothing, upholstery fabrics, and window hangings, stitched a priceless legacy of beauty for posterity. Quilted bedcovers are generally divided into three main groups: whole-cloth quilts, usually sewn so the top formed a continuous pattern; pieced quilts; and appliqué quilts. Both pieced and appliqué quilts are frequently referred to as patchwork.

The appliqué technique involves sewing a piece cut from one fabric onto a ground fabric, such as an individual block, or directly onto the full-sized background fabric. After all of the appliqués have been secured to the background, or the appliquéd blocks have been stitched together, the blank areas or "white spaces" left between the designs are usually quilted in decorative patterns. In some instances parts of the quilting patterns are stuffed with cotton to give a third dimension to the quilt top.

Motifs cut from the exotically designed and expensive palampores and chintz fabrics imported from India and England provided appliqués that were stitched to domestically produced solid color ground fabrics. Quilts using these motifs are said to have been fashioned in the *broderie Perse* (Persian embroidery) style.

Pieced quilts were often considered utilitarian and represented the everyday bedcover. However, piecework produced the often stunning, even astonishing, geometric designs so popular today. The technique of piecework made it possible to achieve an almost endless variety of patterns.

The quilts were fashioned by sewing small bits of fabric together to form

an overall patterned top. The designs were often contained within a series of blocks or patches that could be more easily worked; the blocks were later joined to form the quilt top.

After a quilt top was completed, it was combined with an inner lining of cotton or wool and a backing and mounted on a quilting frame. The frame held the three layers securely and prevented them from shifting during the quilting. This was especially important, for if the material was not held firmly, the lining would puff up between the lines of stitching after washing. There were a number of types of quilting frames: the most basic was made of strips of pegged lumber placed over the back of chairs; one stood on legs; and one was suspended from the ceiling by pulleys which allowed it to be raised and lowered.

Nearly all quilt tops were "marked" before they were quilted. Sometimes an especially skilled draftsperson would attempt this difficult task freehand. More often, wooden or metal quilting blocks or templates made from paper or tin provided the outline that was transferred to the fabric with water soluble ink or dye. At other times, the design was pricked into the fabric with a sharp object. When this technique was used the holes were covered by the quilting stitches.

Fine, intricate quilting stitches were always considered one of the most important elements of a quilt. American women preferred the running stitch to the backstitch; it required less thread and was, therefore, more economical.

Some women chose to do their own quilting. Many, however, took their handiwork to communal bees, which became social events. Even the unskilled needlewoman was invited, for her cooking talents might be used to prepare an end-of-the-day feast for the quilters. Frances Trollope, who emigrated to America with her husband in 1827 and returned to England three years later when their business failed, commented on the "Domestic Manners of the Americans" in 1832 and mentioned such events in her writing:

The ladies of the Union are great workers, and among other enterprises of ingenious industry, they frequently fabricate patchwork quilts. When the external composition of one of these is completed, it is usual to call together their neighbors and friends to witness, and assist at the quilting, which is the completion of this elaborate work. These assemblings are called "quilting frolics," and they are always solemnised with much good cheer and festivity.[1]

1. Frances Trollope, *Domestic Manners of the Americans* (New York, 1949 edition), edited by Donald Smalley, p.414.

More personal accounts, found in diaries and journals, sometimes show that sharp needles were plied by ladies with sharp tongues:

Our minister was married a year ago, and we have been piecing him a bed quilt; and last week we quilted it. I always make a point of going to quiltings, for you can't be backbited to your face, that's a mortal sertenty ... quiltin' just set wimmem to slandern' as easy and beautiful as everything you ever see. So I went.[2]

As daily life became easier and many necessities could be purchased from a store instead of produced by hand at home, leisure time increased for the American woman. No longer was it necessary for her quilts to be purely utilitarian. She could now concern herself more with the decorative aspects of her handiwork. Several years were sometimes spent on a single quilt.

The decorative aspects of bedcovers reached their zenith with the crazy quilts, popular during the last part of the nineteenth and beginning of the twentieth centuries. Called "crazy" because of their randomly shaped pieces which are believed to resemble "crazed" porcelain, it is hypothesized that the fad for these textiles was inspired by an American interest in Japanese goods that began at the Philadelphia Centennial Exposition in 1876. Often, "crazies" are not really quilts at all, as they are technically not quilted—the tops and backings are frequently joined by knots. The small size of many "crazies" also indicates that they probably were not used on beds, but more often ended up as parlor throws or lap robes. They are usually elaborately decorated with a combination of silk, velvet, and other fabrics mixed with embroidery (sometimes in metallic thread), patches of fabric in the shapes of butterflies, flowers, birds, or other animals, and bits and pieces of material saved from a special garment.

Variations of the quilting tradition were also developed by some ethnic and social groups. For example, the pieced bedcovers made by the Amish and Mennonites in Pennsylvania and in the Midwest are distinctively designed and have their own palettes and quilting motifs. The "Plain People" living in agrarian communities in Pennsylvania tended to produce quilts which were conservative in design in that they adhered to simple geometric patterns executed primarily in solid-colored wool. In the Midwest, Amish needleworkers still quilted geometric patterns, but the range and complexity of designs was much greater since the quilters tended to be more influenced by their non-Amish neighbors. Amish quilts from the Midwest were also made of solid-colored fabric, but cotton was the preferred material.

2. "The Quilting at Miss Jones's," *Godey's Lady's Book*, January, 1868.

A great deal of folklore and tradition is related to the making of quilts. Some people believed that to stitch a perfect quilt top would be an affront to God and intentionally worked a "mistake" into the quilt. The names of many quilt patterns reflect regional folklore. Others indicate the religious bent of the quilter: Often the Bible served as a source for names of quilt patterns. Whatever the inspiration for the naming of a pattern, it was meaningful to the maker because even the simplest quilt represented a considerable investment of time and energy. Once a name was firmly established, it was handed down from one generation to the next. As people moved about the ever-expanding country, this tradition was altered. A pattern called by one name in the East might be known by a totally different one on the western frontier. Those who have studied quilts seriously have gathered several thousand names in their efforts to categorize the multitude of patterns used by the American quiltmaker.

In many parts of the country it was the tradition for a young girl to fashion a "baker's dozen" quilts for her dowry. In some places, the girl pieced the quilts herself, and then a special bee would be held to finish either all the quilts, or just the special thirteenth "bridal" quilt. Girls were taught to sew at a very early age and they would begin to make these household furnishings while still quite young. One woman reminisced:

> Before I was three years old, I was started at piecing a quilt. Patchwork, you know. My stint was at first only two blocks a day, but these were sewn together with the greatest care or they were unraveled and done over. Two blocks was called "a single," but when I got a little bigger I had to make two pairs of singles and sew the four blocks together, and I was pretty proud when I had finished them.[3]

For those who could afford to send their daughters to a "Dame" school or a ladies' seminary, girls were also taught at a young age to make a sampler. The execution of a sampler served several purposes in the education of a young woman. It taught her the letters of the alphabet and the numerical system, as well as the stitches she would need to mark her household linens, or sew the clothes for herself and her family.

The earliest American samplers were long and narrow, similar to English pieces of the same period. Most of these had no names or dates stitched onto them. In the eighteenth century, a more American style appeared and names, dates, the name of the school where the piece was stitched, and such pictorial devices as buildings, animals, people, and floral arrangements became common. In the eighteenth and nineteenth centuries, these

3. Marion Nicholl Rawson, *When Antiques Were Young* (New York, 1931), p.129.

beautiful pieces of needlework were symbols of a young woman's accomplishments and were intended to be viewed as pictorial art and framed and prominently displayed in the home.

During the second half of the eighteenth century and continuing into the nineteenth century, "fancy" needlework became popular among the young ladies at school. Young women were given special instruction and developed "accomplishments" which included the skills needed to stitch elaborate silk-on-silk pictorial embroideries, chair seats, and intricate crewel work for bed hangings and curtains. The needlework pictures especially were related to current trends in popular taste, including Classicism and Romanticism, and often depicted scenes from the Bible or literary or classical subjects.

Mourning pictures, memorials to the dearly departed, were also stitched, and later painted, by girls at school. Once believed to be an indication of a girl's morbid fascination with death and dying, these pictures are now accepted as evidence of the fashionableness of sentimentality in the early nineteenth century. Many of the memorials are dedicated to the memory of George Washington and many were stitched in honor of departed relatives the girls never even knew. Frequently they were made long after the death.

Usually, the designs stitched on mourning pictures, samplers, and other embroideries were not the original inventions of the students, but were drawn by the instructor. Accordingly, the scenes tend to be stylized, rather than true to life or based on any particular event. Today, in fact, samplers and other needlework pictures can often be attributed to specific schools and teachers, based on their designs.

Throughout the late seventeenth and early eighteenth centuries, rugs, considered too valuable to use on the floor, were reserved for tabletops. When, by the middle of the eighteenth century, they found their way to the floor, it was only in the homes of the very wealthy. While many nineteenth-century families living in cities and towns could and did afford imported floor coverings, the preponderance of first, handcrafted yarn-sewn, and later, rag hooked rugs in rural households by mid-century is well documented. The hooked rug was executed on a loose burlap backing with a pattern drawn or stenciled on it. Cut-up rags and remnants of unused fabric provided the materials for creating the design. Hooked rugs were created in great variety—some were pictorial, others purely abstract. Many were executed in a manner that recalled imported, expensive Oriental carpets. By the 1860s, pieces of burlap with pre-stenciled patterns were available to aid the rug hooker in creating her rug.

Another popular floor covering was the braided rag rug, which was also made from bits of salvaged material. Braided rugs are known from the beginning of the nineteenth century and are among the simplest handmade rugs to create. Among the most important remaining today are those that were made by the Shakers, which are distinctive for their use of colors and fine craftsmanship. The Shakers often combined techniques, creating rugs that might be knitted and braided in a single piece. They made rugs of this type for use within the community and also sold them to visitors in shops which dealt with the outside world.

In recent years, textiles made by Native Americans have begun to be studied and collected by folk art historians, as they have by folklorists and anthropologists in the past. Blankets of the Northwest Coast, beadwork and quillwork of the Plains tribes and Navajo and Pueblo weavings of the Southwest are among the subjects of interest in the folk art world today.

Navajo weavings have attracted the most attention both because of their great numbers (the Navajo weaving tradition dates from the seventeenth century to the present day) and because of an aesthetic that is not unlike quilts. Also, weaving and the steps involved in preparing the wool, from raising the sheep to spinning the yarn, were the jobs of the Navajo women, as was the making of quilts among Anglo women.

The designs of Navajo blankets are linked to events in the history of the people. Until the middle of the nineteenth century, the blankets were decorated only with geometric patterns, many derived from the Mexican *saltillo*. After the Navajo were confined to life on a reservation, pictorial images began to appear in their weaving, although geometric designs still predominated. Originally, Navajo weavings were meant as wearing blankets, but traders and other outside influences convinced the Navajo that there was a market for rugs and a wide variety of designs, including some that imitated Oriental rugs, began to be seen in their work.

Folk textiles are by no means solely subjects for historical research. Quilt making is enjoying a renaissance not only in this country, but throughout the world. Especially important in the field of American folk art are the quilts made by contemporary African-American women that combine traditional quilting techniques, such as piecing and appliqué, with African textile motifs and sewing patterns, or that recall the African-American experience in America. Also important are the textiles made by the Hmong, the Southeast Asian immigrants who often use their expert sewing skills and native needlework tradition of "pa ndau" to make quilts, wallhangings, clothing, and other items.

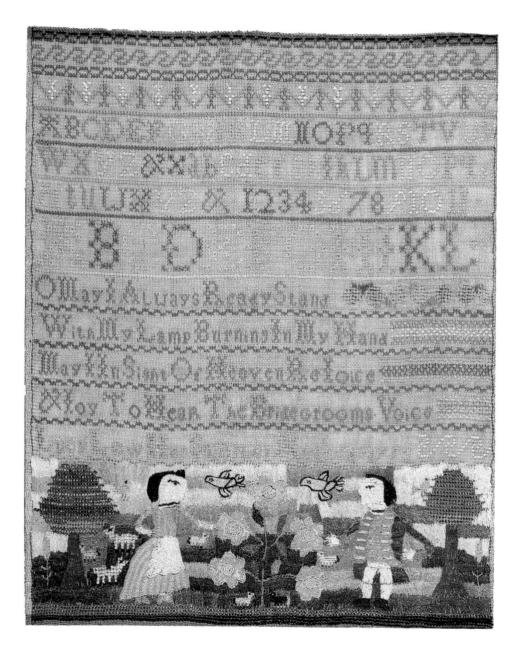

100
Sampler
Lucy Low (1764–1842)
Danvers, Massachusetts; 1776
Silk on linen; $14\frac{1}{2} \times 11\frac{3}{8}$ in.
Promised anonymous gift

Pictorial samplers were often worked in seminaries by girls from well-to-do families. The needlework skills acquired by the girls were considered necessary accomplishments and the finished pieces proudly displayed in their homes. Because they often contain the names of their young makers and the year they were worked, samplers provide fertile ground for genealogical research. Lucy Low was born May 1, 1764 in Danvers, Massachusetts to Caleb Low (1739–1810) and Sarah Shilleber (1739–1815). In 1781, she married John Frost (1758–1829), also of Danvers, and they had seven children. Lucy Low died on July 22, 1842.

101
Lady with a Fan
Hannah Carter
Boston, Massachusetts; c.1750
Crewel yarn on fine canvas; $17\frac{3}{4} \times 16$ in.
Promised anonymous gift

The so-called "Boston Fishing Lady" embroideries were worked by young women in their late teens and early twenties who lived in New England in the eighteenth century. To date, approximately sixty of these needlework pictures are known, although only about twelve contain the "fishing lady" motif. Others, like this tent-stitch embroidery by Hannah Carter, display pastoral scenes. The pictures are believed to have been derived from domestic patterns drawn after English models by Mrs. Susannah Condy, a Boston embroidery teacher.

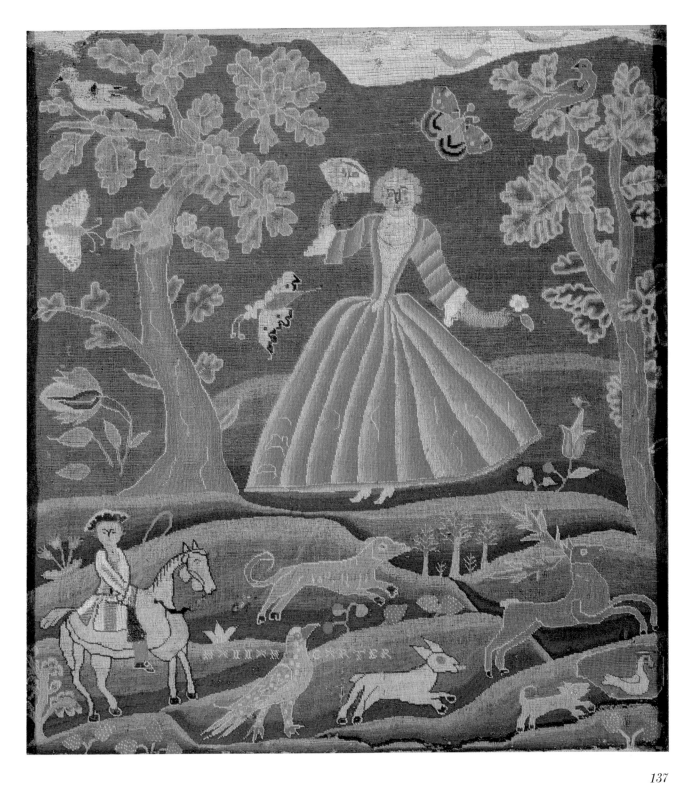

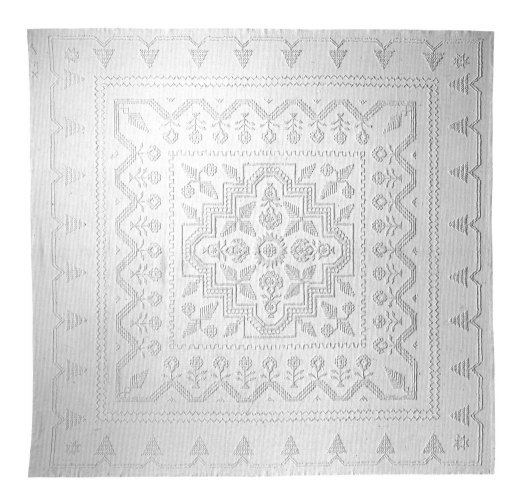

102
Candlewick Spread
Artist unknown; initialed "AFX"
New York State; c.1832
Woven cotton; 85 × 79¾in.
Promised gift of Jay Johnson. P3.1980.1

This woven candlewick spread was
crafted of thick cording or "roving"
similar to the wicks used in making
candles. Woven candlewick spreads
made at home or by professional
weavers were popular during the
second quarter of the nineteenth
century.

103
"Hemfield Railroad" Coverlet
Artist unknown
West Virginia or Pennsylvania; c.1855
Wool and cotton; 90¼ × 81in.
Gift of Stephen L. Snow. 1980.13.1

This double-weave "Snowflake
Medallion" Jacquard coverlet
commemorates the opening of the
Hemfield Railroad. A train pattern has
been woven into the border and the
profile in the corners is believed to be a
portrait of the first president of the
railroad, T. McKennan. Weavers who
are known to have made this pattern
are Daniel Campbell, William Harper,
Martin Burns, George Coulter, and
Harvey Cook. The commemorative
"Hemfield Railroad" coverlets are
thought to refer to a small, partially
completed railroad in southwestern
Pennsylvania.

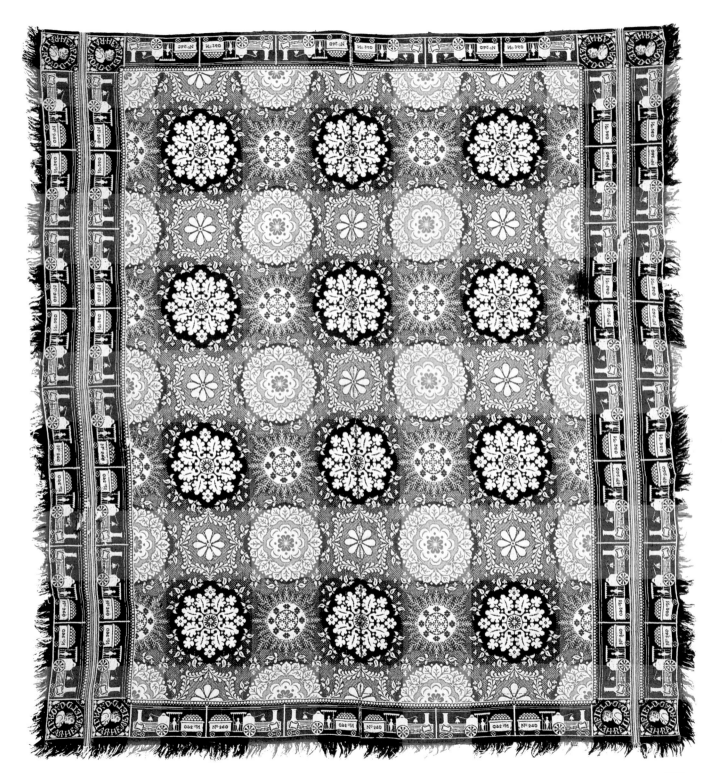

139

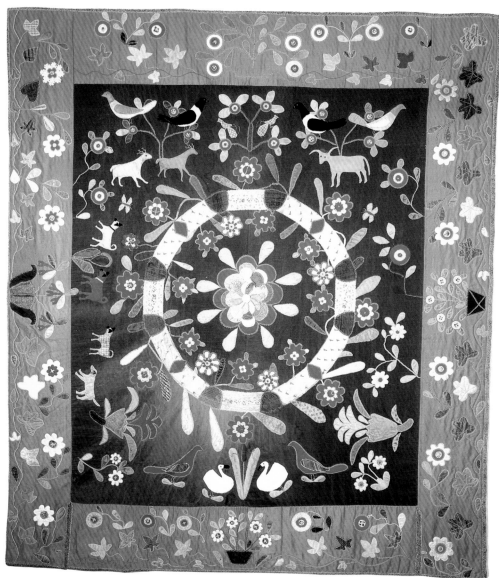

104
Appliquéd and Embroidered Pictorial Bedcover
Artist unknown
Possibly New York; c.1860
Wool, silk, cotton; 87 × 76in.
Promised anonymous gift

Embroidery on wool became popular in America about 1850 and remained so throughout the Victorian period. While not quilted, this bedcover combines the appliqué technique commonly found on quilts and summer spreads and embroidery stitches often seen on crazy quilts of the late nineteenth century.

105
Bed Rug
Artist unknown
Connecticut; c.1800
Wool; 96 × 100in.
Promised anonymous gift

Bed rugs were made by embroidering multiple strands of yarn in a looped running stitch onto a ground fabric. The resulting deep-pile textile was extremely warm. All known bed rugs are from New England, most from the Connecticut River Valley.

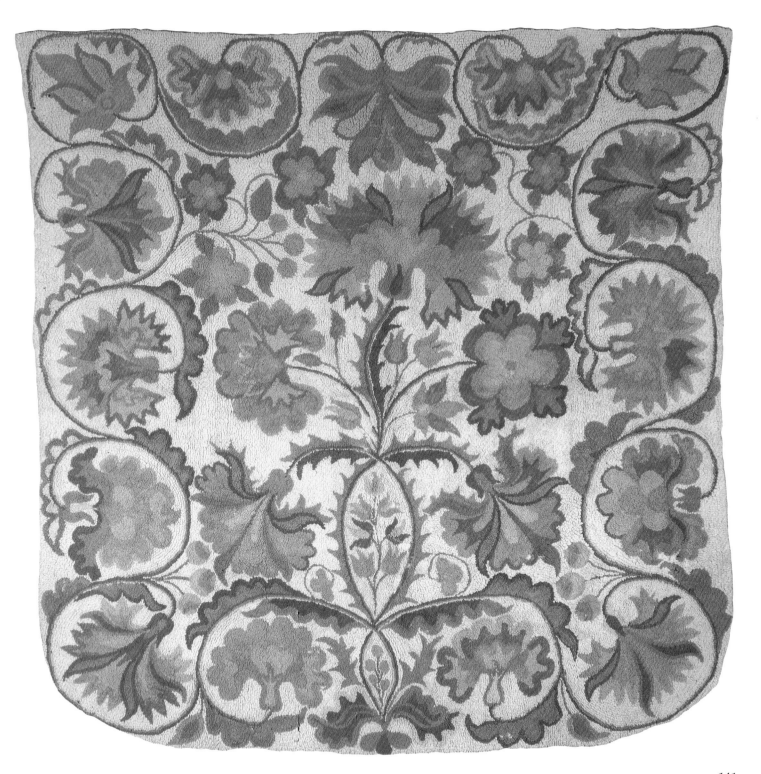

141

106
Glazed Linsey-Woolsey Quilt
Artist unknown
New England; 1815–1825
Glazed linsey-woolsey; 100 × 99 in.
Gift of Cyril I. Nelson in honor of Robert
* Bishop, Director of the Museum of*
* American Folk Art. 1986.13.1*

The glazed or glossy effect seen on this
quilt was probably achieved by coating
the fabric with an egg white and water
mixture which was then polished with
gum arabic or another resinous
substance. Glazing could also be
achieved by rubbing the fabric with a
soft stone until it began to shine.

107
Sunburst Quilt
Possibly Rebecca Scattergood Savery
(1770–1855)
Philadelphia, Pennsylvania;
 1835–1845
Roller printed cottons; 113½ × 110 in.
Gift of Marie D. and Charles A. T.
* O'Neill. 1979.26.2*

This quilt is very similar to two other
"sunbursts" believed to have been
made by Rebecca Scattergood Savery
or close relations, and is also closely
allied to a number of signature quilts
made by Philadelphia-area Quakers at
the same time. The Saverys of central
Philadelphia and the Scattergoods,
who lived just across the river in
Burlington, New Jersey, were two
prominent families among the
Orthodox Quakers in the eighteenth,
nineteenth, and twentieth centuries.
All of the related quilts have strong
family provenance, and some are still
owned by survivors of the original
makers.

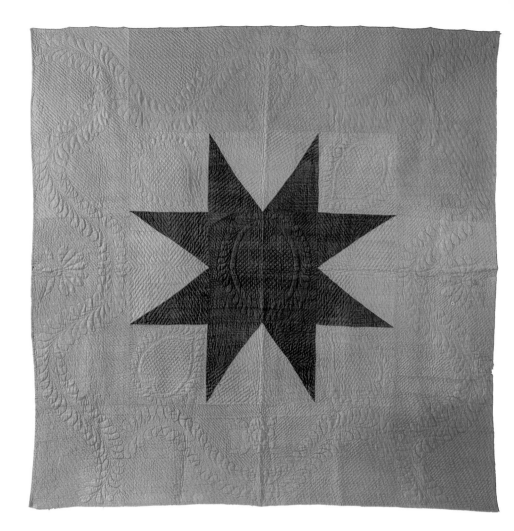

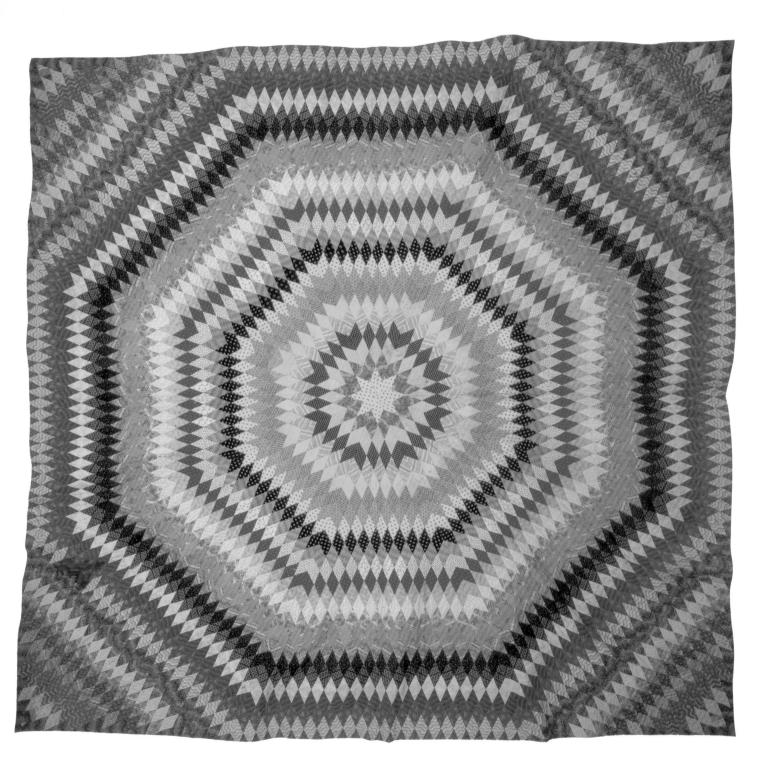

143

108
Baltimore Album Quilt Top
Attributed to Mary Evans (1829–1916)
Baltimore, Maryland; 1849–1852
Cotton, India ink; 109 × 105 in.
Gift of Mr. and Mrs. James O. Keene.
 1984.41.1

This is believed to be one of
approximately twelve quilts made
entirely by Mary Evans. Evans was a
professional quiltmaker who supported
herself by selling quilt blocks for use in
the body of Baltimore Album Quilts
produced by the ladies of the local
Methodist churches. The blocks
combine exceptional stitchery and
an unerring use of rainbow fabrics to
create a sensation of shading and
depth. This quilt top exhibits many
of the motifs by which Mary Evans is
identified: cornucopias, abundant
bouquets, wreaths with white flowers,
a hunting scene, an eagle, and an
inscribed book.

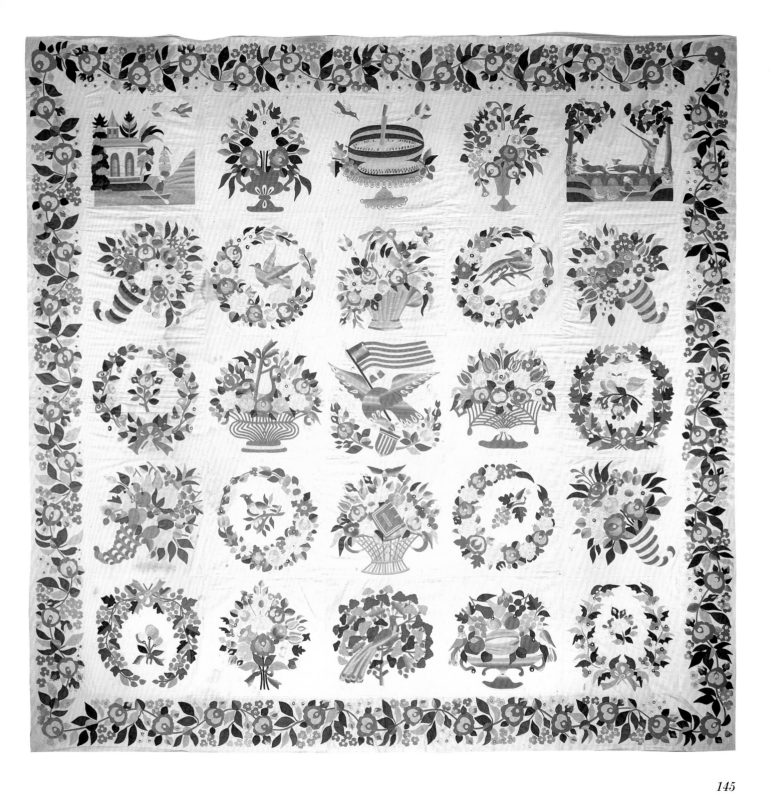

145

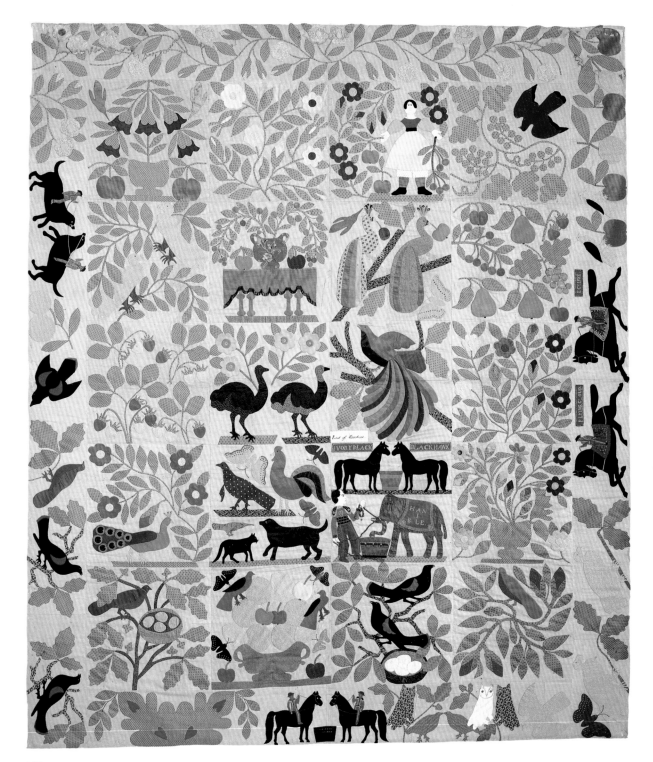

146

109
"Bird of Paradise" Quilt Top
Artist unknown
Vicinity of Albany, New York; 1858–1863
Appliquéd cotton, wool, silk and velvet
 on muslin; sight $84\frac{1}{2} \times 69\frac{5}{8}$ in.
*Gift of the Trustees of the Museum of
American Folk Art. 1979.7.1*

Besides the "Bird of Paradise," other
animals identified on this elaborate
quilt top include the horses, "*Ivory
Black*," "*Black Hawk*," "*Flying Cloud*,"
and "*Eclipse*," and "*Han i ble*" the
elephant. The facts that the top was
never quilted and that the templates
for the bedcover include the figure of a
man that does not appear on the top
suggest that this textile was originally
made in anticipation of a wedding that
did not take place. The piece is dated
primarily by a collection of templates
cut from newsprint that were stored
with the quilt top.

110
Patterns for "Bird of Paradise" Quilt Top
Artist unknown
Vicinity of Albany, New York; 1853–1863
Cut and pinned newspaper and paper;
 Bride: $10\frac{1}{8} \times 7$ in.
 Bridegroom: $10\frac{3}{4} \times 8$ in.
 Elephant: $7\frac{3}{8} \times 9\frac{3}{8}$ in.
*Gift of the Trustees of the Museum of
American Folk Art. 1979.7.2a-k*

111
Daguerreotype: Portrait of a Woman
Photographer unknown
Vicinity of Albany, New York; 1858–1863
Daguerreotype; sight $1\frac{3}{4} \times 1\frac{3}{8}$ in.
*Gift of the Trustees of the Museum of
American Folk Art. 1979.7.3*

This photograph is believed to depict
the woman who made the "Bird of
Paradise" quilt top.

112

"Baby" Crib Quilt
Artist unknown
Kansas; c.1861
Hand dyed, homespun cotton;
$36\frac{7}{8} \times 36\frac{3}{4}$ in.
Gift of Phyllis Haders. 1978.42.1

Quilts with patriotic motifs were frequently made to commemorate events such as presidential campaigns, the admission of new states to the Union, wars, and various expositions, including the Centennial, the Columbian, and the Century of

Progress. On January 29, 1861, a thirty-fourth state, Kansas, was admitted to the Union. Its star was placed on the flag on July fourth of that year. This crib-size patriotic quilt was both pieced and appliquéd.

113
"Gingham Dog" and "Calico Cat"
 Crib Quilt
Artist unknown
Probably Pennsylvania; c.1920
Cotton; $34\frac{5}{8} \times 28\frac{3}{8}$ in.
Gift of Gloria List. 1979.35.1

Pictorial appliquéd and embroidered crib quilts became popular in the first quarter of the twentieth century. Frequently, they were inspired by designs printed in magazines or available as kits, and sometimes the patterns were adapted from children's literature.

150

114
Stenciled Bedspread
Artist unknown
New England; 1825–1835
Stenciled cotton; $91\frac{3}{4} \times 86$in.
Gift of George E. Schoellkopf. 1978.12.1

Stencils for bedcovers became popular
during the first quarter of the
nineteenth century. However, such
bedcovers are rare because they were
made at home and not produced
commercially. The process used for
stenciling on fabric is similar to the art
of "theorem" painting, and involved
applying colors by hand through
openings cut in parchment, paper, or
metal stencils. As this bedcover was
made without a lining and is unquilted,
it was probably used as a summer
spread.

115
Mariner's Compass Quilt
Artist unknown
Maine; c.1885
Cotton; $88\frac{1}{2} \times 83\frac{3}{8}$in.
Gift of Cyril Irwin Nelson in memory of
his grandparents, Guerdon Stearns and
Elinor Irwin Holden, and in honor of
his parents, Cyril Arthur and Elise
Macy Nelson. 1982.22.1

Tiny white anchors printed on the blue
fabric emphasize the nautical design of
this quilt. The corner patches are
initialed "B.B."

116
Summer Spread with Appliquéd Farm Scene

Sarah Ann Gargis
Feasterville or Doylestown,
 Pennsylvania; 1853
Cotton front, muslin back; 96 × 98 in.
Gift of Warner Communications Inc.
 1988.21.1

This pieced and appliquéd summer
spread descended in the family of its
maker, Sarah Ann Gargis. According
to family tradition, the date, 1853,
stitched onto the bedcover along with
the maker's initials, is the date of
Sarah Ann's engagement. The scenes
depicted are the views of daily life on
the farm: plowing, hunting, cutting
down a tree, as well as the farmhouse
and barn, the pasture, the beehive,
the farm implements, and many of the
animals, both domestic and wild, that
would have populated the farmstead.

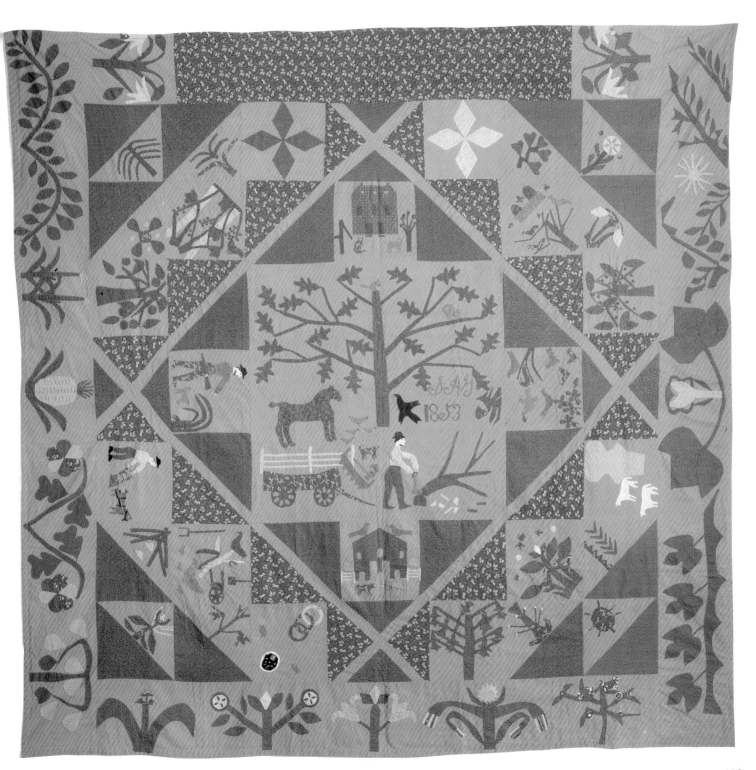

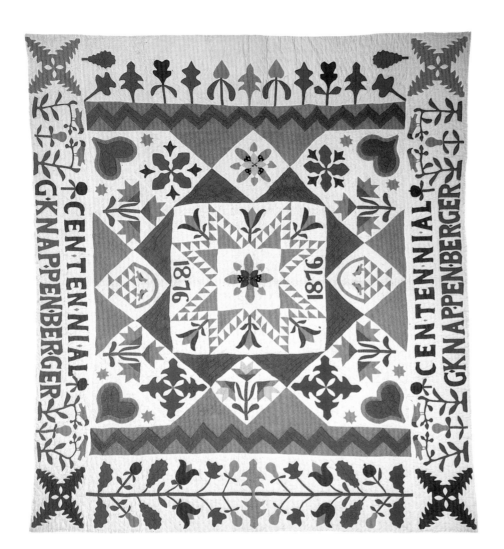

117

"Centennial" Quilt

G. Knappenberger
Probably Pennsylvania; 1876
Cotton; $71\frac{1}{2} \times 83\frac{1}{2}$ in.
Gift of Rhea Goodman. 1979.9.1

This pieced and appliquéd quilt was
made to commemorate America's
Centennial celebration. The colors and
fabrics used in the quilt, and the
hearts, flowers, and birds motifs all
suggest a Pennsylvania origin.

118

Center Diamond Quilt

Artist unknown
Lancaster County, Pennsylvania;
 c.1910
Wool; $84 \times 80\frac{1}{2}$ in.
Gift of Paige Rense. 1981.4.1

Amish quilts from Lancaster County
are traditionally made in wool. From
the middle of the nineteenth century
through the early twentieth century,
a few large scale, geometric patterns
were most often used by Amish
quiltmakers in this region. These
include "Center Diamond" (or
"Diamond in the Square"), "Center
Square," "Bars," and "Sunshine and
Shadow."

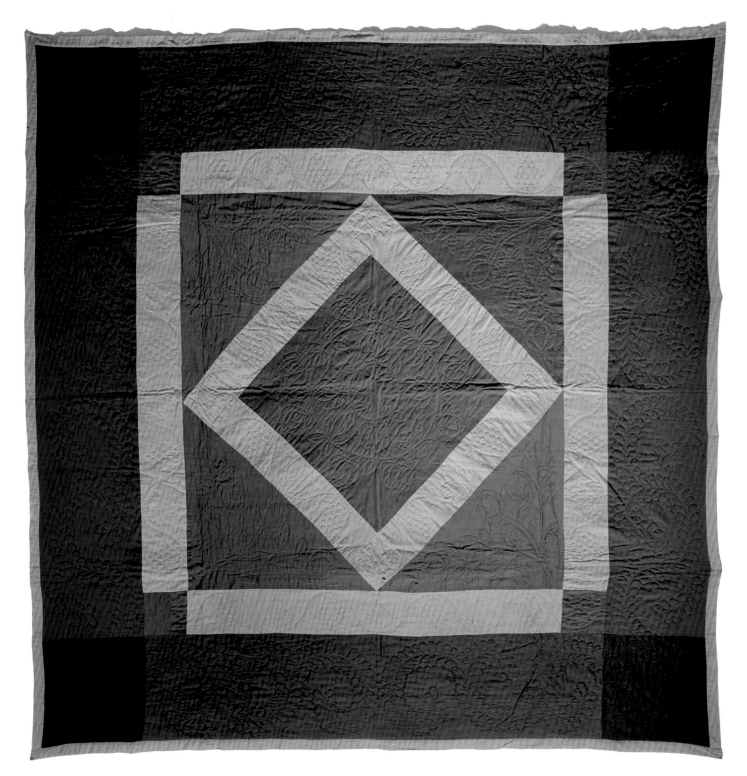

155

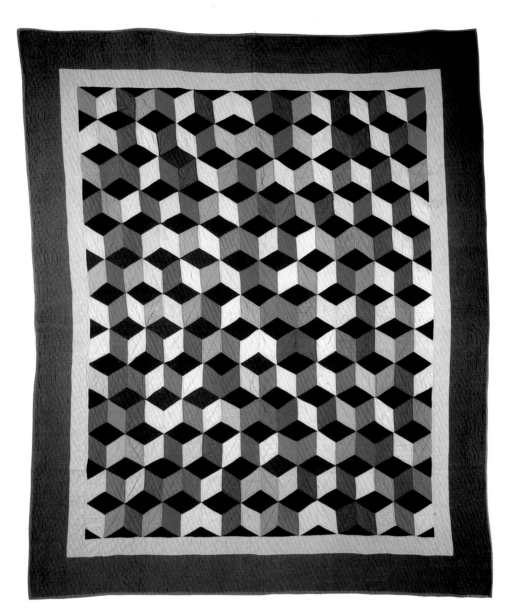

119
Tumbling Blocks Quilt
Mrs. Ed Lantz
Elkhart, Indiana; c.1910
Cotton, wool backing; $81\frac{3}{8} \times 67$ in.
Gift of David Pottinger. 1980.37.62

"Tumbling Blocks" is an example of a pattern that an Amish woman would have adapted from the outside world. The use of only solid colored fabrics in the making of this quilt is a distinctly Amish trait.

120
Lone Star Quilt
Mrs. David Bontraeger
Emma, Indiana; c.1923
Cotton; 84×74 in.
Gift of David Pottinger. 1980.37.50

Amish quilts from the Midwest, including communities in Ohio, Indiana, and Iowa, were usually made of cotton. Most Amish quilts were pieced with a treadle-powered sewing machine (which did not require electricity) and then quilted by hand. This quilt has been initialed "DB" for its original owner, David Bontraeger.

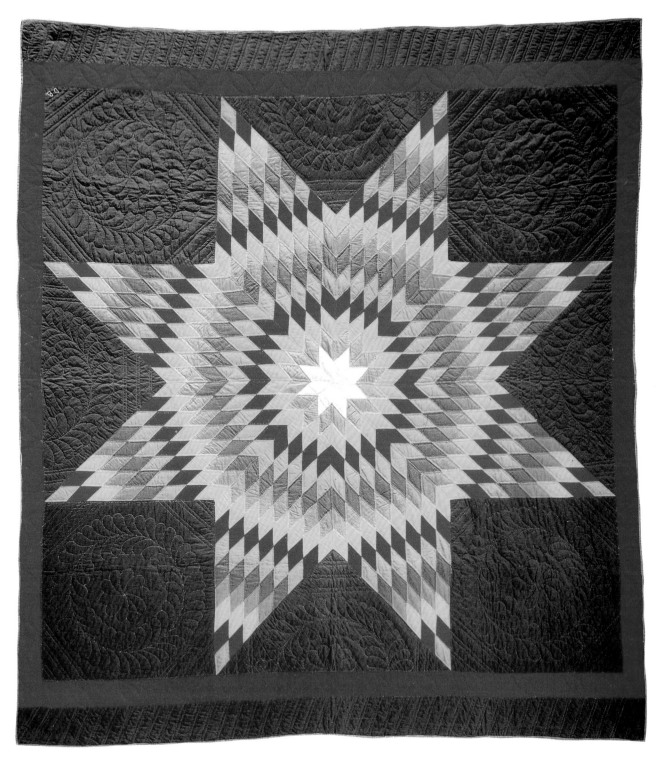

157

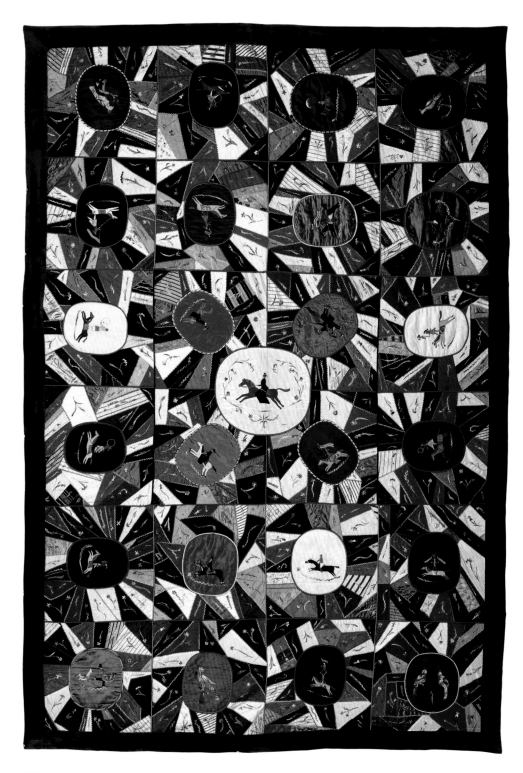

121
Crazy Quilt with Embroidered Equestrian Figures

Artist unknown
New York State; 1884–1900
Silk, velvet, taffeta, silk and grosgrain
 ribbon, polished cotton backing;
 88 × 57 in.
*Gift of Mr. and Mrs. James D.
Clokey III. 1986.12.1*

Unlike the truly "crazy" random patch
quilts, this bedcover and the pillow
shams that match it have a contained
design, with the crazy patches
organized around central medallions.
The figures, some of them stuffed,
depict horseback riders, birds, and
clowns. Fabric scraps used in making
crazy quilts were often obtained
through mail-order firms that
advertised in ladies' magazines.

122
Crazy Patchwork Pillow Shams
Artist unknown
New York State; 1884–1900
Silk, velvet, taffeta, silk and grosgrain
 ribbon; 27 × 27 in. each
Promised gift of Mr. and Mrs. James D.
 Clokey III. P1. 1988.1 a and b

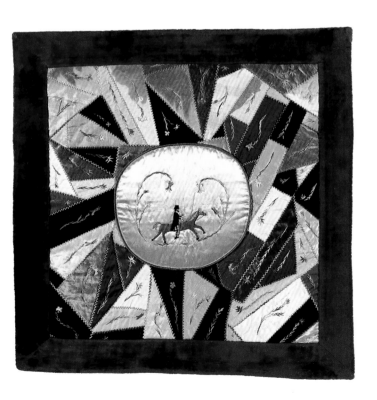

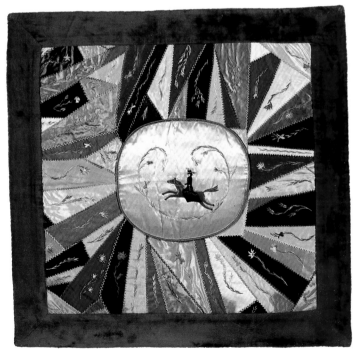

123
Commemorative Patriotic Quilt

Mary C. Baxter
Kearney, New Jersey; c.1898
Cotton; 76 × 78in.
Gift of the Amicus Foundation, Inc.,
 Anne Baxter Klee, and Museum
 Trustees. 1985.15.1

This quilt is an excellent and
graphically successful example of
the patriotic and flag quilt genres.
These quilts were often made upon the
admittance of a state into the Union,
or during times of national emergency.
According to oral tradition, the
Spanish-American War (February–
August, 1898) was the inspiration for
the making of this quilt.

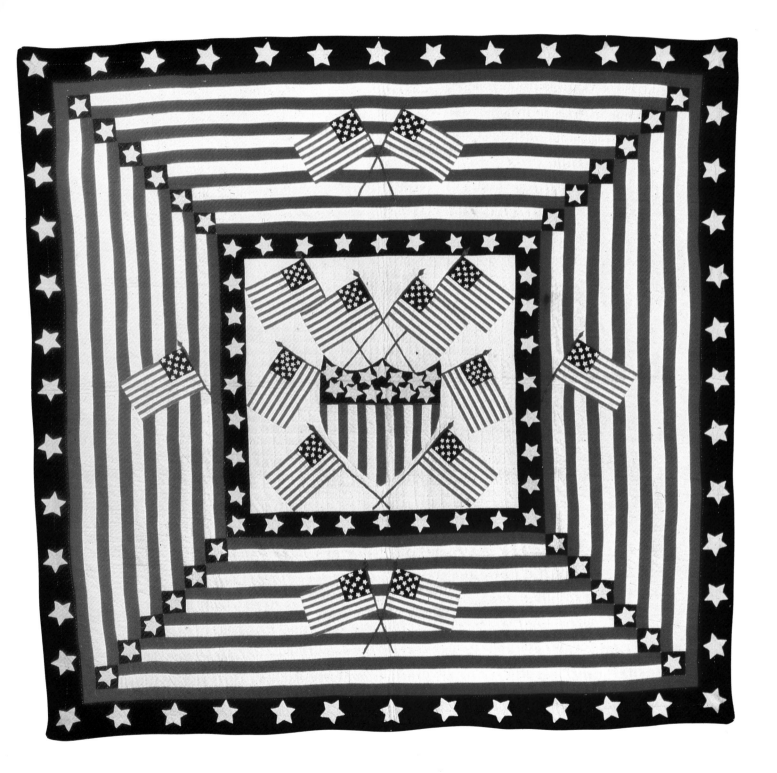

161

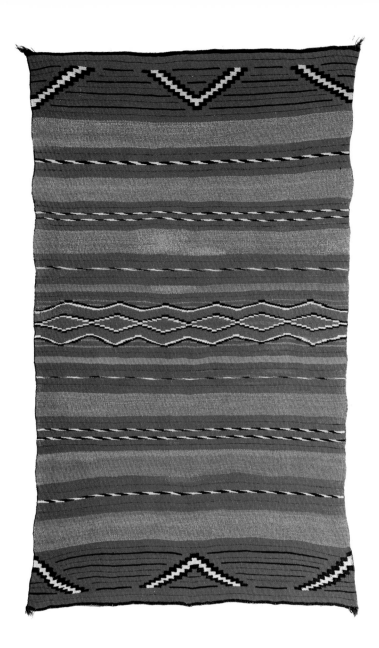

124
Navajo Classic Child's Blanket
Artist unknown
Probably New Mexico; c.1855
Wool (Bayeta and Churro); 30 × 50 in.
Gift of Warner Communications Inc. in
honor of Ralph Lauren. 1988.21.2

The most interesting design element of
a classic child's blanket is the center
pattern, which runs along the spine
when the blanket is worn in the
traditional style. The red in this
blanket is ravelled bayeta, dyed with a
combination of lac and cochineal; the
pink is the same bayeta recarded and
respun with undyed white churro yarn.

125
"Sacret Bibel" Quilt Top
Susan Arrowood
West Chester, Pennsylvania; c.1895
Cotton; 90 × 72 in.
Gift of the Amicus Foundation, Inc., and
Evelyn and Leonard Lauder.
1986.20.1

Stories from the Bible, including
"Jesus on the mountain sending his
desiples threw the world to preach,"
"Adam an eav in the Garden,"
"John baptizing Jesus in the river off
Jordan," and "Noh Ark" have been
appliquéd onto this quilt top. The
maker labeled the different scenes, and
also included her name and the title:
"Sacret Bibel Quilt."

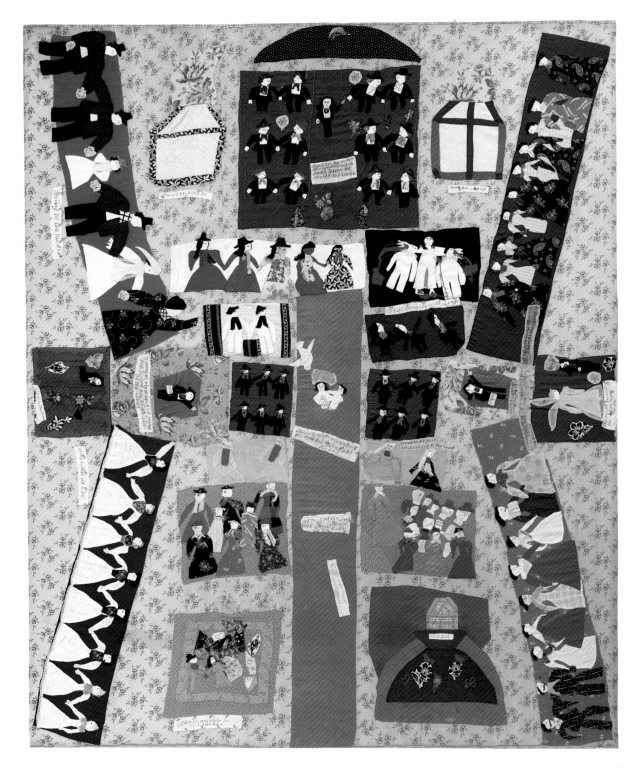

BIBLIOGRAPHY

An American Sampler: Folk Art from the Shelburne Museum (exhibition catalogue). Washington, D.C.: National Gallery of Art, 1987.

Ames, Kenneth L. *Beyond Necessity: Art in the Folk Tradition*. Winterthur, Del.: The Henry Francis Du Pont Winterthur Museum, 1977.

Andrews, Edward Deming. *The People Called Shaker: A Search for the Perfect Society*, 1953. Reprint. New York: Dover Publications, 1963.

Ape to Zebra: A Menagerie of New Mexican Woodcarvings, The Animal Carnival Collection of The Museum of American Folk Art (exhibition catalogue). New York: Museum of American Folk Art, 1985.

Baer, Joshua. *Collecting the Navajo Child's Blanket*. Santa Fe, New Mexico: Morning Star Gallery, 1986.

Baking in the Sun: Visionary Images from the South (exhibition catalogue). Lafayette, La.: University Art Museum, University of Southern Louisiana, 1987.

Barber, Joel. *Wild Fowl Decoys*. New York: Dover Publications, 1954.

Barrett, Didi. *Muffled Voices: Folk Artists in Contemporary America* (exhibition catalogue). New York: Museum of American Folk Art, 1986.

Barrett, Didi, and Kaufman, Barbara Wahl. *A Time to Reap: Late Blooming Folk Artists* (exhibition catalogue). South Orange, N.J.: Seton Hall University and the Museum of American Folk Art, 1985.

Bishop, Robert. *American Folk Sculpture*. New York: E. P. Dutton, 1974.

———. *Folk Painters of America*. New York: E. P. Dutton, 1979.

Bishop, Robert, and Coblentz, Patricia. *American Decorative Arts*. New York: Harry N. Abrams, 1982.

———. *A Gallery of American Weathervanes and Whirligigs*. New York: E. P. Dutton, 1981.

Bishop, Robert, and Safanda, Elizabeth. *A Gallery of Amish Quilts*. New York: E. P. Dutton, 1976.

Bishop, Robert; Weissman, Judith Reiter; McManus, Michael; and Neiman, Henry. *Folk Art: Paintings, Sculpture, and Country Objects*. New York: Alfred A. Knopf, 1983.

Black, Mary. *Erastus Salisbury Field: 1805–1900* (exhibition catalogue). Springfield, Mass: Museum of Fine Arts, 1985.

———. "A Folk Art Whodunit." *Art in America*. vol. 53, no. 3 (June 1965), pp. 96–105.

Black, Mary, and Lipman, Jean. *American Folk Painting*. New York: Clarkson N. Potter, 1966.

Bolton, Ethel Stanwood, and Coe, Eva Johnston. *American Samplers*, 1921. Reprint. New York: Dover Publications, 1973.

Boyd, Elizabeth. *Popular Arts of Spanish New Mexico*. Santa Fe: Museum of New Mexico Press, 1974.

Brant, Sandra, and Cullman, Elissa. *Small Folk: A Celebration of Childhood in America*. New York: E. P. Dutton in Association with the Museum of American Folk Art, 1980.

Brazer, Esther S. *Early American Decoration*. Springfield, Massachusetts: The Pond-Ekberg Company, 1940.

Cahill, Holger. *American Folk Art: The Art of the Common Man in America, 1750–1900* (exhibition catalogue). New York: Museum of Modern Art, 1932.

[Cahill, Holger.] *American Primitives* (exhibition catalogue). Newark, N.J.: Newark Museum, 1930.

Carlisle, Lilian Baker. *Pieced Work and Appliqué Quilts at Shelburne Museum*. Shelburne, Vermont: Shelburne Museum, 1957.

Christensen, Erwin O. *The Index of American Design*. Introduction by Holger Cahill. New York: Macmillan, 1950.

D'Ambrosio, Paul S., and Emans, Charlotte M., *Folk Art's Many Faces*. Cooperstown, New York: New York State Historical Association, 1987.

Davidson, Marshall B. *Life in America*. 2 vols. Boston: Houghton Mifflin Co. in Association with the Metropolitan Museum of Art, 1951.

Davison, Mildred, and Mayer-Thurman, Christa C. *Coverlets*. Chicago: The Art Institute of Chicago, 1973.

DePauw, Linda Grant, and Hunt, Conover. *"Remember the Ladies": Women in America 1750 to 1815* (exhibition catalogue). New York: Viking Press in Association with The Pilgrim Society, 1976.

Dewhurst, C. Kurt; MacDowell, Betty; and MacDowell, Marsha. *Artists in Aprons: Folk Art by American Women.* New York: E. P. Dutton in Association with the Museum of American Folk Art, 1979.

————. *Religious Folk Art in America: Reflections of Faith.* New York: E. P. Dutton in in Association with the Museum of American Folk Art, 1983.

Dinger, Charlotte. *Art of the Carousel.* New Jersey: Carousel Art Inc., 1984.

Distin, William, and Bishop, Robert. *The American Clock.* New York: E. P. Dutton, 1976.

Drepperd, Carl W. *Pioneer America, Its First Three Centuries.* Garden City, N.Y.: Doubleday and Company, 1949.

————. *American Pioneer Art and Artists.* Springfield, Massachusetts: Pond-Ekberg Publishing Company, 1942.

Earnest, Adele. *The Art of the Decoy: American Bird Carvings.* Exton, Pa.: Schiffer Publishing, 1982.

Eaton, Allen. *Immigrant Gifts to American Life: Some Experiments in Appreciation of the Contributions of Our Foreign Born.* (American Immigration Collection, Series 2) Salem, N.H.: Ayer Co., 1970 (Reprint of 1932 edition).

Ebert, John, and Ebert, Katherine. *American Folk Painters.* New York: Charles Scribner's Sons, 1975.

Emlen, Robert P. *Shaker Village Views.* Hanover, N.H.: University Press of New England, 1987.

Ericson, Jack T., ed. *Folk Art in America. Painting and Sculpture.* New York: Mayflower Books, 1979.

Fairbanks, Jonathan L., and Bates, Elizabeth Bidwell. *American Furniture—1620 to the Present.* New York: Richard Marek Publishers, 1981.

Fales, Dean A., and Bishop, Robert. *American Painted Furniture, 1660–1880.* New York, E. P. Dutton, 1972.

Ferrero, Pat; Hedges, Elaine; and Silber, Julie. *Hearts and Hands: The Influence of Women & Quilts on American Society.* San Francisco: The Quilt Digest Press, 1987.

Flayderman, E. Norman. *Scrimshaw and Scrimshanders/Whales and Whalemen.* New Milford, Conn.: N. Flayderman and Co., 1972.

Fleckenstein, Henry A., Jr. *American Factory Decoys.* Exton, Pa.: Schiffer Publishing, 1981.

Flower, Milton E. *Three Cumberland County Wood Carvers: Schimmel, Mountz, Barrett.* Carlisle, Pa.: Cumberland County Historical Society, 1986.

Ford, Alice. *Pictorial American Folk Art, New England to California.* New York: Studio Publications, 1949.

Folk Art Society of Kentucky. *God, Man and the Devil: Religion in Recent Kentucky Folk Art.* Lexington, Ky.: Folk Art Society of Kentucky, 1984.

Fried, Frederick. *Artists in Wood.* New York: Clarkson N. Potter, 1970.

————. *A Pictorial History of the Carousel.* New York: A. S. Barnes and Co., 1964.

Fried, Frederick, and Fried, Mary. *America's Forgotten Folk Arts.* New York: Pantheon Books, 1978.

Garrett, Elizabeth Donaghy. *The Arts of Independence: The DAR Collection.* Washington: The National Society, Daughters of the American Revolution, 1985.

Garvan, Beatrice B. *The Pennsylvania German Collection.* Philadelphia: Philadelphia Museum of Art, 1982.

Garvan, Beatrice B., and Hummel, Charles F. *The Pennsylvania Germans: A Celebration of Their Arts 1683–1850* (exhibition catalogue). Philadelphia: Philadelphia Museum of Art, 1982.

Gordon, Beverly. *Shaker Textile Arts.* Hanover, N.H.: University Press of New England, 1980.

Gosner, Kenneth L. *Working Decoys of the Jersey Coast and Delaware Valley.* Philadelphia: The Alliance Press, 1985.

Graham, John M. *Popular Art in America* (exhibition catalogue). Brooklyn, N.Y.: Brooklyn Museum, 1939.

Haid, Alan G. *Decoys of the Mississippi Flyway.* Exton, Pa.: Schiffer Publishing, 1981.

Hall, Michael D. *Stereoscopic Perspective: Reflections on American Fine and Folk Art.* Ann Arbor, Mich.: UMI Research Press, 1987.

Heisey, John. *A Checklist of American Coverlet Weavers.* Compiled for the Abby Aldrich Rockefeller Folk Art Center. Williamsburg, Va.: The Colonial Williamsburg Foundation, 1978.

Hemphill, Herbert W., Jr. *Folk Sculpture U.S.A.* New York: The Brooklyn Museum, 1976.

Hemphill, Herbert W., Jr., and Weissman, Julia. *Twentieth Century Folk Art and Artists.* New York: E. P. Dutton, 1974.

Hirschl and Adler Modern. *Bill Traylor, 1854–1947.* New York: Hirschl and Adler Modern, 1985.

Holdridge, Barbara, and Holdridge, Lawrence B. *Ammi Phillips: Portrait Painter 1788–1865.* Introduction by Mary Black. New York: Clarkson N. Potter for the Museum of American Folk Art, 1969.

Holstein, Jonathan. *The Pieced Quilt: An American Design Tradition.* New York: New York Graphic Society, 1973.

————. *American Pieced Quilts.* Washington, D.C.: Smithsonian Institution, 1972.

Hornung, Clarence P. *Treasury of American Design.* New York: Harry N. Abrams, N.D.

Janis, Sidney. *They Taught Themselves. American Primitive Painters of the 20th Century.* New York: Dial, 1942.

Johnson, Jay, and Ketchum, William, Jr. *American Folk Art of the Twentieth Century.* New York: Rizzoli, 1983.

Kangas, Gene, and Kangas, Linda. *Decoys, A North American Survey.* Spanish Folk, Utah: Hillcrest Publications, 1983.

[Karolik]. *M. and M. Karolik Collection of American Paintings. 1815–1865.* Essay by John I. H. Baur. Cambridge, Mass.: Harvard University Press for the Museum of Fine Arts, Boston, 1949.

————. *M. & M. Karolik Collection of American Water Colors & Drawings 1800–1875* (exhibition catalogue). 2 vols. Boston: Museum of Fine Arts, 1962.

Katzenberg, Dena S. *Baltimore Album Quilts* (exhibition catalogue). Baltimore: The Baltimore Museum of Art, 1980.

Kauffman, Henry J. *Early American Ironware Cast and Wrought*. Rutland, Vt.: Charles E. Tuttle Company, 1966.

Kent, Kate Peck. *Navajo Weaving: Three Centuries of Change*. Santa Fe, N. M.: School of American Research Press, 1985.

Ketchum, William C., Jr. *Early Potters and Potteries of New York State*. New York: Funk & Wagnalls, 1970.

Keyes, Homer Eaton. "Some American Primitives." *Antiques* 12, no. 2 (August, 1927) pp. 118–122.

Kimball, Art. *The Fish Decoy*. Boulder Junction, Wisc.: Aardvark Publications, 1986.

Klamkin, Charles. *Weather Vanes: The History, Design and Manufacture of an American Folk Art*. New York: Hawthorn Books, 1973.

Kopp, Joel, and Kopp, Kate. *American Hooked and Sewn Rugs, Folk Art Underfoot*. New York: E. P. Dutton, 1975.

Krueger, Glee F. *A Gallery of American Samplers: The Theodore H. Kapnek Collection*. New York: E. P. Dutton in Association with the Museum of American Folk Art, 1978.

———. *New England Samplers to 1840*. Sturbridge, Mass.: Old Sturbridge Village, 1978.

Larsen-Martin, Susan, and Martin, Lauri Robert. *Pioneers in Paradise: Folk and Outsider Artists of the West Coast* (exhibition catalogue). Long Beach, Calif.: Long Beach Museum of Art, Department of Parks and Recreation, 1984.

Lasansky, Jeannette. *Pieced by Mother: Over One Hundred Years of Quiltmaking Tradition*. Lewisburg, Pa.: Oral Traditions Project, 1987.

Lipman, Jean. *American Folk Art in Wood, Metal and Stone*, 1948. Reprint. New York: Dover Publications, 1972.

———. *American Primitive Painting*, 1942. Reprint. New York: Dover Publications, 1969.

Lipman, Jean, and Armstrong, Tom, eds. *American Folk Painters of Three Centuries*. New York: Hudson Hills Press in Association with the Whitney Museum of American Art, 1980.

Lipman, Jean, with Meulendyke, Eve. *American Folk Decoration*, 1951. Reprint. New York: Dover Publications, 1972.

Lipman, Jean; Warren, Elizabeth V.; and Bishop, Robert. *Young America: A Folk-Art History*. New York: Hudson Hills Press in Association with the Museum of American Folk Art, 1986.

Lipman, Jean, and Winchester, Alice. *The Flowering of American Folk Art (1776–1876)*. New York: The Viking Press, 1974.

Lipman, Jean, and Winchester, Alice, eds. *Primitive Painters in America, 1750–1950*, 1950. Reprint. Freeport, N.Y.: Books for Libraries Press, 1971.

Little, Nina Fletcher. *The Abby Aldrich Rockefeller Folk Art Collection* (catalogue). Williamsburg, Va.: Colonial Williamsburg, 1957; distributed by Little, Brown and Company, Boston.

———. *Country Art in New England, 1790–1840*, 1960. Rev. ed. Sturbridge, Mass.: Old Sturbridge Village, 1967.

———. *Country Arts in Early American Homes*. New York: E. P. Dutton, 1975.

———. *Floor Coverings in New England before 1850*. Sturbridge, Mass.: Old Sturbridge Village, 1967.

———. *Land and Seascape as Observed by the Folk Artists* (exhibition catalogue). Williamsburg, Va.: Colonial Williamsburg, 1969.

———. *Little by Little: Six Decades of Collecting American Decorative Arts*. New York: E. P. Dutton, 1984.

———. *Neat and Tidy: Boxes and Their Contents Used in Early American Households*. New York: E. P. Dutton, 1980.

———. *Paintings by New England Provincial Artists 1775–1800* (exhibition catalogue). Boston: Museum of Fine Arts, 1976.

Livingston, Jane, and Beardsley, John. *Black Folk Art in America 1930–1980*. Jackson, Miss.: Published for the Corcoran Gallery of Art by the University Press of Mississippi and the Center for the Study of Southern Culture, 1982.

Luck, Barbara R., and Sackton, Alexander. *Eddie Arning, Selected Drawings, 1964–1973* (exhibition catalogue). Williamsburg, Va.: The Colonial Williamsburg Foundation, 1985.

Ludwig, Allan I. *Graven Images: New England Stonecarving and Its Symbols, 1650–1815*. Middletown, Conn.: Wesleyan University Press, 1966.

Mackey, William. *American Bird Decoys*. New York: E. P. Dutton, 1965.

Mather, Christine, and Mather, Davis. *Lions and Tigers and Bears, Oh My! New Mexican Folk Carvings* (exhibition catalogue). Corpus Christi, Texas: Art Museum of South Texas, 1987.

McMorris, Penny. *Crazy Quilts*. New York: E. P. Dutton, 1984.

Meader, Robert F. W. *Illustrated Guide to Shaker Furniture*. New York: Dover Publications, 1972.

Metcalf, Eugene W., Jr. "Myths in American Folk Art History." *Maine Antique Digest*, November, 1986, pp. 10B–11B.

Missing Pieces: Georgia Folk Art 1770–1976 (exhibition catalogue). Georgia Council for the Arts and Humanities, 1976.

Montgomery, Florence M. *Printed Textiles: English and American Cottons and Linens, 1700–1850*. New York: Viking Press, 1970.

Muller, Charles R., and Rieman, Timothy D. *The Shaker Chair*. Winchester, Ohio: The Canal Press, 1984.

Oppenhimer, Ann Frederick, and Hankla, Susan, eds. *Sermons in Paint: A Howard Finster Folk Art Festival*. Richmond, Va.: University of Richmond, 1984.

Orlofsky, Patsy, and Orlofsky, Myron. *Quilts in America*. New York: McGraw-Hill Book Co., 1974.

Pendergast, A. W., and Ware, W. Porter. *Cigar Store Figures*. Chicago: The Lightner Publishing Company, 1953.

Pinckney, Pauline A. *American Figureheads and Their Carvers*. New York: W. W. Norton & Co., 1940.

Quimby, Ian M. G., and Swank, Scott T., eds. *Perspectives on American Folk Art*. Published for The Henry Francis du Pont Winterthur Museum. New York: W. W. Norton & Company, 1980.

Ramsey, John. *American Potters and Pottery*. New York: Tudor Publishing, 1939.

Rawson, Marion Nicholl. *When Antiques Were Young*. New York: E. P. Dutton, 1931.

Reed, Henry M. *Decorated Furniture of the Mahantango Valley*. Lewisburg, Pa.: Center Gallery, Bucknell University. Distributed by the University of Pennsylvania Press, 1987.

Ring, Betty. *American Needlework Treasures*. New York: E. P. Dutton in Association with the Museum of American Folk Art, 1987.

———. *Let Virtue Be a Guide to Thee: Needlework in the Education of Rhode Island Women, 1730–1830*. Providence, R.I.: The Rhode Island Historical Society, 1983.

———. *Needlework: An Historical Survey*. New York: Universe Books. 1975.

Rubin, Cynthia Elyce, ed. *Southern Folk Art*. Birmingham, Ala.: Oxmoor House, 1985.

Rumford, Beatrix T., ed. *American Folk Paintings: Paintings and Drawings Other Than Portraits from the Abby Aldrich Rockefeller Folk Art Center*. Boston: Little, Brown and Co., a New York Graphic Society Book, Published in Association with the Colonial Williamsburg Foundation, 1988.

———. *American Folk Portraits: Paintings and Drawings from the Abby Aldrich Rockefeller Folk Art Center*. Boston: New York Graphic Society in Association with the Colonial Williamsburg Foundation 1981.

Safford, Carleton, and Bishop, Robert. *America's Quilts and Coverlets*. New York: E. P. Dutton, 1972

Schaffner, Cynthia V. A., and Klein, Susan. *Folk Hearts: A Celebration of the Heart Motif in American Folk Art*. New York: Alfred A. Knopf, 1984.

Schorsch, Anita. *Mourning Becomes America: Mourning Art in the New Nation* (exhibition catalogue). Clinton, N.J.: Main Street Press, 1976.

Sears, Clara E. *Some American Primitives*. New York: Houghton Mifflin and Co., 1941.

Shea, John G. *The American Shakers and Their Furniture*. New York: Van Nostrand Reinhold Co., 1971.

Shelley, Donald A. *The Fraktur-Writings or Illuminated Manuscripts of the Pennsylvania Germans*. Allentown, Pa.: Pennsylvania German Folklore Society,

Sonn, Albert H. *Early American Wrought Iron*. New York: Charles Scribner's Sons, 1928.

Spargo, John. *Early American Pottery and China*. New York: Century Publishing Co., 1926.

Sprigg, June. *Shaker Design* (exhibition catalogue). New York: Whitney Museum of American Art in Association with W. W. Norton & Co., 1986.

Spruill, Julia Cherry. *Women's Life & Work in the Southern Colonies*. New York: W. W. Norton & Co., 1972 edition.

Strickler, Carol. *American Woven Coverlets*. Loveland, Colo.: Interweave Press, 1987.

Swan, Susan Burrows. *Plain & Fancy: American Women and Their Needlework, 1700–1850*. New York: Holt, Rinehart, and Winston, 1977.

Swank, Scott T., et al. *Arts of the Pennsylvania Germans*. New York: Published for the Henry Francis du Pont Winterthur Museum by W. W. Norton & Co., 1983.

Transmitters: The Isolate Artist in America (exhibition catalogue). Philadelphia: Philadelphia College of Art, 1981.

Vlach, John Michael. *The Afro-American Tradition in Decorative Arts*. Cleveland, Ohio: The Cleveland Museum of Art, 1978.

———. *Plain Painters: Making Sense of American Folk Art*. Washington, D.C.: Smithsonian Press, 1988.

Vlach, John Michael, and Bronner, Simon, eds. *Folk Art and Art Worlds: Essays Drawn From the Washington Meeting on Folk Art*. Ann Arbor, Mich.: UMI Research Press, 1986.

Waingrow, Jeff. *American Wildfowl Decoys*. New York: E. P. Dutton in Association with the Museum of American Folk Art, 1985.

Warren, William L. *Bed Ruggs: 1722–1833*. Hartford, Conn.: Wadsworth Atheneum, 1972.

Weiser, Frederick S., and Sullivan, Mary Hammond. "Decorated Furniture of the Schwaben Creek Valley." *Ebbes fer Alle—Ebber Ebbes fer Dich: Something for Everyone—Something for You*. Breiningsville, Pa.: The Pennsylvania German Society, 1980, pp. 331–394.

Weissman, Judith Reiter, and Lavitt, Wendy. *Labors of Love: Traditions in American Textiles*. New York: Alfred A. Knopf, 1987.

Welsh, Peter C. *American Folk Art*. Washington, D.C.: Smithsonian Institution, 1965.

Wertkin, Gerard C. *The Four Seasons of Shaker Life*. New York: Simon and Schuster, 1986.

Wroth, William. *Christian Images in Hispanic New Mexico*. Colorado Springs, Colo.: The Taylor Museum of the Colorado Springs Fine Arts Center, 1982.

———. ed. *Hispanic Crafts of the Southwest* (exhibition catalogue). Colorado Springs, Colo.: The Taylor Museum of the Colarado Springs Fine Arts Center, 1977.